# AMERICAN PAINTING

# ART AND ARCHITECTURE INFORMATION GUIDE SERIES

Series Editor: Sydney Starr Keaveney,
*Associate Professor, Pratt Institute Library*

*Also in the Art and Architecture Series:*

COLOR THEORY—*Edited by Mary L. Buckley**

INDUSTRIAL DESIGN—*Edited by J. Roger Guilfoyle**

ART THERAPY—*Edited by Josef E. Garai**

PHOTOGRAPHY—*Edited by Diana Edkins**

ART EDUCATION—*Edited by Clarence Bunch**

MODERN EUROPEAN PAINTING—*Edited by Ann-Marie Bergholtz**

PRINTS AND PRINTING—*Edited by Jeffrey Wortman**

CREAMICS—*Edited by James Edward Campbell**

AMERICAN SCULPTURE—*Edited by Janis Ekdahl**

AMERICAN ARCHITECTURE FROM THE CIVIL WAR TO WORLD
WAR I—*Edited by Lawrence Wodehouse**

AMERICAN ARCHITECTURE FROM WORLD WAR I TO THE
PRESENT—*Edited by Lawrence Wodehouse**

*in preparation

---

The above series is part of the
## GALE INFORMATION GUIDE LIBRARY

The Library consists of a number of separate Series of guides covering
major areas in the social sciences, humanities, and current affairs.

General Editor: Paul Wasserman, Professor and former Dean, School of Library
and Information Services, University of Maryland

# AMERICAN PAINTING

A Guide to Information Sources

**Sydney Starr Keaveney**
*Associate Professor, Pratt Institute Library*

**Volume 1**
*Art and Architecture:*
*An Information Guide Series*

Riverside Community College
Library
4800 Magnolia Avenue
Riverside, CA 92506
**Gale Research Company**
*Book Tower, Detroit, Michigan 48226*

**Library of Congress
Cataloging in Publication Data**

Keaveney, Sydney Starr.
  American painting.

  (Art and architecture information guide series) (Gale information guide library)
  1. Painting, American--Bibliography.  I.  Title
Z5949.A45K4             016.75913                     73-17522
ISBN 0-8103-1200-X

*to Liam Keaveney*

# VITAE

Sydney Starr Keaveney is an assistant professor of art and architecture and a lecturer at the Graduate School of Library and Information Science at Pratt Institute. She received her B.A. from Wellesley College and her M.A. from Simmons College. Before coming to Pratt Institute, Ms. Keaveney was art reference librarian for the Boston Public Library.

Ms. Keaveney is president of the New York chapter of the Special Libraries Association. She is a contributor to the WILSON LIBRARY BULLETIN and the DICTIONARY OF ART TERMS AND TECHNIQUES, Ralph Meyer, ed.

# CONTENTS

# PREFACE

This guide and those which will follow in the Art and Architecture Series are attempts to organize the existing literature of art and other resources in much-needed areas. The annotations, we trust, will aid the researcher and provide an evaluative quality beyond that of a simple bibliography or listing of institutions.

American art, and in particular, American painting, is much in need of documentation. There has been a tremendous amount of publication, particularly since the 1950's when Abstract Expressionism flourished and New York became the center of the art world. The basic published art bibliographies – Mary Chamberlin's GUIDE TO ART REFERENCE BOOKS (Chicago: American Library Association, 1959) and Louise Lucas' ART BOOKS (Greenwich, Conn.: New York Graphic Society, 1968) – are helpful, but neither contains very much American material.

Making limitations by nationality and medium becomes more difficult than one assumes at first. By "American" I mean specifically of the United States, and have indicated works on the art of various ethnic minorities where available. As for who is an "American" painter – we have absorbed into our culture artists who received their training in other parts of the world throughout the history of this country, and I have tried to be more inclusive than exclusive.

This is, however, a selective work. I have tried to cover only the more reliable and up-to-date writings. For works on individual artists, this becomes difficult. There are important artists about whom little, or little of value, has been written. There are also little-known artists about whom impressive scholarly monographs have been written.

For the sake of consistency, I have in general omitted illustrators, cartoonists, or artists who specialize in a medium other than painting. Today, few artists confine themselves to one medium during their working life, and this must be weighed. Books which discuss an artist's work in a medium other than painting have not been included, although many books are listed which discuss painting and other media.

Not all of the books discussed are scholarly works, although these were preferred. In the annotations, I have often noted the audience to whom the work is directed. The emphasis here is upon post-World War II publications and works of high quality. Unfortunately, works of excellent scholarship combined with good reproductions simply have not yet been published for all important American artists.

Most of my work has been done at Pratt Institute, Columbia University, and the New York Public Library. I extend gratitude for the use of these collections. Books which I could not actually locate to read or peruse have largely been omitted. Omitted also are books of very poor quality, obviously outdated works, and most obvious vanity publishing. "Vanity" publishing is something of a problem. There seems to be a lot of vanity in art publication. Much is produced as publicity, and nearly every brief article or catalog is full of enormous praise. Is a catalog put out by artist's dealer, full of reproductions and some biographical information, a "vanity" publication? Often the relationship seems close, yet in some cases these are the best or only documents produced so far about the artist and his work.

Exhibition catalogs pose great problems for the art library. They are often difficult to obtain. Library of Congress cataloging of them is notoriously slow and a source of hearty disagreement among art librarians. They are rarely hardcover so libraries spend a good deal of money having them bound. Worst of all, they go out of print usually immediately following the exhibition, and if lost or stolen cannot be replaced. Yet they are often the basis for further scholarly studies of the artist's work and may be distributed commercially by a trade publisher for a much more costly sum than the original catalog published by a museum. We also find that many rather modest exhibition catalogs are plumped up with glossy color reproductions, thick paper and hard covers and sold to us as important new books at extravagant prices. And our

readers want color reproductions.

My handling of exhibition catalogs and some other publications has not been identical to the practices of the Library of Congress. In most cases I have assigned authorship to the writer of the main essay or the organizer of the exhibition. The "main entry," in my opinion, should be that person intellectually responsible for the writing or organization of the publication. The museum or other sponsoring organization is usually directly analagous to a publisher, and thus my entries may differ from Library of Congress entries. In cases where authorship could not be assigned, title entries have been made.

The exhibition catalogs selected for inclusion are by no means guaranteed to be a complete listing. For the most part, an attempt was made to note only the better and more recent ones.

Some periodical articles were entered, particularly for artists with more recent reputations. The past five years of ART NEWS and ART FORUM were selectively indexed since they are commonly held in libraries and have had substantive articles on and interviews with many artists who are currently important, and about whom little material has appeared in monographic form.

Bibliographies included within publications have been noted, for in many cases a complete bibliography of a given subject or artist would be extremely lengthy.

Additionally, many artists are distinguished writers. For lack of space, I have listed only those writings which are autobiographical or are directly about American painting or an American painter.

# LIST OF ABBREVIATIONS

A few bibliographies are so extensive that I have selectively indexed them and included the information here so that more material may be found by consulting them. The following abbreviations indicate indexed sources:

IND. 20TH C. ARTISTS: Shapely, John et al. THE INDEX OF TWENTIETH CENTURY ARTISTS. New York: College Art Association, 1933-36. Biographical and bibliographical information, pagination noted.

HUNTER: Hunter, Sam. AMERICAN ART OF THE TWENTIETH CENTURY. New York: Abrams, 1972?. Pagination of bibliography noted. Also a good source for pictures and biographical information.

N.Y. MET. 19TH C.: Howat, John et al. NINETEENTH CENTURY AMERICA: PAINTINGS AND SCULPTURE; AN EXHIBITION IN CELEBRATION OF THE HUNDREDTH ANNIVERSARY OF THE METROPOLITAN MUSEUM OF ART. Greenwich, Conn.: New York Graphic Society, 1970. This work is unpaged but a good selective bibliography is to be found at the back of the volume, as well as biographical information and at least one reproduction in the text.

A.A.A.: Indicates that original source materials, or reproductions of them are in the collection of The Archives of American Art, according to the publication: ARCHIVES OF AMERICAN ART by Garnett McCoy (New York: Bowker, 1972).

*An asterisk means that the book would be appropriate in a small library collection, which does not necessarily specialize in art books.

The cut-off date for the inclusion of materials is July 1973.

# Chapter 1

## GENERAL REFERENCE SOURCES

Chapter 1

# GENERAL REFERENCE SOURCES

## BIBLIOGRAPHIES AND LIBRARY CATALOGS

These are major bibliographies and catalogs of libraries in the field of art. They are not devoted exclusively to American painting but all include significant listings of publications in the field.

ARTBIBLIOGRAPHIES: CURRENT TITLES. Santa Barbara, Calif.: Clio Press, 1972-

> Monthly publication which reproduces photographically the contents pages of some 200 international art journals.

ARTBIBLIOGRAPHIES: MODERN. Santa Barbara, Calif.: Clio Press, 1972- .

> A semi-annual publication which abstracts currently published books, exhibition catalogs, and journal articles on twentieth-century art and artists. This is a continuation of LOMA (see below).

Chamberlin, Mary W. GUIDE TO ART REFERENCE BOOKS. Chicago: American Library Association, 1959. xiv, 418 p.

> An excellent although now dated bibliography for the fine arts. International coverage of scholarly works, however such a broad range of subjects that few are covered in depth. The annotations are very useful, and the appendix lists "Special collections and resources" by countries, including 17 American libraries with outstanding holdings in art history. Extensive index (pp. 361-418).

Clapp, Jane. MUSEUM PUBLICATIONS, PART 1: ANTHROPOLOGY, ARCHAEOLOGY AND ART. New York: Scarecrow, 1962. 434 p.

> A classified bibliography of publications available in 1962 from U.S. and Canadian museums, including books, pamphlets and serial reprints. Does not include administrative reports, news bulletins or most materials listed in BOOKS IN PRINT. Index pp. 294-434. (Part 2 includes biological and earth sciences.)

Columbia University. CATALOG OF THE AVERY MEMORIAL ARCHITECTURAL LIBRARY, 2nd ed., 19 vols., plus supplements. Boston: G.K. Hall, 1968,

1972.

> Despite the title this is a union catalog of all of the holdings of
> Columbia University in the fields of art and architecture, includ-
> ing the excellent collection of over 35,000 titles in the Fine
> Arts Library in addition to the estimated 80,000 architectural
> books in Avery. The four volumes of the first supplement were
> issued in 1972.

Davis, Alexander. LOMA (Literature of Modern Art), 3 vols. London: Lund
Humphries, 1971.

> A briefly published annual index to publications in the field of
> modern art, international in scope. Volume 1 covers 1969; volume
> 2, 1970; and volume 3, 1971. Continued by ARTBIBLIOGRAPH-
> IES: MODERN (see above).

Foster, Donald L. A CHECKLIST OF U.S. GOVERNMENT PUBLICATIONS
IN THE ARTS. (University of Illinois Graduate School of Library Science Oc-
casional Papers, no. 96.) Urbana: University of Illinois Graduate School of
Library Science, 1969. 48 p.

> A compilation of over 600 publications, mostly pamphlets, publish-
> ed by various U.S. government agencies on widely diverse fields
> of art. Includes a subject index.

Harvard University. CATALOG OF THE HARVARD UNIVERSITY FINE ARTS
LIBRARY: THE FOGG ART MUSEUM. 15 vols. Boston: G.K. Hall, 1971.

> Photo-reproduction of the library's card catalog, similar in format
> to the other G.K. Hall publications listed here. This is an out-
> standing scholarly art history library.

Krasilovsky, Alexis Rafael. "Feminism in the Arts: An Interim Bibliography."
ARTFORUM, vol. 10, June 1972, pp. 72-75.

> International in scope, covering many media and annotated, "of-
> fered as a starting point for further studies."

*Lucas, E. Louise. ART BOOKS: A BASIC BIBLIOGRAPHY. Greenwich,
Conn.: New York Graphic Society, 1968. 205 p.

> A comprehensive, basic bibliography meant to form the core of a
> scholarly undergraduate art library. International coverage; in-
> dexed by authors and artists.

_____. BOOKS ON ART: A FOUNDATION LIST, 2nd ed. Cambridge:
Harvard University, Fogg Museum of Art, 1938. 84 p. (First edition published
in the ART BULLETIN. vol. 11, no. 3, September 1929.)

> Lucas' first separately published bibliography of important books
> for the undergraduate art library. It remains a classic.

_____. THE HARVARD LIST OF BOOKS ON ART. Cambridge: Harvard
University Press, 1952. 163 p.

The second of Lucas' basic bibliographies. With each succeeding edition, some important books were dropped because they became unavailable on the market. Thus the earlier editions may have value to the bibliographer.

Metropolitan Museum of Art, New York. THE METROPOLITAN MUSEUM OF ART: LIBRARY CATALOG. 25 vols., plus supplements. Boston: G.K. Hall, 1960.

One of the largest and finest art book collections in the world is described here. Approximately 147,000 books are listed in the basic set (vols. 1-23); volumes 24 and 25 list sales catalogs. The supplements have been issued in 1962, 1965, 1968 and 1970; a fifth supplement is in preparation.

National Book League, England. ART BOOKS: AN ANNOTATED LIST. London: National Book League, in association with the Tate Gallery, 1968. 136 p.

Bibliography of a selection of attractive and authoritative art books exhibited at the Tate Gallery. Primarily books on European art, but some monographs on American painters are included in the section on twentieth-century art.

Sims, Lowery S. "Black Americans in the Visual Arts: A Survey of Bibliographic Material and Research Resources." ARTFORUM. Vol. 11, no. 8, April 1973, pp. 66-70.

An impressive bibliography of books, articles, exhibition catalogs, and even films relating to art done by Black Americans. More than just painting, includes material on various crafts, photography, architecture, etc., plus listings of museums, galleries and other sources of information.

Whitehill, Walter Muir et al. THE ARTS IN EARLY AMERICAN HISTORY. Chapel Hill : University of North Carolina Press, 1965. 170 p.

There is a short historical essay by Whitehill, which ends on p. 33; the rest of the volume is an extensive bibliography by Wendell D. Garrett and Jane N. Garrett on early American art. Well indexed.

### INDEXES AND DIRECTORIES

AMERICAN ART ANNUAL. 37 vols. New York and Washington, D.C. : American Federation of Arts, 1898-1948. Frequency varies; after 1952, continued as separate volumes: AMERICAN ART DIRECTORY and WHO'S WHO IN AMERICAN ART.

An invaluable reference set. Lists art organizations, schools, museums, etc., although scope varies from year to year. Obituaries, auction information, and "Who's Who" sections often included. Founded and for many years edited by Florence N. Levy.

*AMERICAN ART DIRECTORY. New York: R.R. Bowker for the American Federation of Arts, vol. 1, 1952-   .

> A continuation of the AMERICAN ART ANNUAL minus the "Who's Who" sections, and other features. Lists and describes "art organizations, museums, art schools, directors and supervisors of art education in school systems, art schools abroad by country, art magazines, newspapers carrying art notes and their critics, scholarships and fellowships, traveling exhibitions." An essential reference work, issued triennially.

ART INDEX. New York: H.W. Wilson, 1929-   . Issued quarterly, with cumulations now annual; previously they have been triennial (1929-53) and biennial (1953-67).

> Indexes by subject and author nearly 200 art periodicals. Since the majority of these are in English, and most are American, it is an essential index for materials in the study of American painting. Useful also for locating book reviews, reproductions, and reviews of exhibitions.

Art Institute of Chicago. INDEX TO ART PERIODICALS, COMPILED IN THE RYERSON LIBRARY OF THE ART INSTITUTE OF CHICAGO. 11 vols. Boston: G.K. Hall, 1962.

> A periodical index which is, in effect, supplemental to the ART INDEX. This back-indexes many periodicals prior to the 1929 starting date of ART INDEX and indexes a great many more not included in it. Emphasis is upon museum publications; entries are by subject and author.

Monro, Isabel Stevenson and Monro, Kate M. INDEX TO REPRODUCTIONS OF AMERICAN PAINTINGS: A GUIDE TO PICTURES OCCURRING IN MORE THAN EIGHT HUNDRED BOOKS. New York: H.W. Wilson, 1948. 731 p. FIRST SUPPLEMENT. New York: H.W. Wilson, 1964. 480 p.

> Two volumes which index reproductions of American paintings found in books commonly held in library collections. Although the reproductions are not necessarily the best because so much has been published since these books were compiled, they are often helpful in tracking down elusive works. The title and subject indexing of paintings is an unusual and particularly useful feature of these works, especially for the public library.

*Rauschenbusch, Helmut, ed. INTERNATIONAL DIRECTORY OF ARTS. Berlin: Deutsche Zentraldrukerei AG, 1952-   . (One volume published annually; each edition is two volumes.)

> One of the most basic sources for an art library. Lists and describes "museums, universities, artists, collectors, associations, antique dealers, art galleries, auctioneers, publishers, booksellers, restorers," and delightfully, "experts." International coverage; the "artists" section comes as close to an international "Who's Who" in art as is currently published. In four languages: English, German,

French and Spanish; entries for countries in the language of the country concerned in Latin Script - e.g., Nippon (Japan), Osterreich (Austria) and Schweiz (Switzerland).

*READERS' GUIDE TO PERIODICAL LITERATURE. New York: H.W. Wilson, 1900-   . Issued semi-monthly from September to June, monthly in July and August, cumulated annually.

This basic periodical index covers general magazines and they are primarily American. A few art magazines not in the ART INDEX are found here: DESIGN (U.S), ANTIQUES and SCHOOL ARTS; some are in both indexes: AMERICAN ARTISTS, ART IN AMERICA, and ART NEWS among them. Additionally, many general interest magazines carry excellent articles on art, such as the NEW YORKER, SATURDAY REVIEW, HORIZON, and others.

BIOGRAPHICAL DICTIONARIES AND INDEXES

Artists Equity Association, D.C. Chapter. WASHINGTON ARTISTS TODAY. Washington, D.C.: distributed by Acropolis Books, New York, 1967. 79 p. Illus.

Artists Equity Association is an association of artists formed to protect the rights of working artists versus the art "establishment." According to the preface, this volume was compiled in response to a 1962 federal allotment of one half of one percent of construction costs of federal buildings for permanent art works. Few of these artists are well known, and though the librarian might be grateful for such a source, the works illustrated are depressingly pedestrian.

ARTISTS/USA, 1970-71: THE BUYER'S GUIDE TO CONTEMPORARY ART. Philadelphia: Artists/USA, Inc., in association with Livingston Publishing Co., Wynnewood, Pa., 1970. 239 p. Illus., some color plates.

Similar to the above in promoting the interests of cooperating artists rather than being a selective guide. The overall impression is that this is a guide to "schlock" or rather poor-quality, derivative, sentimental works. A few truly important artists, such as Andy Warhol, Robert Rauchenberg, and Robert Indiana, are included. Since many of these artists are not to be found elsewhere, it might possibly be helpful in a public library. The essays "Why collectors buy contemporary American art," and "Problems of the contemporary American artists" spell out a dissatisfaction with the current art scene and market.

Benezit, Emmanuel. DICTIONNAIRE CRITIQUE ET DOCUMENTAIRE DES PEINTRES, SCULPTEURS, DESSINATEURS ET GRAVEURS... 8 vols. Paris: Librarie Grund, 1948-55. Illus.

Major international biographical dictionary, second in coverage only to Thieme-Becker and Vollmer (see below). Signatures and reproductions of works often included. Prices of works listed are of little significance today. Unfortunately this set was produced on very poor paper, with inferior cover boards; the reproductions

also are less than excellent. Nevertheless, the exhaustive cover-
age and general accuracy make it an indispensible tool.

Columbia University. AVERY OBITUARY INDEX OF ARCHITECTS AND ART-
ISTS. Boston: G.K. Hall, 1963. 338 p.

Produced as a supplement to the AVERY INDEX OF ARCHITEC-
TURAL PERIODICALS (Boston: G.K. Hall, 1963, plus supplements).
Intended primarily as a source for information about architects,
however a great many artists are included. Sad though it may be,
often the most inclusive biography of an artist in print will be an
obituary.

*Cummings, Paul. A DICTIONARY OF CONTEMPORARY AMERICAN ARTISTS,
2nd ed. New York: St. Martin's Press, 1971. 368 p. Illus.

At first glance this seems to be similar in scope to WHO'S WHO
IN AMERICAN ART (see below), but it is far more selective. In-
cludes more truly important artists and many thought of as "con-
temporary," yet deceased. Brief entries, bibliography at end of
each entry, and a complete bibliography, pp. 343–68. An excel-
lent source.

CURRENT BIOGRAPHY: WHO'S NEW AND WHY. New York: H.W. Wilson,
1940–   . Monthly with annual cumulations.

Biographical sketches and portraits of contemporary prominent fig-
ures in all fields, including art. References given.

DICTIONARY OF AMERICAN BIOGRAPHY. 11 vols. New Yrok: Scribner,
1932–58.

A basic reference source for biographical data about prominent
Americans, including some artists. References given.

Earle, Helen L. BIOGRAPHICAL SKETCHES OF AMERICAN ARTISTS. 5th ed.
Charlestown, S.C.: Garnier and Co. (Unabridged republication of the edition
originally published by the Michigan State Library in 1924.) 370 p.

A chatty biographical dictionary of American artists who had es-
tablished reputations prior to the 1920's. "American artists of the
legion of honor" p. 15. "Michigan artists" p. 16. Bibliography
pp. 351–70.

*Fielding, Mantle. DICTIONARY OF AMERICAN PAINTERS, SCULPTORS
AND ENGRAVERS: FROM COLONIAL TIMES THROUGH 1926. New York:
Paul A. Strook, 1960. 433 p.

The first edition of this standard reference work was published in
Philadelphia in 1926; subsequently only limited editions, with mi-
nor corrections, have been printed. It is still, however, an im-
portant source for biographical information about American artists
with established reputations prior to 1926. Unfortunately the indi-
vidual entries do not have references, although there is a lengthy

bibliography pp. 424-33.

*Groce, George C. and Wallace, David H. THE NEW YORK HISTORICAL SOCIETY'S DICTIONARY OF ARTISTS IN AMERICA: 1564-1860. New Haven: Yale University Press, 1957. 759 p.

> One of the most important and scholarly reference sources for early American artists. Short biographical entries with references for artists active before 1860. "Key to sources" pp. 713-59.

*Havlice, Patricia Pate. INDEX TO ARTISTIC BIOGRAPHY. 2 vols. Metuchen, N.J.: Scarecrow, 1973.

> Similar in concept to Mallett (see below), although much updated, this indexes 64 major reference works in ten languages for artists' biographies. International in scope, covering all periods, this is a time-saving tool for researchers. Includes bibliography pp. v-vii.

Mallett, Daniel Trowbridge. MALLETT'S INDEX OF ARTISTS. New York: Peter Smith, 1948 (c. 1935). 493 p. SUPPLEMENT TO MALLETT'S INDEX OF ARTISTS. New York: Peter Smith, 1948 (c. 1940). 319 p.

> Reprint of two volumes published originally by R.R. Bowker in 1935 and 1940, which index several basic biographical works. Dated, but a handy two-volume set listing thousands of artists with their dates, nationalities, and abbreviated references. International coverage but strong on American artists. Occasional errors (e.g., Fernand Leger's birthplace listed as Argentine, South America, instead of Argentan, France) not corrected in the reprint. Extensive bibliography included in the front of each volume.

Park, Esther A. MURAL PAINTERS IN AMERICA, PART 1: A BIOGRAPHICAL INDEX. Pittsburg, Kansas: Kansas State Teachers College, 1949. 182 p.

> This indexes material published about American muralists from 1800 to 1947. Emphasis is on midwestern artists and works, many of which no longer exist. The second volume which was to have indexed murals by location was apparently never published.

Shapely, John et al. THE INDEX OF TWENTIETH CENTURY ARTISTS. New York: College Art Association, 1933-36. Published monthly, usually bound in four volumes by year. Some sets have a typewritten index tipped in the back of vol. 4.

> Over 100 American artists chronicled in this scholarly publication. Each entry has a short biographical sketch, awards and honors, affiliations, etc., and a lengthy bibliography. Since many of the references are to periodicals which predate the ART INDEX, this is useful for early material. The bibliographies have been selectively indexed in the "Individual Artists" section of this guide.

Smith, Ralph Clifton. A BIOGRAPHICAL INDEX OF AMERICAN ARTISTS. Baltimore: Williams and Wilkins, 1930. 102 p.

There are entries for nearly 5,000 American artists in this index to other reference sources. Place and dates of birth and death, media in which artist worked are listed. Dated, but sometimes useful for early material on lesser-known artists.

Thieme, Dr. Ulrich and Becker, Dr. Felix. ALLGEMEINES LEXIKON DER BILDENDEN KUNSTLER..., 37 vols. Leipzig: Verlag von Wilhelm Engelmann, 1907-50.

Although in German, this is the most comprehensive biographical dictionary ever published listing artists. International in scope, coverage is from the beginning of history to publication date. Along with the Benezit set mentioned above, it is essential for any art reference library. The coverage of American artists is very good and the references at the end of each entry are excellent. Since each volume was published separately over nearly half a century, more contemporary artists are to be found toward the end of the alphabet. This is referred to as "Thieme-Becker"; the Vollmer set (see below) acts as a supplement.

Vollmer, Hans. ALLGEMEINES LEXIKON DER BILDENDEN KUNSTLER: DES XX JAHRHUNDERTS, 6 vols. Leipzig: Veb. E.A. Seemann Verlag, 1953-62.

Similar in format to the Thieme-Becker set (above), except for shorter entries. This is the most important biographical dictionary for twentieth-century artists, primarily European and American. Published one volume at a time, there is a second alphabetical arrangement beginning in the middle of volume 5, ending in volume 6. Each entry contains bibliographical references. In German language only, although includes many references in English.

Waters, Clara Erskine Clement. ARTISTS OF THE NINETEENTH CENTURY AND THEIR WORKS: A HANDBOOK CONTAINING TWO THOUSAND AND FIFTY BIOGRAPHICAL SKETCHES. 2 vols. in one. Boston: Houghton Mifflin (c. 1907), rev. ed.

A dictionary of European and American artists of the nineteenth century, written at the end of that century. Occasionally useful for obscure artists but quite dated; the value judgements are often more entertaining than authoritative at this late date. Indexed.

*WHO'S WHO IN AMERICAN ART. New York: R.R. Bowker and The American Federation of Arts, 1936- .

Originated as part of the AMERICAN ART ANNUAL and published separately, usually triennially since 1936. Lists biographical information about U.S. and Canadian artists, with a geographical index and an obituary list. Later volumes have listings of open competitions and exhibitions for artists.

Young, William. A DICTIONARY OF AMERICAN ARTISTS, SCULPTORS AND ENGRAVERS. Cambridge: William Young, 1968. 515 p.

A one-volume biographical dictionary of American artists, with

rather short entries. The book is handy for cursory information, but it has obviously drawn from a great many other published works and credits none of them.

## DICTIONARIES AND ENCYCLOPEDIAS

Barron, John N. THE LANGUAGE OF PAINTING: AN INFORMAL DICTIONARY. Cleveland: World, 1967. 207 p. Illus.

A brief dictionary with terms from the history of art and also technical words. Clear, simple entries meant for the layman rather than the specialist. Bibliography of major art books in the back, pp. 205-7.

*ENCYCLOPEDIA OF WORLD ART, 15 vols. New York: McGraw-Hill, 1959-69. Illus., many color plates.

An exhaustive and scholarly reference work. Coverage is of all periods and places but is excellent for articles on American painters and painting. Each article is accompanied by bibliographic references; there are extensive reproductions. Volume 15 is a thorough index.

Lake, Carlton and Maillard, Robert. DICTIONARY OF MODERN PAINTING. New York: Tudor, 1964? 416 p. Illus., many in color.

Translation from the French: DICTIONNAIRE DE LA PEINTURE, Paris: Hazan, 1963. The terms and artists included are largely European, although a few American painters included.

*MCGRAW-HILL DICTIONARY OF ART, 5 vols. New York: McGraw-Hill, 1969. Illus., many in color.

This seems to be a spin-off from the ENCYCLOPEDIA OF WORLD ART but it does not duplicate it. The entries are much shorter and more direct, as the title would indicate. Many entries for U.S. artists and terms. Articles include bibliographies. No index, but with short entries this is not such a handicap. A very worthwhile reference set.

*Mayer, Ralph. A DICTIONARY OF ART TERMS AND TECHNIQUES. New York: Crowell, 1969. 447 p. Illus.

An excellent dictionary of historic and technical terms. Includes many recent technical terms not to be found in other dictionaries. Lengthy bibliography pp. 441-47.

Myers, Bernard S., ed. ENCYCLOPEDIA OF PAINTING. New York: Crown, 1970, 3rd ed. 511 p. illus., some in color.

Really more of a dictionary, with artists and art terms in one alphabet. Includes many Americans. For the layman not the scholar, and with rather poor reproductions.

*PHAIDON DICTIONARY OF TWENTIETH CENTURY ART.  London and New York:  Phaidon, 1973.  420 p., plus plates.

> A dictionary of twentieth-century art styles and terms, with brief biographical entries.  Many contemporary American artists included, with bibliographical references.

Quick, John.  ARTISTS' AND ILLUSTRATORS' ENCYCLOPEDIA.  New York: McGraw-Hill, 1969.  273 p.  Illus.

> A one-volume work (more a dictionary than encyclopedia) with clear, concise definitions and descriptions of art terms and techniques.  Contains an admirable bibliography of technical art books pp. 235-39; index pp. 241-73.

*PRAEGER ENCYCLOPEDIA OF ART.  5 vols.  New York:  Praeger, 1971. Illus., includes color plates.

> Translated and updated from the French:  DICTIONNAIRE UNIVERSEL DE L'ART ET DES ARTISTES, Paris:  Hazan, 1967, 3 vols.  International coverage, yet many U.S. artists and styles included.  Reproductions of uneven quality; index given.

Seuphor, Michel.  DICTIONARY OF ABSTRACT PAINTING WITH A HISTORY OF ABSTRACT PAINTING.  New York: Tudor, 1957?  305 p.  Illus., includes some color.

> Heavily European in content.  Does, however, include brief biographical entries of some major American abstractionists.  "Bibliography of abstract art" pp. 297-305.

Chapter 2

# GENERAL HISTORIES AND SURVEYS
# OF AMERICAN PAINTING

Chapter 2

# GENERAL HISTORIES AND SURVEYS

# OF AMERICAN PAINTING

AMERICAN ART AT HARVARD. Cambridge: Harvard University, William
Hayes Fogg Art Museum, 1972. Unpaged. Illus.

> Catalog of a distinguished exhibition, detailing Harvard Universi-
> ty's holdings in American art, largely paintings.

American Watercolor Society. 200 YEARS OF WATERCOLOR PAINTING IN
AMERICA: AN EXHIBITION COMMEMORATING THE CENTENNIAL OF THE
AMERICAN WATERCOLOR SOCIETY. New York: Metropolitan Museum of
Art, 1966. 64 p. Illus., plates. Members pp. 58-64.

> Two exhibits are included in this catalog, the central one being
> works by current members. Yet more interesting and presented
> first in the catalog is a collection of paintings illustrating the his-
> tory of watercolor painting in the United States.

Barker, Virgil. AMERICAN PAINTING: HISTORY AND INTERPRETATION.
New York: Macmillan, 1950. 717 p. Illus. Notes pp. 669-92. Index pp.
693-717.

> A textbook history of American painting to the beginning of the
> twentieth-century. Still useful but dated.

Bizardel, Yvon. AMERICAN PAINTERS IN PARIS, 1760-1900. New York:
Macmillan, 1960. 177 p. Illus., plates. Index pp. 171-77.

> Travels and experience abroad of American artists from Benjamin
> West to James A. McNeill Whistler.

Burroughs, Alan. LIMNERS AND LIKENESSES: THREE CENTURIES OF AMERI-
CAN PAINTING. New York: Russell and Russell, 1965. 246 p. Illus.
Bibliography pp. 225-26. Index pp. 231-46.

> Reprint of the 1936 book, published by Harvard University Press,
> which was an important assessment of American painting up through

the first three decades of the twentieth century. The black and white reproductions in the reprint are very poor, give only a dim reflection of the paintings they represent.

Chase, Judith Wragg. AFRO-AMERICAN ART AND CRAFT. New York: Van Nostrand Reinhold, 1971. 142 p. Illus. Bibliography pp. 138-39. Index pp. 140-42.

Includes a brief history of African art, with a careful history of its influence upon American art. Chronicles the contributions of Afro-Americans in arts and crafts to the present day, including works by anonymous artists. Brief biographical entries for "The pioneer artists" pp. 93-107. Extensive bibliography.

Clark, Eliot. HISTORY OF THE NATIONAL ACADEMY OF DESIGN: 1825-1953. New York: Columbia University Press, 1954. 296 p. Illus. Appendix pp. 243-85. Index pp. 287-96.

History of the organization which in the late nineteenth and early twentieth centuries played an important part in the development of American painting. Though still headquartered in New York and quietly active, its role has declined. The appendix contains a list of the founders, members, and "Prizes, scholarships and donations."

*Dockstader, Frederick J. INDIAN ART IN AMERICA: THE ARTS AND CRAFTS OF THE NORTH AMERICAN INDIAN. Greenwich, Conn.: New York Graphic Society, 1966. 224 p. Illus., many color plates. Bibliography pp. 222-24.

One of the best surveys of the traditional arts of the American Indians, heavily illustrated, and written by the director of the Museum of the American Indian, New York.

Dover, Cedric. AMERICAN NEGRO ART. Greenwich, Conn.: New York Graphic Society, 1960. 186 p. Illus., some in color. Bibliography pp. 57-60, by Maureen Dover.

Reprinted, though not updated, several times since 1960. An informative work, but in a field which is growing very rapidly it is now dated. The double-column layout, small reproductions, minimal margins, and materials printed on the end papers give the impression of trying to put too much material in too small a format.

*Dunn, Dorothy. AMERICAN INDIAN PAINTING OF THE SOUTHWEST AND PLAINS AREA. Santa Fe: University of New Mexico Press, 1968. 429 p. Illus., many color plates. Bibliography pp. 385-414.

An excellent survey of painting in the traditional manner by southwestern American Indians, particularly the Hopis, Navajos, Apaches, Pueblos, and Cheyennes. Emphasis on "Recent developments" and "A future for Indian painting." Extensive bibliography included.

Feder, Norman. AMERICAN INDIAN ART. New York: Abrams, 1969? Illus., many color plates. Bibliography pp. 439-44.

A handsome picture book, with little text, which surveys
American Indian art by areas. Lengthy bibliography.

Flexner, James Thomas. FIRST FLOWERS OF OUR WILDERNESS: AMERICAN
PAINTING, THE COLONIAL PERIOD. Boston: Houghton Mifflin, 1947. 369
p. Illus., some color plates. Bibliography pp. 323-41. Reprint: Dover,
1969, all reproductions black and white.

> First volume of Flexner's three-volume study of American painting.
> This covers the origins of U.S. paintings and the interaction with
> the European cultural tradition. Tends to be chatty, anecdotal,
> and even patronizing in tone.

_____. THE LIGHT OF DISTANT SKIES: AMERICAN PAINTING, 1760-1835.
New York: Harcourt Brace, 1954. 307 p. Illus. Bibliography pp. 253-
83. Index pp. 285-307. Reprint: Dover, 1969.

> Middle volume of Flexner's history. Benjamin West, Copley, Trum-
> bull, Allston and the Peales are among the artists included.

_____. THAT WILDER IMAGE; THE PAINTING OF AMERICA'S NATIVE
SCHOOL FROM THOMAS COLE TO WINSLOW HOMER. New York: Bonanza
Books, 1962. 407 p. Illus. Bibliography pp. 375-94. Index pp. 395-407.
Reprint: Dover, 1969.

> Covers developments in nineteenth-century American painting, with
> particular emphasis on the landscape tradition. Poor reproductions.
> Third volume of Flexner's history.

*Gardner, Albert Ten Eyck. HISTORY OF WATER COLOR PAINTING IN AMER-
ICA. New York: Reinhold, 1966. 160 p. Illus., many color plates.

> A handsome picture book which surveys watercolor painting in the
> United States, from a 1650 view of New Amsterdam by Laurens
> Block to a 1958 work by Sam Francis. Works of the late nine-
> teenth and early twentieth centuries predominate. Text is lucid,
> aimed at the layman.

*Gerdts, William H. and Burke, Russell. AMERICAN STILL LIFE PAINTING.
New York: Praeger, 1971. 264 p. Illus., some color plates. Notes, pp.
237-55. Bibliography pp. 257-59. Index pp. 261-64.

> The most extensive coverage of the subject to date: from Copley
> and the Peales to pop art. Harnett and his "Trompe l'oeil" school
> are covered at length. Good bibliography.

_____. PAINTING AND SCULPTURE IN NEW JERSEY. Princeton: Van Nos-
trand, 1964. 275 p. Illus. Index pp. 263-75.

> Local artists of New Jersey carefully chronicled from the end of the
> seventeenth century. Some of the major artists included are:
> Asher B. Durand, Martin Johnson Heade, Stuart Davis, Walt Kuhn,
> Lucas Samaras, George Segal, and Roy Lichtenstein. A rewarding
> work to those especially interested in New Jersey history but since

many of the prominent artists have been identified with various
New York schools, Gerdts seems to take a rather narrow viewpoint.

*Goodrich, Lloyd. THREE CENTURIES OF AMERICAN ART. New York: Prae-
ger, published for the Whitney Museum of American Art, 1966. 145 p. Illus.,
some color plates. Indexes are unpaged.

This originated as an exhibition catalog titled ART OF THE UNI-
TED STATES: 1670-1966. Title was changed when commercially
issued by Praeger. The exhibition was a major one, celebrating
the opening of the new museum designed by Marcel Breuer. Good-
rich's text is a rather brief, clear introduction to the history of
American art written for the layman, based on his earlier article,
"What is American in American art," ART IN AMERICA, 1963.
(See Lipman, below.) The reproductions are only fair. Major dif-
ference between the exhibition catalog and the Praeger volume is
the inclusion of an index in THREE CENTURIES... and the exhi-
bition data in the back of ART OF THE UNITED STATES....

Green, Samuel M. AMERICAN ART: A HISTORICAL SURVEY. New York:
The Ronald Press, 1966. 706 p. Illus. Notes pp. 645-54. Glossary pp.
655-61. Suggested reading pp. 663-38. Index pp. 671-706.

Written as a text for an undergraduate survey course in American
art. In addition to painting, sculpture and architecture, includes
material on American developments in the graphic arts and photog-
raphy. Reproductions all in black and white, and various in qual-
ity. Style of writing is occasionally overloaded with adjectives
("which he manages to touch with sentimental nostalgia for a pass-
ing agrarianism, in spite of his objective technique of impression-
istic luminosity," referring to J. Alden Weir, p. 391).

*Gussow, Alan. A SENSE OF PLACE: THE ARTIST AND THE AMERICAN
LAND. New York: Saturday Review Press; a Friends of the Earth Series in col-
laboration with the John Muir Institute for Environmental Studies, 1972. 160 p.
Illus., includes 63 color plates. Title p. 16. Index p. 18.

A truly handsome, well-produced book. Surveys outstanding ex-
amples of American landscape painting, avoiding the pedantic chro-
nological presentation. Statements by the artists as well as brief
notations about them face the excellent reproductions. The earliest
work included is dated 1585, and there are a surprising number of
twentieth-century paintings.

Hess, Thomas B. and Baker, Elizabeth C., eds. ART AND SEXUAL POLITICS.
New York: Collier Books, 1973. 150 p. Illus. Paperbound (hardcover pub-
lished by Macmillan). Includes bibliographic notes.

A reprint of several articles which appeared in ART NEWS, Janu-
ary 1971, concerning women in the fine arts. Broader in scope
than simply American painting, yet these articles present insights
into the experiences of several American artists and critics.

Kouwenhoven, John A. THE ARTS IN MODERN AMERICAN CIVILIZATION.

New York: Norton (c. 1948). 259 p. Illus. "List of sources and references" pp. 225-50. Index pp. 251-59. Paperback. (Original title: MADE IN AMERICA.)

> A cultural history of American "vernacular" arts--such as crafts, inventions, fads--and how they have helped to shape modern American aesthetic sense.

*Larkin, Oliver W. ART AND LIFE IN AMERICA, rev. ed. New York: Holt (c. 1960). 559 p. Illus. Bibliographic notes pp. 491-525. Index pp. 526-59.

> An excellent standard text; the first edition (1949) was awarded the Pulitzer Prize for history in 1950. The revision is barely changed: about 12 pages added updating it, with some rather poor color reproductions. However, it remains readable and informative if not quite up to date.

Lipman, Jean, ed. WHAT IS AMERICAN IN AMERICAN ART. New York: McGraw-Hill, 1963. 180 p. Illus., some color plates.

> A reprint of several essays which first appeared in ART IN AMERICA, 1963. The title is from Lloyd Goodrich's lead article which is followed by over 20 articles by distinguished historians and critics on various aspects of American art forms; directed to the layman.

*McCoubrey, John W. AMERICAN ART, 1700-1960: SOURCES AND DOCUMENTS. Englewood Cliffs: Prentice Hall (c. 1965). 226 p. (Sources and Documents in the History of Art Series.)

> A collection of writings on American artists by artists, historians and literati. Arranged chronologically, with references given in footnotes. An excellent reference but an index and complete list of sources would have improved it.

* _____ . AMERICAN TRADITION IN PAINTING. New York: Braziller, 1963. 128 p. Illus. Bibliographic note p. 126. Index pp. 127-28.

> Brief, thoughtful history of American painting up to the abstract expressionists. Tries to discern how American painting achieves an individuality as distinct from the European tradition.

*McLanathan, Richard. THE AMERICAN TRADITION IN THE ARTS. New York: Harcourt, 1968. 492 p. Illus. Bibliography pp. 471-73. Index pp. 479-92.

> An ambitious, attractive survey meant to be an introduction to the whole of American art, including painting, sculpture, architecture, some crafts and photography. Strongest in coverage of the nineteenth century, with only a brief summary of twentieth-century trends. Excellent bibliography, and the section "Museums and other collections referred to in this book," pp. 465-70, briefly describes many important collections of American art.

*Mendelowitz, Daniel M. A HISTORY OF AMERICAN ART, 2nd ed. New

York: Holt, 1970. 522 p. Illus., some color plates. Bibliography pp. 510-12. Index pp. 513-21.

> A good introductory text for the study of American art. Coverage is through the 1960's, with a final section on "pop art and realism." The reproductions are very good, even most of the color plates.

Pierson, William H. and Davidson, Martha, eds. ARTS OF THE UNITED STATES: A PICTORIAL SURVEY. New York: McGraw-Hill, (c. 1960). 452 p. Illus. Appendixes pp. 419-22. Index pp. 423-52.

> The text is composed of short, general essays by a number of authors. But the book was produced as an accompaniment to a group of color slides "assembled by the University of Georgia, under a grant by Carnegie Corporation of New York" meant to be a survey of American arts. (Slides sold as a set by Sandak, Inc.) Most of the book is composed of small black and white reproductions of these slides, with identification.

Praz, Mario. CONVERSATION PIECES: A SURVEY OF THE INFORMAL GROUP PORTRAIT IN EUROPE AND AMERICA. University Park: Pennsylvania State University Press, 1971. 287 p. Illus., some color plates.

> Translated from the Italian SCENE DI CONVERSAZIONE, this is heavily European in emphasis, although some discussion is included of works by Copley and William Dunlap.

*Prown, David. AMERICAN PAINTING: FROM ITS BEGINNINGS TO THE ARMORY SHOW. Geneva: Skira; distributed by World, Cleveland, 1970? 145 p. Illus., many color plates. Bibliography pp. 135-39. Index pp. 141-45.

> Companion volume to Barbara Rose's AMERICAN PAINTING: THE TWENTIETH CENTURY (see below). Large, with lavish color plates, this is intended for the educated layman. Emphasis is upon the development of American realism.

Quirarte, Jacinto. MEXICAN AMERICAN ARTISTS. Austin: University of Texas Press, 1973. 149 p. Illus., some color plates. Bibliography pp. 139-41. Index pp. 143-49.

> Mexican-American or "Chicano" art is largely undocumented in the histories of American art. This informative work attempts to remedy the lack and shows contributions beginning with Mission architecture, and "Santos," to artists of today. The importance of the Mexican muralists and their impact on American artists is also discussed.

Richardson, E.P. PAINTING IN AMERICA: FROM 1502 TO THE PRESENT. New York: Crowell (c. 1956). 456 p. Illus., some color plates. Bibliography pp. 425-36. Index pp. 437-56.

> A basic text for the introductory study of American painting up to the early 1950's. Adequate illustrations, although the color plates are poor.

*Time-Life editors. AMERICAN PAINTING, 1900-1970. New York: Time-Life, 1970. 189 p. Illus., many color plates. Appendix p. 186. Bibliography p. 187. (Series: Time-Life Library of Art.)

> Directed to the educated adult with little art history background, this is a very readable introduction to the history of American painting. Excellent reproductions, and more of social and cultural background included than in the average art book.

*Wilmerding, John. A HISTORY OF AMERICAN MARINE PAINTING. Salem: The Peabody Museum, and Boston: Little Brown and Co., 1968. 279 p. Illus., some color plates. Bibliography and notes pp. 257-68. Index pp. 271-79.

> Written for the layman, this nevertheless includes much scholarly material. The first chapter, "The Contributions of Portrait Painting," discusses the origin of the tradition of marine painting. Painting in the nineteenth century is, quite naturally, the main focus, though a few twentieth-century artists are included. New York artists predominate, and popular artists such as Frederick Waugh and John Whorf are not included, or are mentioned only in passing. Popular centers of marine painting such as Rockport or Provincetown, Mass., are not mentioned. A handsome book, with catholic selections and judgments.

Wright, Louis et al. THE ARTS IN AMERICA: THE COLONIAL PERIOD, vol. 1, 1966. 368 p.; THE ARTS IN AMERICA: THE 19TH CENTURY, vol. 2, 1969. 412 p. New York: Charles Scribner's Sons. Illus.

> An important compilation of essays covering the history of American art. Actually, less emphasis on painting than on other arts. Lengthy bibliographies and indexes included.

Chapter 3

EARLY PAINTING IN AMERICA: COLONIAL PAINTING

# Chapter 3

## EARLY PAINTING IN AMERICA: COLONIAL PAINTING

Belknap, Waldron Phoenix, Jr. AMERICAN COLONIAL PAINTING: MATE-
RIALS FOR A HISTORY. Cambridge: The Belknap Press of Harvard University
Press, 1959. 377 p. Illus., plates. Bibliography pp. 337-44. Index pp.
355-77.

> A collection of notes and scholarly research papers by the founder
> of Harvard's Belknap Press, who died in 1949. The most important
> article, "The Identity of Robert Feke," was published first in the
> ART BULLETIN, September 1947. Most of the articles show a con-
> cern for New England artists and for genealogy.

Black, Mary and Lipman, Jean. AMERICAN FOLK PAINTING. New York:
Potter (c. 1966). 244 p. Illus., some color plates. Bibliography pp. 233-
40. Index pp. 241-44.

> Short text, written for the layman. Primarily a picture source, and
> while the reproductions are of very interesting works, the color is
> quite poor. Not limited to colonial period.

Dreppard, Carl W. AMERICAN PIONEER ARTS AND ARTISTS. Springfield,
Mass.: Pond-Ekburg, 1942. 172 p. Illus., frontispiece in color. Bibliog-
raphy pp. 170-72.

> One of the first monographs to seriously treat American art from
> the colonial period to the middle of the nineteenth century as art
> history. Written for the educated layman, though at times the
> prose is simplistic.

Hagen, Oskar. THE BIRTH OF THE AMERICAN TRADITION IN ART. New
York: Scribners, 1940. 159 p. Illus. Index pp. 151-59.

> An early attempt to define what is particularly American in U.S.
> colonial painting. Emphasis on the works of Smibert, Feke, Cop-
> ley and West.

Hipkiss, Edwin J. EIGHTEENTH CENTURY AMERICAN ARTS: THE M. AND

M. KAROLIK COLLECTION .... Cambridge: Harvard University Press, published for the Museum of Fine Arts, Boston, 1941. 366 p., plus "Supplementary illustrations."

> Catalog of the first gift of the Karoliks to the Museum of Fine Arts, Boston. An important collection, this includes a great deal of furniture and handicrafts as well as the paintings (which include eight Copleys and two Gilbert Stuarts).

Lee, Cuthbert. EARLY AMERICAN PORTRAIT PAINTERS: THE FOURTEEN PRINCIPAL EARLIEST NATIVE-BORN PAINTERS. New Haven: Yale University Press, 1929. 350 p. Illus., plates. Bibliography pp. 315-34. Index pp. 337-50.

> Primarily biographical material, with anecdotes about the artists' lives. Includes information about Robert Feke, Joseph Badger, Matthew Pratt, J.S. Copley, Benjamin West, C.W. Peale, James Peale, Ralph Earle, Gilbert Stuart, Joseph Wright, John Trumbull, Mather Brown, Robert Fulton, and E.G. Malbone.

Little, Nina Fletcher. AMERICAN DECORATIVE WALL PAINTING, 1700-1850. Sturbridge, Mass.: Old Sturbridge Village, in cooperation with Studio Publications, New York, 1952. 169 p. New enlarged edition, New York: Dutton, 1972. Bibliography pp. 138-40. (1972 ed.: pp. 160-62.) Illus.

> Authoritative study of early American wall paintings, primarily those found in New England although a few examples from other parts of the country are included. Largely "primitive" in style.

Pleasants, J. Hall. FOUR LATE EIGHTEENTH CENTURY ANGLO-AMERICAN LANDSCAPE PAINTERS. Worcester, Mass.: reprinted from the PROCEEDINGS OF THE AMERICAN ANTIQUARIAN SOCIETY, 1943. 146 p. Illus., plates. Includes bibliographical references.

> Scholarly essays on George and Mary Beck, William Groombridge, Francis Guy, and William Winstanley.

Quimby, Ian M.G., ed. AMERICAN PAINTING TO 1776: A REAPPRAISAL. Charlottesville, Va.: published for the Henry Francis duPont Winterthur Museum, Winterthur, Delaware, by the University Press of Virginia, 1971. (Winterthur Conference Report, 1971.) 384 p. Illus. Includes bibliographical references.

> Papers presented by art historians at a 1971 conference on American colonial painting. Includes articles on Smibert, Feke, Vanderlyn, and several on technical aids for identification.

Rorimer, James J., foreword. 101 MASTERPIECES OF AMERICAN PRIMITIVE PAINTING: FROM THE COLLECTION OF EDGAR WILLIAM AND BERNICE CHRYSLER GARBISCH. New York: The American Federation of Arts, distributed by Doubleday, 1961. 159 p. Illus., 101 color plates. "Notes on the artists" pp. 131-38. "Catalogue notes" pp. 141-51. "Index of artists" pp. 155-59.

This volume was produced to accompany the Garbisch collection which was exhibited in 19 American museums from 1961 to 1964. It is largely a picture book, with rather brief introductory essays by James J. Rorimer, John Walker, Albert Ten Eyck Gardner. The reproductions are adequate but the color tends to be muddy. Paintings date from 1710 to 1885.

Wehle, Harry B. AMERICAN MINIATURES, 1730-1850: ONE HUNDRED AND SEVENTY THREE PORTRAITS...AND A BIOGRAPHICAL DICTIONARY OF THE ARTISTS BY THEODORE BOLTON. New York: published for the Metropolitan Museum of Art by Doubleday, Page, 1927. 127 p. Illus., plates. Biographical dictionary pp. 73-113. Bibliography pp. 117-18. Index pp. 121-27.

A scholarly, in-depth study of this specialized field; though now dated, it remains a standard work.

Chapter 4

# NINETEENTH-CENTURY AMERICAN PAINTING

Chapter 4

# NINETEENTH-CENTURY AMERICAN PAINTING

ART NEWS. Vol. 67, September, 1968. Special Issue: "American Nineteenth Century Paintings."

Includes major articles by Barbara Novak O'Doherty, Alfred Frankenstein, Thomas B. Brumbaugh, Elia Kokkinen, and Kenneth Rexroth.

Baur, John I.H. AMERICAN PAINTING IN THE NINETEENTH CENTURY: MAIN TRENDS AND MOVEMENTS. New York: Praeger, 1953. 60 p. Illus., plates.

This book is a modified version of an exhibition catalog produced for a major show of American paintings organized by the American Federation of Arts and the Whitney Museum of American Art, shown in West Germany. Gives a comprehensive history of major nineteenth-century styles and artists for the novice. The reproductions on glossy paper are adequate but the more crudely screened ones on the rougher paper are poor.

_____. THREE NINETEENTH CENTURY AMERICAN PAINTERS: JOHN QUIDOR, EASTMAN JOHNSON, THEODORE ROBINSON; CATALOGS OF THREE EXHIBITIONS PREPARED BY JOHN I.H. BAUR, WITH BIOGRAPHIES OF THE ARTISTS AND ILLUSTRATIONS OF THEIR WORKS; ORIGINALLY PUBLISHED BY THE BROOKLYN MUSEUM; NEW INTRODUCTION BY DONELSON HOOPES. New York: Arno Press, 1969. 57, 82 and 95 p. Illus.

A reprinting of three important exhibition catalogs published between 1940 and 1946. The textual information is brief although informative, and since there is little else available about these artists, the reprint is welcome. The reproductions, however, are murky.

Bing, Samuel. ARTISTIC AMERICA: TIFFANY GLASS AND ART NOUVEAU. Cambridge: M.I.T. Press, 1970. 260 p. Illus., some in color. Index pp. 253-60.

The emergence of the American art nouveau style is chronicled here. This style was far more evident in the decorative arts, architecture and furniture than in painting, and the book devotes only pp. 17–48 to documenting European influences in American painting, and particularly French influence.

Boston, Museum of Fine Arts. M. AND M. KAROLIK COLLECTION OF AMERICAN PAINTINGS: 1815-1865. Cambridge: Harvard University Press, for the Museum of Fine Arts, Boston, 1949. 544 p. Illus., plates. Appendixes.

The second major collection of American art presented to the Museum of Fine Arts, Boston, by the Karoliks. (See also Hipkiss, above.) This volume is heavily illustrated, with works arranged by the artists' surnames. Although a detailed catalog of a particular collection, it is a major collection. Included is an essay "Trends in American Painting, 1815-1865," by John I.H. Baur.

_____. M. AND M. KAROLIK COLLECTION OF AMERICAN WATERCOLORS AND DRAWINGS, 1800-1875, 2 vols. Boston: 1962. 352 and 337 p. Illus., some color plates. Indexes and appendixes included. Bibliographies: (vol. 1) p. 328, (vol. 2) p. 345.

Handsome catalog of the third gift of American art to the Museum of Fine Arts, Boston, from the Karoliks. Substantial documentation and biographical information about the artists whose works are included.

Curry, Larry. THE AMERICAN WEST: PAINTERS FROM CATLIN TO RUSSELL. New York: Viking, in association with the Los Angeles County Museum of Art, 1972. 198 p. Illus., some in color. Bibliographies pp. 192-98.

Catalog of an exhibition held in Los Angeles, San Francisco, and St. Louis in 1972. The foreword by Archibald Hanna and commentary by Curry point out the close relationship between much western landscape painting and the Hudson River school.

Dickson, Harold. ARTS OF THE YOUNG REPUBLIC: THE AGE OF WILLIAM DUNLAP. Chapel Hill: University of North Carolina Press, 1968. 234 p. Illus., plates. Index pp. 231-34.

Catalog of an exhibition held at the University of North Carolina. While the works represented are excellent selections, they are not the more famous works one might expect in a book with this title. The text gives a fine introduction to the art of the early nineteenth century.

Flexner, James Thomas. AMERICA'S OLD MASTERS. New York: Viking, 1939. 365 p. Illus. Bibliography pp. 343-52. Index pp. 359-65. Reprint: Dover, 1967.

Written for the layman; full of biographical anecdotes about four artists whose work spanned the late eighteenth and early nineteenth centuries: Benjamin West, John Singleton Copley, Charles Willson Peale, and Gilbert Stuart.

*_____. NINETEENTH CENTURY AMERICAN PAINTING. New York: Putnams, 1970. 256 p. Illus., 60 color plates. Index pp. 253-56.

Larger, more lavish, and titled more straightforwardly than Flexner's earlier books, this is nevertheless heavily dependent upon the earlier writings. The text is full of anecdotes and chatty stories, and the reproductions are disappointing. Nevertheless, the book serves as an adequate introduction to American nineteenth-century painting for the non-specialist.

Frankenstein, Alfred. AFTER THE HUNT: WILLIAM HARNETT AND OTHER AMERICAN STILL LIFE PAINTERS, 1870-1900. Rev. ed., Berkeley and Los Angeles: University of California Press, 1969. 201 p. Illus., frontispiece in color. Index pp. 193-200.

A major scholarly study of the work of Harnett and others who practiced the "Trompe l'oeil" style in the late nineteenth century. First edition was published in 1953.

_____. THE REALITY OF APPEARANCE: THE TROMPE L'OEIL TRADITION IN AMERICAN PAINTING. Greenwich, Conn.: New York Graphic Society, 1970. 156 p. Illus., includes eight color plates.

Catalog of a major traveling exhibition of the "Trompe l'oeil," or super-real, style of painting still lifes which was especially popular in the late nineteenth century.

Harris, Neil. THE ARTIST IN AMERICAN SOCIETY: THE FORMATIVE YEARS, 1790-1860. New York: Braziller, 1966. 432 p. Illus. Bibliography pp. 317-24. Index pp. 414-32.

Well-documented cultural history of nineteenth-century art attitudes, business practices, and institutions. From a wealth of early sources, draws a clear picture of contrasting artists' milieus from the "elite" of the academics to the itinerant painters.

*Hoopes, Donelson F. THE AMERICAN IMPRESSIONISTS. New York: Watson Guptill, 1972. 160 p. Illus., 64 color plates. Biographical notes pp. 148-53. Bibliography pp. 155-57. Index pp. 158-60.

An attractive and informative book, perhaps stretching a point, but showing the strong influence of French impressionism in the late nineteenth century on Americans painting in the United States and in Europe. Included: Cassatt, Inness, Sargent, W.M. Chase, Theodore Robinson, Twachtman, Bellows, Glackens, Prendergast, and many lesser-known artists.

*Howat, John K. THE HUDSON RIVER AND ITS PAINTERS. New York: Viking, Studio, 1972. 207 p. Illus., many color plates. Bibliography pp. 193-201. Index pp. 203-7.

A tribute to the landscape of the Hudson River and the many artists who have painted it, notably the nineteenth-century "Hudson River School." Most of the book is devoted to the plates, de-

scribed individually in "Notes" pp. 131-90, by John Howat and Sandra Feldman. Includes foreword by Carl Carmer, and preface by James Biddle. Good bibliography.

Lipman, Jean. AMERICAN PRIMITIVE PAINTING. London: Oxford University Press, 1942. 158 p. Illus., some color plates. Bibliography pp. 139-42. Exhibitions pp. 143-45. Primitive painters known by name pp. 147-58. Reprint: Dover, 1972.

A popular introduction to "primitive" American painting, with works of the nineteenth century predominating. Includes some interesting comparisons of works by more sophisticated artists, in order to more clearly define "primitive." The reproductions are only fair.

Lynes, Russell. THE ART-MAKERS OF NINETEENTH CENTURY AMERICA. New York: Atheneum, 1970. 514 p. Illus. Sources and acknowledgments pp. 493-98. Index pp. 499-514.

A highly anecdotal survey of the nineteenth-century art world by a popular historian. His concern with reputations, artistic and otherwise, is directed to the unsophisticated reader more interested in cultural history than art history. Intelligently dwells on the vagaries of taste, however.

McGrath, Robert L. EARLY VERMONT WALL PAINTINGS, 1790-1850. Hanover, N.H.: University Press of New England, 1972. 105 p. Illus. Includes bibliographical references.

More limited in geographical area than the work by Little (p.26), this is nevertheless an excellent study of wall paintings by indigenous, or "primitive," American artists, most of whom are anonymous. The comparisons with the artists of Pompeii seem rather far-fetched, however.

Miller, Lillian. PATRONS AND PATRIOTISM: THE ENCOURAGEMENT OF THE FINE ARTS IN THE UNITED STATES, 1790-1860. Chicago: University of Chicago Press, 1966. 335 p. Illus. Bibliography pp. 299-315. Index pp. 317-35.

A history of governmental and institutional involvement in the arts during the early years of the republic. Information about individual collectors is included. A scholarly work, heavily annotated.

Morgan, John Hill. EARLY AMERICAN PAINTERS: ILLUSTRATED BY EXAMPLES IN THE COLLECTION OF THE NEW YORK HISTORICAL SOCIETY. New York: New York Historical Society, 1921. 136 p. Illus., plates. Bibliography p. 121. Index pp. 126-36.

An early, scholarly work on eighteenth and nineteenth century American portrait painting.

Mumford, Lewis. THE BROWN DECADES: A STUDY OF THE ARTS IN AMERICA, 1865-1895. New York: Dover, 1931. 266 p. Illus. Sources and books pp. 249-58. Index pp. 259-66.

Includes more information about architecture than painting, but the writing is perceptive about the cultural and aesthetic values of the late nineteenth century.

Richardson, E.P. AMERICAN ROMANTIC PAINTING. New York: Weyhe, 1944. 50 p. Illus.

Nineteenth-century landscape, portrait, and genre painters discussed in a brief introductory text. Alphabetically arranged, brief biographical sketches of 88 artists, and over 200 reproductions included.

Rossi, Paul A. and Hunt, David C. THE ART OF THE OLD WEST. New York: Knopf, 1971. 335 p. Illus. Bibliography pp. 332-35.

Lavish chronicle of western U.S. art from the late eighteenth to the early twentieth century, from the collection of the Gilcrease Institute, Tulsa, Oklahoma. Genre paintings, animal studies, landscapes, giving an encyclopedic view of the settling of the U.S. west. C.M. Russell, G. Catlin, F. Remington predominate; many other artists included. Good reproductions on glossy paper.

Sweet, Frederick A. THE HUDSON RIVER SCHOOL AND THE EARLY AMERICAN LANDSCAPE TRADITION. Chicago: Art Institute of Chicago, 1945. 123 p. Illus., frontispiece in color.

Catalog of a major exhibition, also shown at the Whitney Museum of American Art, New York. Biographical entries, arranged chronologically by birthdate make up the largest part of this work.

_____. SARGENT, WHISTLER AND MARY CASSATT. Chicago: Art Institute of Chicago, 1954. 101 p. Illus., some color plates.

Important exhibition catalog of the work of these three important expatriates; brief essays, many illustrations with detailed captions.

Chapter 5

# MODERN PAINTING: THE TWENTIETH CENTURY

# Chapter 5

## MODERN PAINTING: THE TWENTIETH CENTURY

AFRO-AMERICAN ARTISTS: NEW YORK AND BOSTON. Boston: The Museum of the National Center of Afro-American Artists, the Museum of Fine Arts, and the School of the Museum of Fine Arts, 1970. Unpaged. Illus.

 The works of 70 contemporary Black American artists are included in this exhibition catalog, with an introduction by Edmund B. Gaither. Brief biographical entries for each artist included toward the back of the volume.

Agee, William C. THE 1930'S: PAINTING AND SCULPTURE IN AMERICA. New York: Whitney Museum of American Art, 1968. Unpaged. Illus., some color plates. Selected bibliography at back of volume.

 Agee collected material for the Archives of American Art on government programs of the 1930's in the arts, which provided the inspiration for this exhibition. The catalog reveals not so much the governmental contributions but major aesthetic trends. Excellent bibliography, includes manuscript material.

_____. SYNCHROMISM AND COLOR PRINCIPLES IN AMERICAN PAINTING. New York: Knoedler, 1965. 53 p. Illus., plates, some in color.

 An important re-evaluation of the synchromist movement, this catalog accompanied an extensive exhibition.

Amaya, Mario. POP ART AND AFTER. New York: Viking, 1965. 148 p. Illus., some in color. Bibliography pp. 143-45. Index pp. 146-48.

 Survey of the "pop" movement in the United States and Great Britain, written at the height of its popularity.

AMERICAN ABSTRACT ARTISTS. New York, 1938. Unpaged. Illus.

 This first catalog of an exhibit, meant to be an annual, was edited by Balcomb Greene. The American Abstract Artists were an important group of avant-garde artists, based in New York. This includes articles by 11 artists which are attempts to explain abstrac-

tion to a then-baffled public.

AMERICAN ABSTRACT ARTISTS, 1939. New York, 1939. Unpaged. Illus.

The second exhibition catalog by the American Abstract Artists, with an introductory essay by George L.K. Morris. Arranged alphabetically by artist, with biographical sketches and full-page reproductions of works by members.

AMERICAN ABSTRACT ARTISTS. New York: Ram Press, 1946. Unpaged. Illus.

Liberally illustrated, this catalog includes essays by Lazlo Moholy Nagy, Piet Mondrian, Josef Albers, and Leger.

AMERICAN ABSTRACT ARTISTS, 1936-1966. New York: Ram Press, 1966. Unpaged. Illus.

An introductory essay by Ruth Gurin chronicles the history of this influential group of artists, and the abstract art movement in the United States. A list of members is given at the back of the volume, and a number of black and white illustrations are included.

*Arnason, H.H. HISTORY OF MODERN ART: PAINTING, SCULPTURE, ARCHITECTURE. New York: Abrams, 1968. 663 p. Illus., 264 color plates. Bibliography pp. 631-43. Index pp. 644-62.

An authoratative and heavily illustrated introductory history of European and United States modern art movements from the mid-nineteenth century through the middle 1960's.

ART NEWS. Vol. 70, September, 1971. Special Issue: "Southern California."

Features several articles about artists, collectors and museums in Southern California, including "Los Angeles, 1971" by Elizabeth Baker, "Art and the corporations" by David Antin.

ART NEWS. Vol. 72, Summer 1973. "Special California Issue."

Articles included: "The Los Angeles Art Scene" by Milton Estrow; "Some Problems and Solutions, New Museums in Southern California" by Judy Kinnard; "In the Southern California Galleries...," "The L.A. Fine Arts Squad" by William Wilson; "Blossoming of the Bay Area" by Jerome Tarshis, etc.

*ART SINCE MID-CENTURY: THE NEW INTERNATIONALISM. 2 vols. Greenwich, Conn.: New York Graphic Society, 1971. (Vol. 1 titled ABSTRACT ART. Vol. 2 titled FIGURATIVE ART.) 301 and 332 p. Illus., many color plates. Artists' statements: (vol. 1) pp. 289-96, (vol. 2) pp. 323-29. Indexes: (vol. 1) pp. 297-301, (vol. 2) pp. 329-32.

A collection of essays by well-known art critics on European and American art movements since 1945. Includes: (vol. 1) "Abstract Expressionism" by Irving H. Sandler; (vol. 2) "Jasper Johns and Robert Rauschenberg" by Lawrence Alloway and "American Pop Art" by Mario Amaya.

The Art Students League. INSTRUCTORS. New York, 1940?

> A series of pamphlets, each giving a brief biographical sketch, plus a photographic portrait and reproductions of works by then instructors at the Art Students League. Subjects: Alexander Abels, Homer Boss, Charles S. Chapman, Jean Charlot, Jon Corbino, Frank Vincent Dumond, Ernest Fiene, Anne Goldthwaite, Morris Kantor, Yasuo Kuniyoshi, Robert Laurent, Arthur Lee, William C. McNulty, Paul Manship, James Michael Newell, Kimon Nicolaides, William C. Palmer, George Picken, Raphael Soyer, Harry Sternberg, Howard A. Trafton, Vaclav Vytlacil, Edmund Yaghjian, William Zorach.

Ashton, Dore. THE LIFE AND TIMES OF THE NEW YORK SCHOOL. London: Adams and Dart, 1973. (New York: Viking, 1973. Published with title: THE NEW YORK SCHOOL: A CULTURAL RECKONING.) 246 p. Illus. Bibliography pp. 235-40. Index pp. 241-46.

> A history of the abstract expressionist movement in New York in the 1950's, with emphasis on the political and social climate, and the conflict between art as social commentary and "art for art's sake."

Barker, Virgil. FROM REALISM TO REALITY IN RECENT AMERICAN PAINTING. Lincoln: University of Nebraska Press, 1959. 93 p. Illus.

> This originated as a lecture given in 1958 at the University of Nebraska, in which Barker discussed at length the imagery used by contemporary artists and its antecedents. He has concluded that the "self sufficing reality of pigment" is a logical descendent from early concepts of reality (p. 90).

Barrett, Cyril. OP ART. New York: Viking, 1970. 192 p. Illus., some in color. Bibliography p. 188. Index pp. 189-92.

> Barrett is British, and concentrates on the work of European artists, although some Americans are included. He puts the origin of "op art" with impressionism and futurism.

Battcock, Gregory, ed. MINIMAL ART: A CRITICAL ANTHOLOGY. New York: Dutton, 1968. 448 p. Paperback. Illus. Index pp. 445-48.

> A collection of essays about contemporary "minimal" abstract painting, sculpture, photography, and other art forms. European and American in coverage. Most of the essays are reprinted from journals.

_____, ed. THE NEW ART: A CRITICAL ANTHOLOGY. New York: Dutton, 1966. 254 p. Illus.

> Reprints of articles from periodicals, mostly from the early 1960's, concerning trends in modern art. The emphasis is particularly on the "pop" movement.

Baur, John I.H. BETWEEN THE FAIRS: 25 YEARS OF AMERICAN ART, 1939-1964. New York: Praeger, for the Whitney Museum of American Art, 1964. 90 p. Illus., some color plates. Index to plates pp. 89-90.

> Exhibition catalog consisting mostly of reproductions. The brief
> text by Baur muses that "the spontaneous explosion of pop art all
> over the country during the last few years raises the possibility that
> it may become a movement of considerable duration and importance,
> not just a two-day marvel. It is the first 'realist' reaction against
> abstract expressionism..." (p.11). The "fairs" of the title are, of
> course, the two New York World Fairs.

_____. THE EIGHT. New York: Brooklyn Museum, 1943. 39 p. Illus., portraits.

> Important exhibition catalog of the works of the group known also
> popularly as "The Ash Can School": Robert Henri, John Sloan,
> William Glackens, Ernest Lawson, Maurice Prendergast, George B.
> Luks, Everett Shinn, and Arthur B. Davies. In addition to the
> documentation of this show, Baur has indicated works shown at the
> original exhibition of the Eight at the Macbeth Gallery, New York,
> in 1908.

_____. NEW ART IN AMERICA: FIFTY PAINTERS OF THE 20TH CENTURY. Greenwich, Conn.: New York Graphic Society, in cooperation with Praeger, 1957. 283 p. Illus., some color plates.

> Aimed frankly at the layman, and with rather poor reproductions
> by today's standards, this is an attempt "to choose the fifty lead-
> ing painters in twentieth century American art" (foreword). An
> interesting, if superficial, chronicle of modern American art. The
> fame of some of the artists has diminished in the years since pub-
> lication (e.g., Alton Pickens, Franklin C. Watkins). References
> at the end of each article; index to artists on last page.

_____. REVOLUTION AND TRADITION IN MODERN AMERICAN PAINT-ING. Cambridge: Harvard University Press, 1951. 170 p. Illus. (The Library of Congress Series in American Civilization.) Bibliographical references included in "Notes" pp. 159-60. Index pp. 163-70.

> A history of the first 50 years of American twentieth-century paint-
> ing, with an emphasis on the importance of abstraction and the
> impact of the Armory Show.

Bearden, Romare, foreword. FIFTEEN UNDER FORTY: PAINTING BY YOUNG NEW YORK STATE BLACK ARTISTS. Saratoga, N.Y.: Gallery Museum, Hall of Springs, Saratoga Performing Arts Center, 1970. Unpaged. Illus.

> Catalog of an exhibition of the works of 15 young Black artists,
> arranged alphabetically. Includes brief career summary and repro-
> duction of one work by each artist.

Brandeis University. AMERICAN ART SINCE 1950. Waltham, Mass.: Bran-

deis University, Poses Institute of Fine Arts and the Institute of Contemporary Art, Boston, 1962. 83 p. Illus., some in color.

> A major exhibition which was first held at the Seattle World's Fair in 1962. Includes good reproductions and biographical entries for nearly 100 artists with important reputations in the early 1960's.

Brown, Milton W. AMERICAN PAINTING FROM THE ARMORY SHOW TO THE DEPRESSION. Princeton: Princeton University Press, 1955. 244 p. Illus. Bibliography pp. 201-37. Index pp. 239-44.

> An important in-depth study of the American art world from the 1913 Armory Show to the advent of the depression in 1929. An era when European influences were having a major impact, Stieglitz's 291 Gallery was flourishing, the Eight and the Fourteenth Street School were reshaping American aesthetics. The chapter on "Pseudo-science" (pp. 160-64) and its related bibliography is a fascinating criticism of some of the more eccentric and eclectic theories of the period.

_____. THE STORY OF THE ARMORY SHOW. New York? The Joseph Hirshhorn Foundation, distributed by the New York Graphic Society, Greenwich, Conn., 1963? 320 p. Illus., plates. Catalogue raisonne pp. 217-301. Bibliography pp. 303-6. Appendixes pp. 307-13. Index pp. 314-20.

> An extensive study of the Armory Show of 1913 and its impact. The avant-garde European and American art seen for the first time by much of the American public caused great shock. Brown gives the background for such a reaction and details the work shown and its influences.

Bruce, Edward and Watson, Forbes. ART IN FEDERAL BUILDINGS: AN ILLUSTRATED RECORD OF THE TREASURY DEPARTMENT'S NEW PROGRAM IN PAINTING AND SCULPTURE. (Vol. 1: MURAL DESIGNS.) Washington, D.C. Art in Federal Buildings, Inc., 1936. 309 p. Illus., includes plates and diagrams. (No other volumes published.)

> A record of murals painted in the 1930's for the Treasury Department's project for U.S. federal buildings. This project differed from the better-known W.P.A. projects in that it was a program to provide the best quality work, and not primarily a program designed to alleviate unemployment. Many of the murals no longer exist, and the brief biographies of participating artists are informative.

Cahill, Holger and Barr, Alfred H., Jr. et al. ART IN AMERICA IN MODERN TIMES. Freeport, N.Y.: Books for Libraries Press, 1969. 110 p. Illus. Reprint of 1934 publication.

> Cahill was director of the W.P.A. and Federal Art Projects and Barr the director of the then-infant Museum of Modern Art, New York, when this was first put together from a series of educational radio broadcasts. Aimed at the general public, this gives an interesting insight into the official taste of the 1930's. The reproductions in the reprint edition are very poor.

Campbell, Lawrence. "The Museum of Non-Objective Painting Revisited." ART NEWS. Vol. 71, December 1972, p. 40. Illus.

> Brief history of an influential New York museum which existed between 1939 and 1951 and was the predecessor of today's Guggenheim Museum.

Carroll, Donald and Lucie Smith, Edward. MOVEMENTS IN MODERN ART. New York: Horizon Press, 1973. 208 p. Illus. Index pp. 205-8.

> Conversations about modern art between Lucie Smith, a well-known British critic, and Carroll, "a layman with a reputation as one of England's wittiest conversationalists" (jacket); for the educated non-specialist. Some insightful comments about the American scene.

*Coke, Van Deren. THE PAINTER AND THE PHOTOGRAPH: FROM DELA-CROIX TO WARHOL. Albuquerque: University of New Mexico Press, 1964. Revised and enlarged, 1972. 324 p. Illus. Notes pp. 305-15. Index pp. 316-24.

> This originated as an exhibition catalog in 1964. Shows the dependence of painters on the photograph and the influence of paintings on photography, with many surprising and explicit examples. European and American artists included.

Doty, Robert. CONTEMPORARY BLACK ARTISTS IN AMERICA. New York: Whitney Museum of American Art, 1971. 64 p. Illus., some in color. Bibliography pp. 60-64.

> Catalog of a major exhibition; most of the artists included are quite young and few other than Jacob Lawrence and Charles White are well known. The bibliography by Libby Seaberg is one of the best to date on Black American artists.

_____. HUMAN CONCERN/PERSONAL TORMENT: THE GROTESQUE IN AMERICAN ART. New York: published for the Whitney Museum of American Art by Praeger, 1969. Unpaged. Bibliography in back of volume.

> Catalog of an exhibition chronicling some of the most violent and disturbing works of contemporary art. "Grotesque" is used to describe works with subject matter that is often vicious, protesting, surreal, erotic, and threatening. Includes painting, sculpture, photography, and graphic arts.

Elderfield, John. "American Geometric Abstraction in the Late Thirties." ART-FORUM, vol. 11, December 1972, pp. 35-42. Illus. Bibliographic notes.

> Article inspired by an exhibition of the same name being circulated by the American Federation of Arts which shows works by the artists who formed the American Abstract Artists Group.

Fax, Elton C. SEVENTEEN BLACK ARTISTS. New York: Dodd, Mead, 1971. 306 p. Illus. Index pp. 300-6.

> Fax, himself an artist, has written a popular introduction to a

volume which includes the work of: Elizabeth Catlett, John Wilson, Lawrence Jones, Charles White, Eldzier Cortor, Rex Goreleigh, Charlotte Amevor, Romare Bearden, Jacob Lawrence, Roy de Cavara, Faith Ringold, Earl Hooks, James F. Lewis, Benny Andrews, Norma Morgan, John Biggers, and John Torres.

Finch, Christopher. POP ART: OBJECT AND IMAGE. London: Studio Vista; New York: Dutton, 1968. 168 p.

An introduction to the work of American and British "pop" artists. The introductory essay, "Illusion and Allusion," chronicles the history of pictorial vision from the Renaissance to the 1960's.

FORTY ARTISTS UNDER FORTY. New York: Whitney Museum of American Art, 1962. 50 p. Illus., some in color. Sponsored by the New York State Council on the Arts, circulated by the American Federation of Arts.

Brief exhibition catalog of works by young Americans. Foreword by Lloyd Goodrich, biographical notes by Edward Bryant.

FOUR AMERICAN EXPRESSIONISTS: DORIS CAESAR, CHAIM GROSS, KARL KNATHS, ABRAHAM RATTNER. New York: Whitney Museum of Modern Art [sic], 1959.

An exhibition which traveled to several other museums, this includes paintings by Knaths and Rattner, and sculpture by Caesar and Gross.

Fried, Michael. THREE AMERICAN PAINTERS: KENNETH NOLAND, JULES OLITSKI, FRANK STELLA. Cambridge: Harvard University, William Hayes Fogg Art Museum, 1965. 59 p. Illus., includes plates.

An exhibition which was also held at the Pasadena Art Museum, the catalog includes an informative lengthy essay. However, no color reproductions are included, a decided lack in the case of these three contemporary artists for whom color is most important.

Friedman, B.H., ed. SCHOOL OF NEW YORK: SOME YOUNGER ARTISTS. New York: Grove Press, 1959. 84 p. Illus., some color plates.

A slim, attractive book which presented the work of 11 then avant-garde artists, mostly painters: Helen Frankenthaler, Robert Goodnough, Grace Hartigan, Jasper Johns, Alfred Leslie, Joan Mitchell, Raymond Parker, Robert Rauschenberg, Larry Rivers, Jon Schueler, and Richard Stankiewicz, with essays by several authors.

Fuller, Mary. "Was There a San Francisco School?" ARTFORUM. Vol. 9, January 1971, pp. 46-53. Illus.

Subtitled: "Yes: I think we developed differently. No: That's just curatorial baloney." Discusses work by John Grillo, James Bond Dixon, Edward Dugmore, Ernest Briggs, Jack Jefferson, Edward Corbett, Clay Spohn, among others.

*Geldzahler, Henry. AMERICAN PAINTING IN THE TWENTIETH CENTURY. New York: Metropolitan Museum of Art, distributed by the New York Graphic Society, Greenwich, Conn., 1965. 236 p. Illus. Biographies pp. 209-26. Bibliography pp. 227-30. Index pp. 231-36.

> Written for the non-specialist as an introduction to American paint-
> ing of this century, with a bibliography meant to be a basic read-
> ing list. The reproductions are all black and white, and illustrate
> works in the Metropolitan Museum of Art, New York, where Geld-
> zahler was at the time of this publication the associate curator of
> American paintings and sculpture.

*_____. NEW YORK PAINTING AND SCULPTURE: 1940-1970. New York: E.P. Dutton, 1969. 494 p. Illus., some color plates. Biographical data pp. 429-51. Selected bibliography pp. 455-86. Index pp. 489-94.

> This originated as a catalog of an exhibition held at the Metro-
> politan Museum of Art as one of the Centennial exhibits in 1970.
> Geldzahler assembled the exhibition and wrote the summary article,
> pp. 15-38. Also included are brief articles by Robert Rosenblum,
> Harold Rosenberg, William Rubin, Clement Greenberg and Michael
> Fried, which are reprinted from various art periodicals.

Geske, Norman A. VENICE 34: THE FIGURATIVE TRADITION IN RECENT AMERICAN ART. Washington, D.C.: Smithsonian Institution for the National Collection of Fine Arts, 1968. 131 p. Illus., some color plates. Includes biographical and bibliographical notes.

> Substantial, separately published catalog of the American show at
> this international biennial exhibition. Includes works by: Leonard
> Baskin, Byron Burford, Robert Cremean, Edwin Dickinson, Richard
> Diebenkorn, Frank Gallo, Red Grooms, James McGarrell, Reuben
> Nakian, Fairfield Porter.

Goosen, E.C. THE ART OF THE REAL U.S.A., 1948-1968. New York: Museum of Modern Art, distributed by New York Graphic Society, Greenwich, Conn., 1968. 64 p. Illus., some in color. Bibliography pp. 59-64.

> An exhibition which tried to define the mainstream of American
> art during this 20-year period. The result is a show consisting of
> large, handsome, abstract works, with little in the way of kinetic,
> op, pop, or other identifiable styles or trends. Thirty-three art-
> ists included. Lengthy bibliography by Bernard Karpel.

Greenberg, Clement. POST PAINTERLY ABSTRACTION. Los Angeles: Los Angeles County Museum of Art, sponsored by the Contemporary Art Council, 1964. 72 p. Illus.

> "The opposite of painterly is clear, unbroken, and sharp definition
> ..." (p. 1). An exhibition, which was also shown in Minneapo-
> lis and Toronto, of the works of some 30 younger painters, inclu-
> ding Frank Stella, Jules Olitsky, Ellsworth Kelly, Nicholas Krush-
> enick.

Greene, Carrol, introduction. FIVE FAMOUS BLACK ARTISTS: ROMARE BEARDEN, JACOB LAWRENCE, HORACE PIPPIN, CHARLES WHITE, HALE WOODRUFF. Boston: The National Center of Afro-American Artists, 1970. Unpaged. Illus.

> Exhibition catalog consisting primarily of black and white repro-
> ductions of works by these artists, with little text.

Guggenheim, Peggy. ART OF THIS CENTURY: OBJECTS, DRAWINGS, PHO-TOGRAPHS, PAINTING, SCULPTURE, COLLAGES: 1910-1942. New York: Art of This Century, 1942. 156 p. Illus.

> Peggy Guggenheim's New York gallery, "Art of This Century," was
> an important force on the American art scene; this volume is a re-
> flection of the art and values espoused there. Avant-garde Euro-
> pean artists predominated, and this publication includes essays by
> Andre Breton, Piet Mondriaan, and Alfred H. Barr, Jr., as well
> as "Manifesto of the Futurist Painters: 1910" by Boccioni, Sever-
> ini, et al; "Realistic Manifesto" by Gabo and Pevsner; "Inspira-
> tion to Order" by Max Ernst; and "Notes on Abstract Art" by Ben
> Nicholson.

*Hamilton, George Heard. 19TH AND 20TH CENTURY ART: PAINTING, SCULPTURE AND ARCHITECTURE. New York: Abrams, 1970? 484 p. Illus., 64 color plates. Bibliography pp. 459-64. Index pp. 465-81.

> Written for the "educated layman," this is a history of the visual
> arts in Europe and the United States. Rather similar in coverage
> to Arnason, HISTORY OF MODERN ART (see above); however, art
> forms are not segregated by media, and Hamilton describes more
> interaction and more influences.

Henning, Edward B. FIFTY YEARS OF MODERN ART, 1916-1966. Cleveland: Cleveland Museum of Art, 1966. 210 p. Illus., some color plates.

> A substantial exhibition catalog of a show which was an attempt to
> gather modern U.S. and European works of the highest quality.
> The result is a collection of outstanding paintings and sculpture by
> 100 major artists.

Hess, Thomas B. ABSTRACT PAINTING: BACKGROUND AND AMERICAN PHASE. New York: Viking, 1951. 164 p. Illus., some in color.

> An enthusiastic argument for, and history of, abstraction. Empha-
> sis is on American abstractionists. Still valid, though dated. The
> color reproductions are poor.

Hopkins, Henry T. "Contemporary Art in Texas." ART NEWS. Vol. 72, May 1973, p. 40. Illus.

> Young Texan artists: Jack Mims, James King, George Green, Rob-
> ert Wade, Vernon Fisher, among others.

Hudson, Andrew. TEN WASHINGTON ARTISTS, 1950-1970: MORRIS LOUIS

AND OTHERS. Edmonton, Canada: Edmonton Art Gallery, 1970. 62 p. Illus., some color plates. Bibliography p. 12.

Works by major artists from the Washington, D.C., area, many of whom are often referred to as "color field" painters: Morris Louis, Kenneth Noland, Gene Davis, and others.

*Hunter, Sam. AMERICAN ART OF THE 20TH CENTURY. New York: Abrams, 1972. 487 p. Illus., 166 color plates. Bibliographies pp. 437-70. Index pp. 471-86.

One of the best introductory books written to date on American twentieth-century art. Hunter concentrates on the more recent trends such as pop art, hard-edge painting, minimalism, earth-works, happenings, conceptual art, etc. The reproductions are extensive and quite good. Lengthy bibliography by Bernard Karpel, Roberta P. Smith, and Nicole S. Metzer is excellent; entries are indexed in the chapter on "Individual painters."

_____. MODERN AMERICAN PAINTING AND SCULPTURE. New York: Dell, 1959. 256 p. Illus., some in color. Bibliography pp. 221-49. Index pp. 250-56.

Unfortunately this was issued only as a paperback of poor quality, making it nearly useless for institutional purchase. Though dated, it was a popular and very readable history of American painting and sculpture. Hunter conveys the excitement of the fifties when it was felt by some that abstract expressionism was the culmination of centuries of development of art styles. This book helps one to recapture the fervent, crusading nature of this point of view.

Janis, Sidney. THEY TAUGHT THEMSELVES: AMERICAN PRIMITIVE PAINTERS OF THE 20TH CENTURY. New York: Dial Press, 1942. 236 p. Illus., 2 color plates. Foreword by Alfred H. Barr, Jr.

Gallery owner Janis wrote this as a catalog to accompany a major show of self-taught artists held at the Museum of Modern Art, New York. A few of these artists have retained some of their fame – Grandma Moses, John Kane, and Joseph Pickett – but most are little known today. The cheerful, childlike paintings combine with an elementary text written for the layman to produce a rather contrived and even cloying effect.

Karpel, Bernard, ed. THE ARMORY SHOW, 1913: DOCUMENTS. New York: Arno, 1973? 132 p. Illus.

Yet to be published, a major collection of documents from the col-lection of the Library of the Museum of Modern Art, New York.

Keppel, Frederick P. and Duffus, R.L. THE ARTS IN AMERICAN LIFE. New York: McGraw-Hill, 1933. 227 p. Charts. Index pp. 209-27.

Report by the President's Research Committee, named by Herbert Hoover in December, 1929, to survey the position of the arts in the light of the changing social conditions brought on by the de-

pression. An important element in bringing about the W.P.A. and Treasury Department projects of the 1930's.

Kozloff, Max. "American Painting During the Cold War." ARTFORUM, vol. 11, May 1973, pp. 43-54. Illus., color plates. Bibliographic notes.

Revised version of the introduction to an exhibition catalog, 25 YEARS OF AMERICAN PAINTING, 1948-73, held at the Des Moines Art Center, 1973. Hunter discusses abstract expressionism and the emergence of pop art in a wider cultural and political context than is usual.

Kuh, Katherine. THE ARTIST'S VOICE: TALKS WITH SEVENTEEN ARTISTS. New York: Harper and Row, 1960. 248 p. Illus.

Transcriptions of interviews with 17 major contemporary artists, mostly Americans: Josef Albers, Ivan Albright, Alexander Calder, Stuart Davis, Edwin Dickinson, Marcel Duchamp, Naum Gabo, Morris Graves, Hans Hofmann, Edward Hopper, Franz Kline, Jacques Lipchitz, Isamu Noguchi, Georgia O'Keeffe, Ben Shahn, David Smith, and Mark Tobey. Brief chronologies of the artists' lives are included.

*Kulterman, Udo. THE NEW PAINTING. New York: Praeger, 1969. 207 p. Illus., some color plates. Bibliography pp. 67-71. Biographies pp. 169-206.

A survey of international avant-garde painting. Some abstraction is included, but the emphasis is upon pop artists and the post-pop figurative works. Several erotic works are included.

* . NEW REALISM. Greenwich, Conn.: New York Graphic Society, 1972. 44 p., plus plates, some in color. Biographies pp. 39-42. Bibliography pp. 43-44.

An important monograph about the recent "super-realist" trend in painting. Includes Americans largely from New York and Los Angeles, such as Alfred Leslie, Chuck Close, Philip Pearlstein, Gabriel Laderman, Alex Katz, John Clem Clarke, and about forty others. Does not adequately distinguish between those artists who work directly from photographs and those who work from life.

Lanes, Jerrold. "Boston Painting, 1880-1930." ARTFORUM. Vol. 11, January 1972, pp. 49-51. Illus.

Review of an exhibition held at the Boston Museum of Fine Arts which documents the importance of fin-de-siecle and early twentieth-century Boston in cultural and artistic history.

*Lewis, Samella S. and Waddy, Ruth G. BLACK ARTISTS ON ART. 2 vols. Los Angeles: Contemporary Crafts, 1969-71. Illus., some color plates.

A primary source for aesthetics and motivations of contemporary Black American artists. Includes statements by the artists, reproduction of works, and portrait of each. Brief biographical entries included at the back of each volume.

*Lippard, Lucy. POP ART. New York: Praeger, 1966. 216 p. Illus., color plates. Bibliography pp. 206–8. Index pp. 215–16.

The best book to date on the pop phenomenon. Includes essays by Lawrence Alloway, Nancy Marmer and Nicolas Calas.

*Lucie Smith, Edward. LATE MODERN: THE VISUAL ARTS SINCE 1945. New York: Praeger, 1969. 288 p. Illus., some color plates. "Further reading" p. 275. Index pp. 286–88.

Painting and sculpture in Europe and the United States; this is an introduction to major movements from abstract expressionism to happenings and technology experiments.

McDarrah, Fred W. THE ARTIST'S WORLD IN PICTURES. New York: Dutton, 1961. 191 p. Illus. Index pp. 190–91.

Picture book with a minimal amount of text; lovingly and rather candidly showing us the public and private worlds of nearly 300 artists, critics, and important art world personages of the New York 1950's and early 1960's.

McKinzie, Richard D. THE NEW DEAL FOR ARTISTS. Princeton: Princeton University Press, 1973. 203 p. Illus. Notes on sources pp. 193–95. Index pp. 197–203.

A history of the various Federal Art Projects of the 1930's and early 1940's. Scholarly work with lengthy footnotes, many reproductions of works produced for these projects, and portraits of participating artists.

MODERN ARTISTS IN AMERICA: FIRST SERIES. New York: Wittenborn Schultz, 1951? 198 p. Bibliography pp. 173–92. Indexes pp. 193–98.

Projected originally as an annual, this gives a fascinating glimpse of the New York art scene around 1950. Robert Motherwell and Ad Reinhardt were editorial associates, Robert Siskind, photographer; documentation by Bernard Karpel. Chronicles "Artists' Sessions at Studio 35," "The Western Round Table of Modern Art," "Exhibitions of Artists in New York Galleries," "Art Publications, 1949–50," and other articles.

Monte, James K. 22 REALISTS. New York: Whitney Museum of American Art, 1970. 63 p. Illus. Selected bibliography pp. 60–63.

A definitive exhibition of contemporary realist artists, particularly those working from photographs, or producing the effect of "superreal" works: William Bailey, Jack Beal, Robert Bechtle, Harold Bruder, John Clem Clarke, Charles (Chuck) Close, Arthur Elias, Audrey Flack, Maxwell Hendler, Richard Joseph, Howard Kanovitz, Gabriel Laderman, Alfred Leslie, Richard McLean, Malcolm Morley, Philip Pearlstein, Donald Perlis, Paul Staiger, Sidney Tillim, Paul Wisenfeld, and Donald James Wynn.

*NEW ART AROUND THE WORLD: PAINTING AND SCULPTURE. New

York: Abrams, 1966. 510 p. Illus., 132 color plates. Index pp. 493-510.

> A collection of essays; of particular importance: "American Art
> Since 1945" by Sam Hunter, pp. 9-58.

(The following are in chronological rather than alphabetical order:)

New York Museum of Modern Art. SIXTH LOAN EXHIBITION: WINSLOW
HOMER, ALBERT RYDER, THOMAS EAKINS. New York, 1930. 31 p., plus
illus.

> A very early MOMA catalog, which lacks the extensive documen-
> tation of later publications. Brief essays by Alfred H. Barr, Jr.,
> Frank J. Mather, Bryson Burroughs, and Lloyd Goodrich. Poor re-
> productions.

_____. PAINTING AND SCULPTURE FROM 16 AMERICAN CITIES. New
York, 1933. Unpaged. Illus.

> An attempt to look beyond New York. Arranged by city, with
> small black and white reproductions of works by artists who have
> now nearly all fallen into obscurity. Brief biographical entries,
> but no index to artists. (New York is not included.)

_____. AMERICANS, 1942: EIGHTEEN ARTISTS FROM NINE STATES.
New York, 1942. 128 p. Illus.

> Edited by Dorothy Miller, with statements by the artists. Includes:
> Darrell Austin, Hyman Bloom, Raymond Breinin, Samuel Cashwan,
> Francis Chapin, Emma Lu Davis, Morris Graves, Joseph Hirsch,
> Donal Hord, Charles Howard, Rico Lebrun, Jack Levine, Helen
> Lundeberg, Fletcher Martin, Octavio Medellin, Knud Merrild,
> Mitchell Siporin, and Everett Spruce.

_____. AMERICAN REALISTS AND MAGIC REALISTS. New York: 1943.
67 p. Illus. Reprint: Arno, 1973?

> One of the most important of the series of American Artists' exhib-
> its arranged by Dorothy Miller. The catalog was edited by Mil-
> ler and Alfred H. Barr, Jr. This realists' show included several
> nineteenth-century artists as well as contemporaries: Audubon,
> Mount, Peale, Eakins, as well as Andrew Wyeth, Ben Shahn,
> Ivan Albright, Paul Cadmus, and others.

_____. FOURTEEN AMERICANS. New York, 1946. 80 p. Illus.

> Edited by Dorothy Miller, includes: David Aronson, Ben L. Cul-
> well, Arshile Gorky, David Hare, Loren McIver, Robert Mother-
> well, Isamu Noguchi, I. Rice Periera, Alton Pickens, C.S. Pride,
> Theodore J. Roszak, Honore Sharrer, Saul Steinberg, and Mark
> Tobey.

_____. FIFTEEN AMERICANS. New York, 1952. 47 p. Illus.

Includes statements by the artists: William Baziotes, Edward Cor-

bett, Edwin Dickinson, Herbert Ferber, Joseph Glasco, Herbert Katzman, Frederick Kiesler, Irving Kriesberg, Richard Lippold, Jackson Pollock, Herman Rose, Mark Rothko, Clyfford Still, B.W. Tomlin, and Thomas Wilfred. Edited by Dorothy Miller.

_____. TWELVE AMERICANS. New York, 1956. 96 p. Illus.

Edited by Dorothy Miller, includes: Ernest Briggs, James Brooks, Sam Francis, Fritz Glarner, Philip Guston, Raoul Hague, Grace Hartigan, Franz Kline, Ibram Lassaw, Seymour Lipton, Jose de Rivera, and Larry Rivers.

_____. SIXTEEN AMERICANS. New York, 1959. 96 p. Illus.

J. DeFeo, Wally Hedrick, James Jarvaise, Jasper Johns, Ellsworth Kelly, Alfred Leslie, Landes Lewitin, Richard Lytle, Robert Mallary, Louise Nevelson, Robert Rauschenberg, Julius Schmidt, Richard Stankiewicz, Frank Stella, Albert Urban, and Jack Youngerman, included in this catalog edited by Dorothy Miller.

_____. AMERICANS, 1963. New York, 1963, distributed by Doubleday. 112 p. Illus.

Fifteen artists in this exhibit: Anuskiewicz, Bontecou, Chryssa, Richard Lindner, Claes Oldenburg, Ad Reinhardt, S.H. Drummond, Edward Higgins, Robert Indiana, Gabriel Kohn, Michael Le Kakis, Marisol, James Rosenquist, Jason Seley, and David Simpson. Catalog edited by Dorothy Miller.

_____. AMERICAN ART OF THE 20'S AND 30'S: PAINTINGS BY NINETEEN LIVING AMERICANS; PAINTINGS AND SCULPTURE BY LIVING AMERICANS; MURALS BY AMERICAN PAINTERS AND PHOTOGRAPHERS. New York: Arno, 1969. Various pagination. Illus.

Reprint of three early catalogs of exhibitions of works by Americans at the Museum of Modern Art, New York; originally published in 1929, 1930, and 1932. Minimal documentation, no indexes. Many of the reputations of the artists included have fallen into obscurity.

New York. Whitney Museum of American Art. BIENNIAL EXHIBITIONS OF CONTEMPORARY AMERICAN PAINTING. New York: 1932-33-____. Variously paged. 17 volumes to 1972.

Variously titled "Annual" or "Biennial," these exhibitions have been major shows of American art. The catalogs have reflected what the curators have considered important on the contemporary scene. There is strong disagreement about the success of these shows and the resultant catalogs.

THE NEW YORK PAINTER, A CENTURY OF TEACHING: MORSE TO HOFMANN. New York: New York University Art Collection, 1967. 107 p. Illus. Chronology (teachers and students) pp. 100-1. Bibliography pp. 102-7. Essay "The New York Painter, 1650-1913 and 1900-32" by Milton W. Brown.

An ambitious exhibition which attempted to show the interaction between New York painters and their prominent students. Some interesting relationships are revealed.

1913 ARMORY SHOW: 50TH ANNIVERSARY EXHIBITION. Utica, N.Y.: Munson-Williams-Proctor Institute and New York (city) Henry Street Settlement, 1963. 212 p. Illus., plates, some in color. Index of illustrations pp. 210-12.

A largely pictorial catalog of an exhibit which attempted to re-assemble the works from the original Armory Show of 1913. There is a brief essay by Milton Brown on the impact of that show included.

Nordness, Lee, ed. Text by Allen S. Weller. ART: USA: NOW, 2 vols. New York: Viking, 1963. 474 p. Separate indexes: (vol. 1) pp. 225-35, (vol. 2) pp. 463-72.

Nordness assembled an extensive collection of contemporary American paintings for the S.C. Johnson (Wax) Co., Racine, Wisconsin, which was widely exhibited in the middle 1960's. This handsome two-volume catalog of that collection gives detailed information about the artists whose works were collected, and good reproductions as well as photographs of the artists. Arranged by birthdates of artists.

O'Connor, Francis V. ART FOR THE MILLIONS. Greenwich, Conn.: New York Graphic Society, 1973. 317 p. Illus. Appendixes pp. 268-307. Bibliography pp. 307-10. Index pp. 311-17.

While doing research for his other writings on federal art projects of the 1930's, O'Connor found references to this manuscript consisting of essays by artists who had participated in these projects, solicited by Emanuel Benson, but never published. Included: "Concerning Mural Painting" by Philip Evergood, "Abstract Painting Today" by Stuart Davis, "What is American Design" by Constance Rourke, and other essays; plus extensive background notes and information provided by O'Connor.

_____. FEDERAL ART PATRONAGE: 1933 to 1943. College Park: University of Maryland Art Gallery, 1966. 60 p. Illus. Bibliography pp. 41-54.

Written to accompany an exhibition of works produced under various federal government projects during this ten-year period. O'Connor includes a brief but clear description of several of these undertakings: FWAP, TRAP, WPA, etc. A chronology of projects is included, p. 40.

_____.FEDERAL SUPPORT FOR THE VISUAL ARTS: THE NEW DEAL AND NOW; A REPORT ON THE NEW DEAL ART PROJECTS IN NEW YORK CITY AND STATE WITH RECOMMENDATIONS FOR PRESENT DAY FEDERAL SUPPORT FOR THE VISUAL ARTS TO THE NATIONAL ENDOWMENT FOR THE ARTS, WASHINGTON, D.C.; OCTOBER 1968. Greenwich, Conn.: New York Graphic Society, 1969. 226 p. Bibliography pp. 209-26. Paperback.

Result of a research project directed by O'Connor under a grant from the National Endowment for the Arts. A massive compilation of data, but unattractively published as an offset reproduction of typescript, and lacking illustrations. Limited to New York. Very extensive bibliography.

_____. THE NEW DEAL ART PROJECTS: AN ANTHOLOGY OF MEMOIRS. Washington, D.C.: Smithsonian Institution Press, 1972. 339 p. Illus. Bibliography pp. 330-31. Index pp. 333-39.

Most of the memoirs included here were obtained as a result of the research project of which O'Connor's FEDERAL SUPPORT FOR THE VISUAL ARTS...(see above) was a report. A handsome format with photos and reproductions from the period make this an attractive and informative work.

Pitz, Henry C. THE BRANDYWINE TRADITION. Boston: Houghton Mifflin, 1969. 252 p. Illus., plates, some in color. Bibliography pp. 243-46. Index pp. 247-52.

A popular history for the layman of the several remarkable artists and illustrators who have lived in the Brandywine Valley (Pennsylvania) area, particularly Howard Pyle and the Wyeths.

Porter, James A. MODERN NEGRO ART. New York: Dryden Press, 1943. Reprint: Arno, 1973? 272 p. Illus. Bibliography pp. 183-92. Index pp. 193-200.

A pioneering study of American Black artists. Includes a great deal of social history, and remains a solid work for the contributions of Black American artists prior to 1940.

Rashell, Jacob. JEWISH ARTISTS IN AMERICA. New York: Vantage Press, 1967. 197 p. Illus. Index p. 197.

Possibly useful because there is biographical information about eighteen artists who are not well known, with the exceptions of Seymour Lipton and William Gropper. The style of writing is sentimental and puerile, the reproductions poor.

Ritchie, Andrew Carnduff. ABSTRACT PAINTING AND SCULPTURE IN AMERICA. New York: Museum of Modern Art, 1951. 159 p. Illus., some color plates. Bibliography by Bernard Karpel pp. 156-59.

A well-written history of abstraction from its European ancestry to the American painters of the early 1950's. This volume accompanied a major exhibition of abstract American art, and is still a useful introduction for the layman.

*Rose, Barbara. AMERICAN ART SINCE 1900: A CRITICAL HISTORY. New York: Praeger, 1967. 320 p. Illus., some in color. Bibliography pp. 298-300. Index of names pp. 316-20.

An excellent history, yet compact and readable. Begins with the

"Ash Can School," emphasizes the importance of the Armory Show, the W.P.A., through abstract expressionism to pop art and the hard-edge painters of the 1960's.

\*\_\_\_\_\_. AMERICAN PAINTING: THE TWENTIETH CENTURY. Geneva: Skira, distributed by World, Cleveland, 1970? 126 p. Illus., many color plates. Bibliography pp. 119-26. Index pp. 123-26.

> Companion volume to Brown. AMERICAN PAINTING: FROM ITS BEGINNINGS TO THE ARMORY SHOW (see above). A handsome chronicle of twentieth-century American painting. Emphasizes the ascendency of abstraction.

\*\_\_\_\_\_, ed. READINGS IN AMERICAN ART SINCE 1900: A DOCUMEN-TARY SURVEY. New York: Praeger, 1968. 224 p. Illus., plates. Bibliography pp. 209-24.

> Excerpts from writings by artists and critics, similar in concept to the work by McCoubrey, AMERICAN ART, 1700-1960 (see p. 19), but limited to the twentieth century. There is a small amount of duplication of material in these two books (e.g., Jackson Pollock), but they complement each other rather neatly. Ms. Rose provides background and summary information before each entry.

Rosenberg, Harold. THE ANXIOUS OBJECT: ART TODAY AND ITS AUDI-ENCE. New York: Horizon, 1964. 2nd ed. 1966.

> A collection of essays on the contemporary art scene by one of its most important critics. Comments on government participation, the gallery scene, the interaction of the art world and the public, and other topics.

\_\_\_\_\_. ARTWORKS AND PACKAGES. New York: Horizon, 1969. 232 p. Illus., some in color. Index pp. 229-32.

> A history, heavily illustrated, of contemporary avant-garde art movements, including pop art, minimal works, kinetic sculpture and "packages." International coverage, but much U.S. material included.

\_\_\_\_\_. THE DE-DEFINITION OF ART. New York: Horizon Press, 1972. 256 p. Illus. Index pp. 251-56.

> A collection of essays on problems in contemporary art, along with articles on individual artists. Many of these appeared first in the NEW YORKER magazine. American art and artists predominate.

Rubin, William S. DADA AND SURREALIST ART. New York: Abrams, 1968. 525 p. Illus., 60 color plates. Bibliography pp. 492-512. Index pp. 513-24.

> Greatly expanded treatment of the earlier DADA, SURREALISM AND THEIR HERITAGE (see next page). Most of the expansion consists of the addition of pictorial material, especially color plates. Lengthier bibliography included.

\*    . DADA, SURREALISM AND THEIR HERITAGE. New York: Museum of Modern Art, distributed by New York Graphic Society, Greenwich, Conn., 1968. 252 p. Illus. Chronology pp. 197-216. Bibliography pp. 217-27. Index pp. 244-55.

> Written to accompany a major exhibition of surrealist and Dada works held in 1968 at the Museum of Modern Art, New York, and also at the Chicago Art Institute and the Los Angeles County Museum. Covers developments in Europe and the United States.

Rublowsky, John. POP ART. New York: Basic Books, 1965. 174 p. Illus., many in color.

> A popular introduction to the world of pop art. Heavily illustrated, with emphasis on New York artists. Chapters on Lichtenstein, Oldenburg, Rosenquist, Warhol and Wesselman, plus one on "Collectors and galleries." Seems to freeze a particular moment and movement in time.

Russell, John and Gablik, Suzi. POP ART REDEFINED. New York: Praeger, 1969. 240 p. Illus., some in color. Index pp. 233-40.

> A British book written to accompany an exhibit of "Anglo-American pop art," organized by the Arts Council of Great Britain. Includes a number of statements by participating artists.

\*Sandler, Irving. THE TRIUMPH OF AMERICAN PAINTING: A HISTORY OF ABSTRACT EXPRESSIONISM. New York: Praeger, 1970. 301 p. Illus., some color plates. Biographies pp. 277-80. Bibliographies pp. 281-98. Index pp. 299-301.

> The most comprehensive survey of abstract expressionism and the New York school of the 1950's. In particular: William Baziotes, James Brooks, Willem de Kooning, Arshile Gorky, Adolph Gotlieb, Philip Guston, Hans Hofmann, Franz Kline, Robert Motherwell, Barnett Newman, Jackson Pollock, Ad Reinhardt, Mark Rothko, Clyfford Still, and Bradley Walker Tomlin.

Santini, Pier Carlo. MODERN LANDSCAPE PAINTING. London: Phaidon, 1972. 350 p. Illus., several color plates. Bibliography p. 61. Index pp. 349-50.

> Translation from the Italian IL PAESAGGIO NELLA PITTURA CONTEMPORANEA (Venice: Electra Editrice, 1971). A good survey of the subject, although European artists predominate. Americans included: Stuart Davis, Lyonel Feininger, Edward Hopper, John Marin, Ben Shahn, and Charles Sheeler.

Schulze, Franz. FANTASTIC IMAGES: CHICAGO ART SINCE 1945. Chicago: Follett, 1972. 223 p. Illus., some color plates.

> Survey of modern art in Chicago, with the work of 28 artists, including Leon Golub, H.C. Westermann, June Leaf, James Nutt, and others. A vital, exciting collection, however many are erotic, others aggressively vulgar--not for the delicate reader.

Seitz, William C. and Goodrich, Lloyd. SAO PAULO 9; UNITED STATES OF AMERICA / ESTADOS UNIDOS DA AMERICA; EDWARD HOPPER; ENVIRON-MENT U.S.A.: 1957-1967; MEIO-NATURAL U.S.A.: 1957-1967. Washington, D.C.: Published for the National Collection of Fine Arts by the Smithsonian Institution Press, 1967. 165 p. Illus., some in color. Bibliography pp. 113-46.

> The American exhibition at the ninth biennial Sao Paulo international show. The Hopper show had been selected just prior to his death in 1967, and became a kind of memorial. The "environment" exhibit is misleading in its title. It is a collection of figural and pop art, which in its relative "realism" reflects the U.S. environment.

Solomon, Alan and Mulas, Ugo. NEW YORK: THE NEW ART SCENE. New York: Holt, Rinehart, Winston, 1967. 341 p. Illus. Index p. 339.

> A picture book of photographs of the New York art world of the mid-1960's. Candid shots of artists at work, including Duchamp, Newman, Warhol, Bontecou, Oldenburg, and others. Biographical notes given.

Taylor, Edward K., foreword. NEW BLACK ARTISTS: AN EXHIBITION ORGANIZED BY THE HARLEM CULTURAL COUNCIL IN COOPERATION WITH THE SCHOOL OF THE ARTS AND THE URBAN CENTER OF COLUMBIA UNIVERSITY. New York: Brooklyn Museum and Columbia University, 1969. Unpaged. Illus.

> Twelve younger Black artists who "...are not just incidentally Black, but have Blackness as an important element of their work" (foreword). Alphabetically arranged, with brief biographical entries, reproductions and portraits of the artists included.

*Tuchman, Maurice. NEW YORK SCHOOL: THE FIRST GENERATION. Greenwich, Conn.: New York Graphic Society. 1972? 228 p. Illus., all in black and white, 20 in color. Bibliographies included.

> Revised edition of an exhibition catalog of a show of abstract expressionist works held at the Los Angeles County Museum in 1965. A good introduction to the era, with a text composed of statements by artists and comments by critics. Baziotes, DeKooning, Gorky, Gottlieb, Guston, Hofmann, Kline, Motherwell, Newman, Pollock, Pousette-Dart, Reinhardt, Rothko, Still, and Tomlin figure prominently.

291; NO. 1-12: 1915-1916. New York: Arno Press, 1972. 46 p. Illus., some color.

> Reprint of an important monthly produced in 1915-16 by Alfred Stieglitz, Marius DeZayas, and Francis Picabia. This new volume has an introduction by Dorothy Norman, providing background. The journal was important because of its role in introducing avantgarde European and American art to the American public. It took its title from Stieglitz's gallery at 291 Fifth Avenue. The

reprint edition is, however, currently overpriced at $90.00.

Weller, Alan S. CONTEMPORARY AMERICAN PAINTING AND SCULPTURE. Urbana: University of Illinois Press, 1967. 183 p. Illus.

A substantial catalog of an exhibition which included works by over 100 American artists.

_____. THE JOYS AND SORROWS OF RECENT AMERICAN ART. Urbana: University of Illinois Press, 1968. 185 p. Illus.

Developed from a lecture series. "Signs and symbols," "Contemporary old masters," and "Rejection and renewal" intelligently discuss twentieth-century painting.

Chapter 6

INDIVIDUAL ARTISTS

Chapter 6

INDIVIDUAL ARTISTS

ABBEY, EDWIN AUSTIN  1852-1911

Lucas, E.V.  EDWIN AUSTIN ABBEY; ROYAL ACADEMICIAN:  THE RECORD
OF HIS LIFE AND WORK, 2 vols.  New York:  Scribners, 1921.  518 p.
Illus.  Index pp. 493-518.

> Definitive biography and chronicle of Abbey's prolific career.  A
> Philadelphian who spent much of his adult life in London, Abbey
> enjoyed immense acclaim during his life.  His major works are
> dramatic murals in an illustrative and academic style.

\*     \*     \*     \*     \*

ALBERS, JOSEF  1888-

Albers, Josef.  INTERACTION OF COLOR.  New Haven, Yale University
Press, 1963.  Variously paged.  Boxed.  Includes color silkscreened plates.
Abridged edition:  Yale University Press, 1971.  74 p., seven color plates.

> This monumental work by Albers is not about American painting
> but it has been enormously influential.  Developed from Albers'
> Bauhaus experiences, it demonstrates the effects of colors upon
> each other.  The original volume is unsurpassed in demonstrating
> various effects, and the silkscreen plates were most carefully pro-
> duced.  The abridged edition gives us Albers' text, but the color
> plates only hint at the original edition's value.

Gomringer, Eugen.  JOSEF ALBERS:  HIS WORK AS CONTRIBUTION TO
VISUAL ARTICULATION IN THE TWENTIETH CENTURY.  New York:  Witten-
born, 1968.  185 p.  Illus., includes color plates, some are silkscreened.
Bibliographies pp. 189-91.  Index pp. 195-97.

> Translation of a German work, this is a lavishly produced mono-
> graph which originated as an exhibition catalog of a show held
> in Basel, 1968-69.  Remains the basic work on Albers.  The book
> combines an interesting mixture of offset, letterpress and silkscreen

printing, unfortunately on poor paper which is rapidly discoloring.

JOSEF ALBERS AT THE METROPOLITAN MUSEUM OF ART: AN EXHIBITION OF HIS PAINTINGS AND PRINTS. New York: Metropolitan Museum of Art, 1971. 76 p. Illus., some color plates. Bibliography pp. 74-76.

A major exhibition catalog, with an introduction by Henry Geld-zahler. Little text, but well-illustrated and an up-to-date bibliography.

Rowell, Margit. "On Albers' Color." ARTFORUM, vol. 10, January 1972, pp. 26-37. Illus.

Selections from a book to be published in the near future. A perceptive article about the area in which Albers has been most influential.

*Spies, Werner. ALBERS. Abrams, 1970? 79 p. Illus., some color plates. Bibliography pp. 75-79.

A brief, attractive introduction to Albers' life and work. Translated from the German.

(Also see: Hunter, p. 456; A.A.A.)

*     *     *     *     *

ALBRIGHT, IVAN   1897-

Sweet, Frederick. IVAN ALBRIGHT. Chicago: Art Institute, 1964. 56 p. Illus., some color plates.

Exhibition catalog which includes several of Albright's large near-surreal figurative paintings and a few sculptures. Includes foreword by John Maxon, commentary by Jean Dubuffet, and a statement by Albright.

*     *     *     *     *

ALEXANDER, JOHN WHITE   1856-1915

MAGAZINE OF ART. "John W. Alexander Memorial Number; with Eighteen Reproductions of His Paintings." New York: American Federation of Arts, 1916. 345-73 p. Illus.

The July 1916 issue of the MAGAZINE OF ART, with commemorative essays by Edwin H. Blashfield, Howard R. Butler, Charles Dana Gibson, and others. Alexander was an important portraitist and romantic figure painter whose reputation has faded somewhat since his death.

(Also see: N.Y. MET. 19TH C.)

ALLSTON, WASHINGTON 1779-1843

Flagg, Jared. THE LIFE AND LETTERS OF WASHINGTON ALLSTON. New York: Benjamin Blom, 1969. 435 p. Illus. Index pp. 427-35.

> Reprint of the 1892 edition. Remains a basic monograph since little else has been published, and includes much documentation as well as letters and other primary source materials.

Richardson, E.P. WASHINGTON ALLSTON: A STUDY OF THE ROMANTIC ARTIST IN AMERICA. Chicago: University of Chicago Press, 1948. 233 p. Illus., plates. Bibliography pp. 220-28.

> Scholarly monograph which includes a catalog of "existing and recorded paintings by Washington Allston, by Edgar Preston Richardson and Henry Wadsworth Longfellow Dana."

(Also see: N.Y. MET. 19TH C.)

\* \* \* \* \*

AMES, EZRA 1768-1836

Bolton, Theodore and Cortelyou, Irwin F. EZRA AMES OF ALBANY: PORTRAIT PAINTER, CRAFTSMAN, ROYAL ARCH MASON, BANKER, 1768-1836; AND A CATALOGUE OF HIS WORKS BY IRWIN F. CORTELYOU. New York: New York Historical Society, 1955. 398 p. Illus. Bibliography pp. 359-70. Index pp. 371-98.

> The definitive monograph on an early versatile and prolific artist. Includes excerpts from his letters and account books.

\* \* \* \* \*

ANSCHUTZ, THOMAS POLLOCK 1851-1912

N.Y. MET. 19TH C.

\* \* \* \* \*

ANUSZKIEWICZ, RICHARD 1930-

NEW PAINTINGS BY ANUSZKIEWICZ. New York: Sidney Janis Gallery, 1967. 20 p. Illus., one color plate.

> Good reproductions of the artist's strong geometrical abstractions, but no text in this slim exhibition catalog.

(Also see: HUNTER, p. 457.)

\* \* \* \* \*

AUDUBON, JOHN JAMES 1785-1851

Audubon, John James. THE BIRDS OF AMERICA. New York: Macmillan, 1944. Unpaged. 435 color plates. Indexed.

> The original set of THE BIRDS OF AMERICA was published in London, 1827 to 1838, with engravings after Audubon's paintings. This collection of reproductions is not a superior one; bird identification is emphasized in the commentary.

Ford, Alice, ed. AUDUBON'S ANIMALS: THE QUADRUPEDS OF NORTH AMERICA. New York: Studio, 1951. 222 p. Illus., some color plates.

> Originally, these plates appeared in THE VIVIPAROUS QUADRUPEDS OF NORTH AMERICA, 1842 to 1848, with engravings after Audubon's paintings. This is an attractive republication, and contains substantial information about Audubon and the publication of the first edition.

_____. JOHN JAMES AUDUBON. Norman: University of Oklahoma Press, 1964. 488 p. Illus., some in color. Bibliography pp. 451-69.

> Standard biography of the artist, which includes excerpts from Audubon's letters.

THE IMPERIAL COLLECTION OF AUDUBON ANIMALS: THE QUADRUPEDS OF NORTH AMERICA. Maplewood, N.J.: Hammond, 1967. 307 p. Illus., many color reproductions. Index pp. 302-7. Bibliography p. 307.

> Edited by Victor H. Cahalane with a foreword by Fairfield Osborne, this is an attractive collection of Audubon's animal paintings (reproductions of engravings after the paintings), though the reproductions lack sharpness and the colors are dulled. For animal lovers, not art historians.

THE ORIGINAL WATER-COLOR PAINTINGS BY JOHN JAMES AUDUBON FOR "THE BIRDS OF AMERICA": REPRODUCED IN COLOR FOR THE FIRST TIME FROM THE COLLECTION OF THE NEW YORK HISTORICAL SOCIETY. 2 vols. New York: American Heritage, distributed by Houghton Mifflin, 1966. Illus., many color plates.

> The most satisfactory reproduction to date--the only one which reproduces from Audobon's paintings rather than engravings after the paintings. Edited by M.B. Davidson; includes many quotations from Audubon.

(Also see: N.Y. MET. 19TH C.; A.A.A.)

* * * * *

AVERY, MILTON 1893-1965

Breeskin, Adelyn D., introduction. MILTON AVERY. Washington, D.C.: The National Collection of Fine Arts, Smithsonian Institution, distributed by New York Graphic Society, Greenwich, Conn., 1969. Unpaged. "Selected

references" on last page. Illus., some in color.

> Catalog of a traveling exhibition, largely reproductions. Essay by Breeskin and a commemorative essay by Mark Rothko (who was tragically to take his own life the following year) make up the text. The reproductions are of indifferent quality.

Getlein, Frank. MILTON AVERY, 1893-1965. Lincoln, Nebraska: Sheldon Memorial Art Gallery, 1966? 46 p. Illus.

> Brief exhibition catalog, Getlein compares Avery with Matisse, and comments on his canvas' special quality of light. Unfortunately, no color reproductions.

Kramer, Hilton. MILTON AVERY: PAINTINGS, 1930-1960. New York: Thomas Yoseloff, 1962. 30 p., plus 112 plates, some in color.

> Monograph consisting mostly of reproductions of Avery's abstracts, landscapes, and figurative paintings. The reproductions are often slightly fuzzy. Brief critical text.

MILTON AVERY: LATE PAINTINGS. Irvine: University of California, Art Gallery, 1971. 32 p. Illus., plates, some in color. Bibliography pp. 31-32.

> A catalog of an exhibition of Avery's subtle "color abstraction" works from the late 1950's and early 1960's.

(Also see: HUNTER, p. 457; A.A.A.)

<p style="text-align:center">*   *   *   *   *</p>

BANNARD, DARBY 1931-

Champa, Kermit. "The Recent Work of Darby Bannard." ARTFORUM, vol. 7, October 1968, pp. 62-66. Illus.

> Bannard is an influential younger painter who writes under the name of Walter Darby Bannard. His work illustrated in this article is in the abstract color-field tradition.

<p style="text-align:center">*   *   *   *   *</p>

BARANIK, RUDOLF 1920-

Newman, Daniel, ed. RUDOLF BARANIK: NAPALM ELEGY. New York: Lerner Heller, 1973. 39 p. Illus. Bibliography p. 39.

> Brief catalog issued by Lerner Heller Gallery, with an interview by Irving Sandler and a preface by Lawrence Alloway. Included are abstract works from 1960 to 1973, intended as an expression of the tragedy of Vietnam.

<p style="text-align:center">*   *   *   *   *</p>

BARD, JAMES 1815-1897

<p style="text-align:center">65</p>

## BARD, JOHN 1815-1856

Sniffen, Harold and Brown, Alexander. "James and John Bard, Painters of Steamboat Portraits." ART IN AMERICA, vol. 37, April 1949, pp. 51-66.

> Twin brothers who became accomplished self-taught marine artists, specializing in the boats on the Hudson River.

\* \* \* \* \*

## BASKIN, LEONARD 1922-

*Baskin, Leonard. BASKIN: SCULPTURE, DRAWINGS AND PRINTS. New York: Braziller, 1970. 170 p. Illus., two color plates. Bibliography pp. 167-70.

> Baskin is known primarily for his sculpture and graphic works. However, several of the drawings included in this volume are wash drawings, and show his facility with a brush. This handsome book is the best work on Baskin so far.

\* \* \* \* \*

## BAYER, HERBERT 1900-

HERBERT BAYER: PAINTER, DESIGNER, ARCHITECT. New York: Reinhold, 1967. 211 p. Illus. some color plates. Bibliography pp. 207-11.

> An excellent monograph on Bayer, a versatile former Bauhaus master who has been very influential in modern American design.

Dorner, Alexander. THE WAY BEYOND ART: THE WORK OF HERBERT BAYER. New York: Wittenborn, 1947. 244 p. Illus., some color plates. Index pp. 241-44.

> An early book about Bayer's work, including his paintings, posters, advertisements, magazine covers, typography, and designs for exhibitions. Introduction by John Dewey.

HERBERT BAYER, RECENT WORKS. New York: Marlborough Gallery, 1971. 48 p. Illus., some in color.

> Largely reproductions of recent paintings and sculpture exhibited at Marlborough. Brief text by Jan Van Der Marck.

\* \* \* \* \*

## BAZIOTES, WILLIAM 1912-1963

Alloway, Lawrence. WILLIAM BAZIOTES: A MEMORIAL EXHIBITION. New York: Solomon R. Guggenheim Museum, 1965. 51 p. Illus. Bibliography pp. 44-45.

> Substantive catalog of an exhibition held two years after the artist's death. Lengthy bibliography by Susan Tumarin and Alice

Hildreth.

WILLIAM BAZIOTES: THE LATE WORK, 1946-1962. New York: Marlborough Gallery, 1971. 28 p. Illus., some color plates.

This slim exhibition catalog includes a brief essay by Clyfford Still and a statement made much earlier by Baziotes. List of exhibitions included.

(Also see: A.A.A.)

\* \* \* \* \*

BEARDEN, ROMARE 1914-

Bearden, Romare and Holty, Carl. THE PAINTER'S MIND: A STUDY OF THE RELATIONS OF STRUCTURE AND SPACE IN PAINTING. New York: Crown, 1969. 224 p. Illus.

Basic book for the art student on visual concepts in painting. Not limited to American painting, and does not include examples of Bearden's work.

Pomeroy, Ralph. "Black Persephone." ART NEWS, vol. 66, October 1967, p. 45. Illus.

Review of an exhibition at Cordier-Ekstrom Gallery, New York, of paintings by this prominent Black American artist.

(Also see: HUNTER, p. 457; A.A.A.)

\* \* \* \* \*

BELLOWS, GEORGE 1882-1925

Bellows, Emma S. THE PAINTINGS OF GEORGE BELLOWS. New York: Knopf, 1929. Unpaged, 147 plates.

A loving memorial to Bellows, produced in a limited edition with an essay he authored. Largely reproductions of his work, this volume was organized by his wife.

Boswell, Peyton, Jr. GEORGE BELLOWS. New York: Crown, 1942. 112 p. Illus., some color plates. Bibliography pp. 26-30.

A popular introduction to Bellow's work. Boswell refers to Bellows as "the outstanding dramatist among American artists." Adequate reproductions, lengthy bibliography.

Braider, Donald. GEORGE BELLOWS AND THE ASHCAN SCHOOL OF PAINTING. New York: Doubleday, 1971. 153 p. Illus. Index pp. 147-53.

Biography of Bellows, written for the layman. Bellows led a more than usually interesting life. Supplemental to the understanding

of his stylistic development.

GEORGE BELLOWS: PAINTINGS, DRAWINGS AND PRINTS. Chicago: Art Institute, 1946. 92 p. Illus.

Catalog of an exhaustive retrospective held 20 years after the artist's death. Includes short essays by Eugene Speicher, Frederick A. Sweet, and Carl O. Schniewind.

Morgan, Charles H. GEORGE BELLOWS: PAINTER OF AMERICA. New York: Reynal, 1965. 381 p. Illus., some in color. Index pp. 371-81.

A most readable biography of Bellows, who nearly became a professional baseball player, and died at the young age of 42.

(Also see: HUNTER, p. 457; IND. 20TH C. ARTISTS. Vol. 1: pp. 81-94, 19a, 43a. Vol. 3: no. 11-12, p. 21.)

\* \* \* \* \*

BENGSTON, BILLY AL 1934-

Monte, James. "Bengston in Los Angeles: The County Museum Presents the Artist's First Retrospective." ARTFORUM, vol. 7, November 1968, pp. 36-40. Illus.

Review of a large exhibition of the work of this young West Coast artist.

_____. BILLY AL BENGSTON. Los Angeles: Los Angeles County Museum of Art, sponsored by the Contemporary Art Council, 1968. Unpaged. Illus.

Catalog of the exhibition reviewed above; includes many reproductions of Bengston's large geometrical abstracts. The catalog was designed by Ed Ruscha and features a cover made of felt and sandpaper.

\* \* \* \* \*

BENTON, THOMAS HART 1889-

Benton, Thomas Hart. AN ARTIST IN AMERICA. Columbia: University of Missouri Press, 1968, 3rd ed. 369 p. Illus.

This edition of Benton's memoirs, first written in 1951, has a foreword by Clarence R. Decker. Benton's observations are refreshingly crotchety, and he shows contempt for abstract art. This book contains a very lengthy section on his observations of the American social scene earlier in the century, particularly the rural south. The illustrations are reproductions of sketches made on his travels.

_____. AN AMERICAN IN ART: A PROFESSIONAL AND TECHNICAL

AUTOBIOGRAPHY. Lawrence: The University Press of Kansas, 1969. 197 p. Illus. Index pp. 193-97.

> This autobiographical work expands on Benton's experiences: his friendships with other artists, his travels, and his personal reactions to developments in twentieth-century art. As Benton says in his opening statement: "One of the commonest complaints about AN ARTIST IN AMERICA is that it provides too sketchy an account of my technical development." This reproduces many of his better-known paintings (in black and white) and includes his essay "American regionalism," reprinted from THE UNIVERSITY OF KANSAS CITY REVIEW, vol. 18, no. 1, 1951.

(Also see: HUNTER, p. 457; IND. 20TH C. ARTISTS. Vol. 2: pp. 97-100, 17a. Vol. 3: no. 11-12, p. 53.)

\* \* \* \* \*

BERMAN, EUGENE 1899-1972

Levy, Julien. EUGENE BERMAN. New York: American Studio Books, 1947. 80 p. Illus., color frontispiece.

> Brief text by Levy refers to Berman's paintings as "neo-Romantic" or "neo-Baroque." This is primarily a picture book, with reproductions of Berman's fantastic works from 1928 to the early 1940's.

\* \* \* \* \*

BIDDLE, GEORGE 1885-1973

Biddle, George. AN AMERICAN ARTIST'S STORY. Boston: Little Brown, 1939. 326 p. Illus.

> Autobiography of an artist who was influential in the formation of, and participated in, the federal art projects of the 1930's, and was an important muralist. Describes his education, which included Harvard College and Harvard Law School; his travels; his social views; and ends with his concern for the upheaval and hatred he perceived in Europe, just prior to World War II.

(Also see: IND. 20TH C. ARTISTS. Vol. 2: pp. 101-3, 18a. Vol. 3: no. 11-12, p. 54; A.A.A.)

\* \* \* \* \*

BIEDERMAN, CHARLES (KAREL) JOSEPH 1906-

Biederman, C.J. LETTERS ON THE NEW ART. Red Wing, Minn.: Art History, 1951. 95 p. Illus.

> A slim volume of philosophy and a defense of abstract art by one of America's pioneer abstractionists, or a "constructivist," as Bie-

derman refers to himself. This work reproduces some of Bieder-
man's paintings.

CHARLES BIEDERMAN: A RETROSPECTIVE EXHIBITION WITH ESPECIAL EM-
PHASIS ON THE STRUCTURIST WORKS OF 1936-69. London: Arts Council
of Great Britain, 1969. Unpaged. Illus., some in color.

An exhibition held at Hayward Gallery in London, and Leister
Museum and Art Gallery. Includes brief essays on Biederman's
long involvement with "structurism" (constructivism), by Robin
Denny and Jan Van Der Marck. Bibliography included.

\* \* \* \* \*

BIERSTADT, ALBERT  1830-1902

Hendricks, Gordon. A. BIERSTADT. Fort Worth, Texas: Amon Carter Mu-
seum, 1972. 48 p. Illus., plates, some in color.

Bierstadt was popularly regarded at the end of the nineteenth cen-
tury as one of America's greatest landscape artists. His popular-
ity declined during the first half of this century, but his work is
being reappreciated because of various exhibitions, of which this
has been the most important to date. Hendricks' catalog is ex-
cellent, and fills a major gap in the literature.

(Also see: N.Y. MET. 19TH C.)

\* \* \* \* \*

BINGHAM, GEORGE CALEB  1811-1879

Bloch, E. Maurice. GEORGE CALEB BINGHAM: THE EVOLUTION OF AN
ARTIST; 2 vols. Berkeley and Los Angeles: University of California Press,
1967. 339 and 238 p. Illus., plates, frontispiece (vol. 1) in color. Bibliog-
raphy (vol. 1) pp. 263-97. Indexes.

The most authoritative scholarly monograph on Bingham to date.
Primarily detailed critical evaluation of the paintings, with little
discussion of his personality, social milieu, or political career.

_____ . GEORGE CALEB BINGHAM, 1811-1879. Washington, D.C.: Na-
tional Collection of Fine Arts, Smithsonian Institution Press, 1968. 99 p.
Illus. Bibliography pp. 97-99.

An important traveling exhibition of Bingham's work seen in Wash-
ington, Cleveland, and Los Angeles. Much of the material in
the catalog is based on Bloch's monograph (above).

Christ-Janer, Albert. GEORGE CALEB BINGHAM OF MISSOURI: THE STORY
OF AN ARTIST. New York: Dodd, Mead, 1940. 171 p. Illus., plates,
some in color. Bibliography pp. 146-48.

The first major modern book on Bingham, reinterpreting him for the

twentieth century. Based on the early Rusk monograph (below).
Lengthy biographical material, including numerous letters and an
account of his political career. Preface is by Thomas Hart Benton.

McDermott, John Francis. GEORGE CALEB BINGHAM: RIVER PORTRAITIST.
Norman: University of Oklahoma Press, 1959. 454 p. Illus. "Sources con-
sulted" pp. 438–46. Index pp. 447–54.

A scholarly biography and analysis of Bingham's paintings. In-
cludes a checklist of his works (pp. 412–37).

Rusk, Fern. GEORGE CALEB BINGHAM: THE MISSOURI ARTIST. Jefferson
City: Hugh Stevens Co., 1917. 135 p. Illus.

The first monograph on Bingham, upon which much subsequent
scholarship is based. Revision of a master's thesis submitted to
the University of Missouri in 1914.

(Also see: N.Y. MET. 19TH C.)

*     *     *     *     *

BIRCH, THOMAS  1779–1851

BIRCH, WILLIAM RUSSELL  1755–1834

Gerdts, William H. THOMAS BIRCH, 1779–1851: PAINTINGS AND DRAW-
INGS; WITH A SELECTION OF MINIATURES BY HIS FATHER, WILLIAM RUS-
SELL BIRCH, 1755–1834; AND A GROUP OF PAINTINGS BY OTHER ARTISTS
OF THE PHILADELPHIA MARITIME TRADITION. Philadelphia: Maritime Mu-
seum, 1966. 64 p. Illus.

Catalog which accompanied an exhibition, with black and white
reproductions and brief text on Thomas Birch, an early portraitist
and marine painter, and his father, who painted portrait miniatures.

(Also see: N.Y. MET. 19TH C.)

*     *     *     *     *

BLANCH, ARNOLD  1896–1968

ARNOLD BLANCH. New York: American Artists Group, 1946. Unpaged.
Illus., color frontispiece, portrait on cover. (American Artists Group, Mono-
graph no. 18)

Small monograph, with a brief autobiographical essay by this art-
ist who enjoyed popularity in the 1940's. Many black and white
reproductions of poor quality.

(Also see: INDEX OF 20TH C. ARTISTS. Vol. 3: pp. 281–83, no. 11–12,
p. 87.)

BLOOM, HYMAN 1913–

Wight, Frederick S. HYMAN BLOOM. Boston: Institute of Contemporary
Art, 1954. 115 p. Illus., some in color.

> A traveling exhibition which was also shown at the Whitney, New
> York; Albright, Buffalo; Lowe Gallery, Coral Gables; De Young
> Museum, San Francisco. The catalog has a postscript by Lloyd
> Goodrich. The rich painterly surfaces of Bloom's works do not
> adequately reproduce.

\*    \*    \*    \*    \*

BLUEMNER, OSCAR JULIUS 1867–1938

OSCAR BLUEMNER: AMERICAN COLORIST. Cambridge: Harvard University,
Fogg Art Museum, 1967. Unpaged. Illus. Includes bibliography.

> A German-born American whose work is described in this exhibition
> catalog as "symbolic realism."

\*    \*    \*    \*    \*

BLUME, PETER 1906–

Getlein, Frank. PETER BLUME. New York: Kennedy Galleries, 1968. Un-
paged. Illus., 2 color plates.

> An exhibition catalog which includes Blume's works from 1929 to
> 1967, and a brief text by Getlein detailing Blume's long and dis-
> tinguished career.

(Also see: HUNTER, p. 457; IND. 20TH C. ARTISTS. Vol. 3: pp. 285–86,
no. 11–12, p. 87.)

\*    \*    \*    \*    \*

BLYTHE, DAVID GILMOUR 1815–1865

Miller, Dorothy. THE LIFE AND WORK OF DAVID G. BLYTHE. Pittsburgh:
University of Pittsburgh Press, 1950. 142 p. Illus. Bibliography pp. 135–38.
Index pp. 139–42.

> Authoritative monograph on Blythe, a nineteenth-century genre
> painter from Pittsburgh. Reproductions are few and rather poor.

(Also see: N.Y. MET. 19TH C.)

\*    \*    \*    \*    \*

BOHROD, AARON 1907–

Bohrod, Aaron. A DECADE OF STILL LIFE. Madison: University of Wiscon-
sin Press, 1966. 298 p. Illus., many color plates.

An autobiographical work, heavily illustrated, by Bohrod, a paint-
er of still lifes in the "Trompe l'Oeil" tradition.

\* \* \* \* \*

BOLOTOWSKY, ILYA 1907-

Campbell, Lawrence. "Squaring the Circle and Vice-Versa." ART NEWS,
vol. 68, February 1970, p. 38. Illus., color plate.

Major article on Bolotowsky on the occasion of an exhibition at
the Grace Borgenicht Gallery, New York. "Bolotowsky, thirty
years a neo-plasticist, returns with new columns, diamonds, rec-
tangles, and circles...."

ILYA BOLOTOWSKY: PAINTINGS AND COLUMNS. Albuquerque: Univer-
sity of New Mexico, 1970. 24 p. Illus., some in color.

Brief catalog of a large traveling exhibition of the works of an
early American abstractionist.

(Also see: A.A.A.)

\* \* \* \* \*

BORIE, ADOLPHE 1877-1934

Biddle, George. ADOLPHE BORIE. Washington, D.C.: The American Fed-
eration of Arts, 1937. 121 p. Illus., plates, color frontispiece.

Brief text written by fellow artist Biddle shortly after Borie's death.
Mostly a collection of reproductions of Borie's paintings and draw-
ings.

(Also see: IND. 20TH C. ARTISTS. Vol. 3: pp. 201-3, no. 11-12, p. 73.)

\* \* \* \* \*

BREVOORT, JAMES RENWICK 1832-1918

McColley, Sutherland. THE WORKS OF JAMES RENWICK BREVOORT, 1832-
1918: AMERICAN LANDSCAPE PAINTER. Yonkers, N.Y.: Hudson River
Museum, 1972. 67 p. Illus. Bibliography pp. 63-64.

Exhibition catalog of landscapes by this lesser-known American
painter. Adequate documentation, but poor black and white re-
productions.

\* \* \* \* \*

BROOKS, JAMES 1906-

Hunter, Sam. JAMES BROOKS. New York: Praeger for the Whitney Museum

of American Art, 1963. 55 p. Illus., a few in color.

> Exhibition also shown at the Rose Art Museum, Brandeis University.
> This is a good introduction to the work of Brooks, who began as a
> social realist in the 1930's, and whose style has evolved to lyrical
> abstraction.

JAMES BROOKS. Dallas: Museum of Fine Arts, 1972. Unpaged. Illus., some
in color.

> Includes statements by the artist, introduction by Merrill C. Rueppel,
> with a list of exhibitions and a selected bibliography at the back of
> this slim exhibition catalog.

Kingsley, April. "James Brooks: Stain into Image." ART NEWS, vol. 71,
December 1972, pp. 48-49. Illus., including color plates.

> Discussion of Brooks' painting inspired by an exhibition at Martha
> Jackson Gallery, New York. Calls Brooks "one of America's two
> or three 'old masters.'"

Rosenstein, Harris. "Beyond Control." ART NEWS, vol. 69, February 1971,
p. 148. Illus., color plates.

> Review of an exhibition at Martha Jackson Gallery, New York.

(Also see: HUNTER, p. 457; A.A.A.)

\* \* \* \* \*

## BROOKS, ROMAINE 1874-1970

Breeskin, Adelyn. ROMAINE BROOKS: THIEF OF SOULS. Washington, D.C.:
published for the National Collection of Fine Arts by the Smithsonian Institution
Press, 1971. 143 p. Illus., some color plates. Bibliography pp. 137-42.

> An important exhibition catalog of works by this expatriate portraitist.
> Breeskin gives biographical information, including a description of
> the artist's unhappy childhood and her later success in Europe.

\* \* \* \* \*

## BURCHFIELD, CHARLES 1893-1967

Baur, John I.H. CHARLES BURCHFIELD. New York: published for the
Whitney Museum of American Art by Macmillan, 1956. 86 p. Illus., some
in color. Bibliography pp. 82-85.

> "This book grew out of a retrospective exhibition of Charles Burch-
> field's painting and drawing held at the Whitney...1956." An excel-
> lent survey of the artist's work, with a good introductory text.

CHARLES BURCHFIELD. New York: American Artist Group, 1945. Unpaged.
Illus. (Monograph no. 13)

> Typical small volume of this series, with a brief foreword by Burch-

field, a biographical outline at the back, and a collection of rather poor black and white reproductions.

CHARLES BURCHFIELD, EARLY WATERCOLORS. New York: Museum of Modern Art, 1930. 12 p. Illus.

One of the earliest publications of the Museum of Modern Art, it lacks the thoroughness of scholarship and documentation of later publications. Consists of very brief text and a collection of rather indifferent reproductions of Birchfield's early works.

Trovato, Joseph S., introduction. CHARLES BURCHFIELD: CATALOGUE OF PAINTINGS IN PUBLIC AND PRIVATE COLLECTIONS. Utica, N.Y.: Munson-Williams-Proctor Institute, 1970. 367 p. Illus., including color plates. Bibliography pp. 333–44, by Bernard Karpel.

The largest exhibition of Burchfield's work ever shown was accompanied by this substantial and informative catalog. Documentation of most of his paintings included, and a great many illustrated. Excellent bibliography included.

(Also see: HUNTER, p. 457; IND. 20TH C. ARTISTS. Vol. 2: no. 3, pp. 38–40.)

*   *   *   *   *

CASSATT, MARY 1844–1926

Breeskin, Adelyn. MARY CASSATT: A CATALOGUE RAISONNE OF THE OILS, PASTELS, WATERCOLORS AND DRAWINGS. Washington, D.C.: Smithsonian Institution Press, 1970. 322 p. Illus., some in color. Bibliography pp. 307–9.

A major work documenting provenances, exhibition histories, and other descriptive facts about all known works by Cassatt, excluding the prints. (Breeskin had previously contributed to the publication of THE GRAPHIC ART OF MARY CASSATT, Smithsonian, 1967.)

*_____. MARY CASSATT: 1844–1926. Washington, D.C.: National Gallery of Art. 119 p. Illus. 90 plates, 11 in color. Bibliography p. 119.

A major exhibition of Cassatt's work which heralded a positive reevaluation of her contribution to the history of American art.

Breuning, Margaret. MARY CASSATT. New York: Hyperion Press, distributed by Duell, Sloan and Pearce, 1944. 48 p. Illus., some in color. Bibliography p. 10.

A picture book meant to be an introduction to Cassatt's work for the layman. The reproductions are not very good by today's standards. Cassatt's birthdate is given as 1848.

*Bullard, E. John. MARY CASSATT: OILS AND PASTELS. New York: Watson Guptill, in cooperation with the National Gallery of Art, Washington, D.C., 1972. Bibliography p. 8. Index pp. 86–87.

Bullard helped to organize the large retrospective of Cassatt's work in 1970 (catalog, above). This book is an outgrowth, meant to be an introductory survey of her life and work. The reproductions are excellent; a pleasantly readable volume.

Sweet, Frederick. MARY CASSATT, 1844-1926. Chicago: International Galleries, 1965. Unpaged. Illus., some color plates. Bibliography at back of volume.

Sweet, curator of American painting and sculpture at the Art Institute of Chicago, organized this extensive exhibition. The catalog is brief, with little text, mostly documentation of the works shown. Notes by S.E. Johnson discuss the problems of dating her works.

_____. MISS MARY CASSATT: IMPRESSIONIST FROM PENNSYLVANIA. Norman: University of Oklahoma Press, 1966. 242 p. Illus., plates, 8 in color. Sources pp. 222-28. Index pp. 229-42.

A biography which draws extensively from Cassatt's letters. Gives much detailed information; discusses her relationship with Degas, but draws no conclusions. Lengthy bibliography.

(Also see: IND. 20TH C. ARTISTS. Vol. 2: pp. 1-8, 1a, 2a. Vol. 3: no. 11-12, p. 37; N.Y. MET. 19TH C.; A.A.A.)

\* \* \* \* \*

CATLIN, GEORGE 1796-1872

Catlin, George. EPISODES FROM LIFE AMONG THE INDIANS, AND LAST RAMBLES: WITH 152 SCENES AND PORTRAITS BY THE ARTIST. Norman: University of Oklahoma Press, 1959. Edited by Marvin C. Ross. 357 p. Illus., plates. Bibliography pp. 343-44.

Brief introduction describing Catlin's life and work. Most of the text is Catlin's own descriptive writing.

CATLIN'S NORTH AMERICAN INDIAN PORTFOLIO: HUNTING SCENES AND AMUSEMENTS OF THE ROCKY MOUNTAINS AND PRAIRIES OF AMERICA; FROM DRAWINGS AND NOTES BY THE AUTHOR, MADE DURING EIGHT YEARS' TRAVEL AMONGST FORTY-EIGHT OF THE WILDEST AND MOST REMOTE TRIBES OF SAVAGES IN NORTH AMERICA. London: George Catlin, Egyptian Hall, 1844.

A rare and valuable collection of colored lithographs after Catlin's paintings, in folio size.

Haberly, Lloyd. PURSUIT OF THE HORIZON: A LIFE OF GEORGE CATLIN, PAINTER AND RECORDER OF THE AMERICAN INDIAN. New York: Macmillan, 1948. 239 p. Illus., 17 plates.

Popularly written biography, the prose is slightly old-fashioned and flowery.

Halpin, Marjorie. CATLIN'S INDIAN GALLERY. Chicago: R.R. Donnelly, , 1965. Four colored plates, issued in portfolio.

> Brief text: "The George Catlin Paintings in the U.S. National Museum," and portfolio of reproductions.

McCracken, Harold. GEORGE CATLIN AND THE OLD FRONTIER. New York: Dial, 1959. 216 p. Illus., some color. Bibliography pp. 212-14.

> An attractive survey of Catlin's life and work, with many illustrations, emphasizing the importance of Catlin's documentation of American Indian life.

Roehm, Marjorie (Catlin), ed. THE LETTERS OF GEORGE CATLIN AND HIS FAMILY: A CHRONICLE OF THE AMERICAN WEST. Berkeley: University of California Press, 1966. 463 p. Illus., includes genealogical table. Bibliographic footnotes.

> Catlin was skilled in describing his travels in the American West with his pen as well as with a brush. These letters are fascinating, probably most valuable to historians and anthropology enthusiasts.

(Also see: N.Y. MET. 19TH C.)

*     *     *     *     *

CHASE, WILLIAM MERRITT  1849-1916

Roof, Katharine Metcalf. THE LIFE AND ART OF WILLIAM MERRITT CHASE ...WITH LETTERS, PERSONAL REMINISCENCES, AND ILLUSTRATIVE MATERIALS. New York: Scribners, 1917. 352 p. Illus., plates. Introduction by Alice Gerson Chase.

> A biography of Chase written just after his death, with the cooperation of and an introduction by his wife.

Story, Ala. THE FIRST WEST COAST RETROSPECTIVE EXHIBITION OF PAINTINGS BY WILLIAM MERRITT CHASE, 1849-1916. Santa Barbara: University of California, Santa Barbara, Art Gallery, 1964. 69 p. Illus., some in color. Includes bibliography.

> Major exhibition of work by this academic portrait painter. Includes "A Personal Recollection" by Ala Story.

(Also see: IND. 20TH C. ARTISTS. Vol. 2: pp. 17-27, 5a. Vol. 3: no. 11-12, p. 41. N.Y. MET. 19TH C.; A.A.A.)

*     *     *     *     *

CHURCH, FREDERIC EDWIN  1826-1900

Huntington, David C. FREDERIC EDWIN CHURCH. Washington, D.C.: National Collection of Fine Arts, Smithsonian Institution, 1966. 85 p. Illus.,

some in color.

Catalog of a major exhibition of Church's romantic landscape paintings, shown in Washington and also at the Albany Institute of History and Art, and Knoedler's, New York.

_____. THE LANDSCAPES OF FREDERIC EDWIN CHURCH: VISION OF AN AMERICAN ERA. New York: Braziller, 1966. 210 p. Illus., plates, 8 in color. Notes pp. 198-204. Index pp. 206-10.

The first monograph on Church and his landscape paintings. Church was a student of Thomas Cole, and is especially known for his Hudson Valley scenes. Church's home "Olana," designed by Calvert Vaux and which has recently been opened to the public, is also pictured and discussed.

(Also see: N.Y. MET. 19TH C.; A.A.A.)

\* \* \* \* \*

CLARKE, JOHN CLEM 1937-

Wilson, William S. "John Clem Clarke Transmits a Picture." ART NEWS, vol. 68, Summer 1969, p. 46. Illus.

Describes Clarke's unusual stencil technique, particularly as applied to producing paintings which are reproductions of familiar works by old masters.

\* \* \* \* \*

COLE, THOMAS 1801-1848

Merritt, Howard S. THOMAS COLE. Rochester, N.Y.: Memorial Art Gallery of the University of Rochester, 1969. 120 p. Illus., plates, some in color. Bibliography pp. 115-17.

An exhibition catalog of the romantic landscapes by Cole; exhibited also at Munson-Williams-Proctor Institute, Utica; Albany Institute of History and Art; and the Whitney Museum of American Art, New York.

Noble, Louis Legrand. THE LIFE AND WORKS OF THOMAS COLE. Cambridge: Harvard University Press, 1964. 333 p. Illus., plates. Notes pp. 313-24. Index pp. 329-33. Edited by Elliot S. Vesell.

Republication of a work written originally in 1853, with a new introduction by Elliot S. Vesell, and extensive notes. This remains a basic source.

Wallach, Alan. "Thomas Cole: British Esthetics and American Scenery." ARTFORUM, vol. 8, October 1969, pp. 46-49. Illus.

Article on Cole inspired by a major traveling exhibition of his

landscape and history paintings.

(Also see:  CROPSEY; N.Y. MET. 19TH C.; A.A.A.)

\*    \*    \*    \*    \*

COPLEY, JOHN SINGLETON  1738-1815

Copley, John Singleton.  LETTERS AND PAPERS OF JOHN SINGLETON COPLEY AND HENRY PELHAM, 1739-76.  New York: Kennedy Graphics and DaCapo Press, 1970.  Reprint of 1914 ed., published by Massachusetts Historical Society, Boston.  384 p.  Illus.

> Copley and Pelham were half-brothers; their extensive correspondence was discovered at the beginning of this century in the Public Record Office, London.  Apparently Copley and his half-brother fell under the suspicion of the American government during the Revolutionary War years; they were forced to turn over all personal papers, and this cache remained until its publication in 1914. A useful source for documentation and background of Copley's early career.

Flexner, James Thomas.  JOHN SINGLETON COPLEY.  Boston:  Houghton Mifflin, 1948.  139 p.  Illus., plates.  Bibliography pp. 117-23.

> Revised version of a biography published previously as a section in AMERICA'S OLD MASTERS (see above).  Very large type and exaggerated simplicity of language make it appropriate for young readers.

*Frankenstein, Alfred and the editors of Time-Life Books.  THE WORLD OF COPLEY: 1738-1815.  New York:  Time-Life Books, 1970.  192 p.  Illus., plates, many in color.  Bibliography p. 185.  Index p. 187.

> Meant for the educated generalist, rather than the art historian; an attractive and informative book.  Concentrates more on the political and social developments than do most art books.  Well-documented and authoritative, with handsome illustrations.

Prown, Jules David.  JOHN SINGLETON COPLEY: 1738-1815.  Washington: National Gallery of Art; New York:  Metropolitan Museum; and Boston: Museum of Fine Arts, distributed by October House, 1965.  Illus., 16 in color. Bibliography p. 134.

> Catalog of an important exhibition.  The essay by Prown is an excellent introduction to Copley's work.

_____ .  JOHN SINGLETON COPLEY, 2 vols.  Vol. 1:  IN AMERICA, 1738-1774.  Vol. 2:  IN ENGLAND, 1774-1815.  491 p.  Illus., plates, one in color.  Bibliographies:  (vol. 1) pp. 201-2, (vol. 2) pp. 463-72. Index:  (vol. 2) pp. 473-91.

> The most comprehensive and scholarly study of Copley's work to date.  Includes much biographical information.  Prown made use of a computer to analyse data about Copley and his sitters.

CROPSEY, JASPER FRANCIS  1823-1900

Bermingham, Peter.  JASPER F. CROPSEY, 1823-1900, A RETROSPECTIVE
VIEW OF AMERICA'S PAINTER OF AUTUMN: AN EXHIBITION OF OIL
PAINTINGS AND WATERCOLORS BY THE ARTIST ALONG WITH SELECTED
WORKS BY THOMAS COLE, DAVID JOHNSON AND GEORGE INNESS.
College Park:  University of Maryland Art Gallery, 1968.  65 p.  Illus.
Bibliography pp. 64-65.

> Scholarly exhibition catalog, with a preface by George Levitine
> and a foreword by William H. Gerdts.  Extensive documentation
> about the work of this landscape painter of the Hudson River
> School.  The reproductions are all black and white, and below
> average in quality.

Talbot, William S.  JASPER F. CROPSEY, 1823-1900.  Cleveland:  Museum of
Art, 1970.  114 p.  Illus., 4 color plates.  Bibliography pp. 111-12.  Index pp.
113-14.

> Traveling exhibition, also seen at Munson-Williams-Proctor Insti-
> tute, Utica, and the National Collection of Fine Arts, Washing-
> ton, D.C.  A substantial and excellent catalog.

(Also see:  N.Y. MET. 19TH C.)

\*     \*     \*     \*     \*

D'ARCANGELO, ALLAN  1930-

ALLAN D'ARCANGELO:  RECENT WORK.  New York:  Marlborough Gallery,
1971.  24 p.  Illus., some in color.

> No text, simply reproductions of D'Arcangelo's paintings, which
> are large geometric abstracts, repeating a chevron motif.

(Also see:  HUNTER, p. 458.)

\*     \*     \*     \*     \*

DAVIES, ARTHUR BOWEN  1862-1928

ARTHUR BOWEN DAVIES, 1862-1928:  A CENTENNIAL EXHIBITION.  Utica,
N.Y.:  Munson-Williams-Proctor Institute, 1962.  16 p.  Illus., plates.

> This catalog is primarily a collection of reproductions of the art-
> ist's work from 1887-1920's.  Includes a brief essay, "A Recol-
> lection of Arthur B. Davies," by Walter Pach.

CATALOGUE OF A MEMORIAL EXHIBITION OF THE WORKS OF ARTHUR B.
DAVIES.  New York:  Metropolitan Museum of Art, 1930.  36 p. plus 189 p.

> A major retrospective held just two years after Davies' death.
> There is an introduction by Bryson Burroughs; paintings are ar-
> ranged by approximate chronology.  (Davies did not date his work.)

Philips, Duncan et al. ARTHUR B. DAVIES: ESSAYS ON THE MAN AND HIS ART. Washington, D.C.: Philips Publications, no. 3, 1924. 78 p. Illus., plates, frontispiece in color.

> The first monograph on Davies, with contributions by six writers. Chiefly useful for the collection of reproductions, although they are undated.

(Also see: HUNTER, p. 458; A.A.A.)

\*   \*   \*   \*   \*

DAVIS, GENE  1920-

Davis, Gene. "Gene Davis on Gene Davis." ART IN AMERICA, vol. 61, no. 3, May-June 1973, pp. 36-41. Illus., color plates.

> An interview by Donald Wall about Davis' work. Includes a stunning reproduction of the road to the Philadelphia Museum of Art painted in stripes: "Franklin's Footpath," 1972.

GENE DAVIS: AN EXHIBITION. San Francisco: Museum of Art, and Washington, D.C.: Washington Gallery of Modern Art, 1968. 23 p. Illus., plates, some in color. Bibliography pp. 17-18.

> Includes an essay by Gerald Nordland: "If dripped paint was the most essential element of painters in the 1950's, solid colored bars or stripes have emerged as the most widely utilized convention of the abstract painters of the 1960's. There is strong evidence to support the position that Gene Davis was the first American painter to use hard-edge stripes...."

Rose, Barbara. "A Conversation with Gene Davis." ARTFORUM, vol. 10, March 1971, pp. 50-54. Illus.

> Davis answers questions about his painting and the Washington, D.C., art scene.

Wall, Donald. "The Micro-Paintings of Gene Davis." ARTFORUM, vol. 7, December 1968, pp. 46-50. Includes bibliographic notes.

> Discussion of a tongue-in-cheek exhibition of paintings approximately 1" x 1" each, designed as a reaction against over-large paintings. One caption describes a group of paintings as "Colonies of micro-painting...."

\*   \*   \*   \*   \*

DAVIS, RON  1937-

Elderfield, John. "New Paintings by Ron Davis." ARTFORUM, vol. 9, March 1971, pp. 32-34. Illus.

> Brief article on this young painter of geometric abstracts.

DAVIS, STUART 1894-1964

Blesh, Rudi. STUART DAVIS. New York: Grove Press, 1960. 64 p. Illus., 12 color plates.

>A brief introductory monograph meant to be an introduction to Davis' work. Much of the text is biographical.

Goosen, E.C. STUART DAVIS. New York: Braziller, 1959, 128 p. Illus., plates, some in color. Bibliography pp. 121-23.

>A survey of Davis' work, with examples as early as 1911. The text discusses the evolution of his style and his influences while providing biographical information.

*Kelder, Diane, ed. STUART DAVIS. New York: Praeger, 1971. 212 p. Illus., some color plates. Bibliography pp. 201-9. Index pp. 210-12.

>The text is composed largely of essays by Davis, selected and edited by Kelder. There is a brief section on "Writings and criticism about Stuart Davis"; a lengthy bibliography is included.

STUART DAVIS. New York: American Artists Group, 1945. Unpaged. Illus. (Monograph no. 6)

>Includes an autobiographical essay and a biographical note at the back of the volume. The poor illustrations are typical of this series of miniature books.

STUART DAVIS MEMORIAL EXHIBITION. Washington, D.C.: Smithsonian Institution, National Collection of Fine Arts, 1965. 98 p. Illus. Bibliography pp. 90-96.

>A substantial catalog of a major exhibition, held the year following Davis' death. Includes a lengthy essay on Davis and his work by H.H. Arnason.

Sweeney, James Johnson. STUART DAVIS. New York: Museum of Modern Art, 1945. 40 p. Illus., 3 color plates. Bibliography pp. 37-40.

>Brief monograph written to accompany a major exhibition of Davis' work held in 1945. Perceptive text stresses the importance of Davis' studies with Henri, the impact of the Armory Show (Davis had five watercolors in that historic show), Davis' participation in the W.P.A., and finally, his "Return to easel painting."

(Also see: HUNTER, p. 458; A.A.A.)

*     *     *     *     *

DEHN, ADOLF ARTHUR 1895-1968

Dehn, Adolf Arthur. WATERCOLOR, GOUACHE AND CASEIN PAINTING. New York: Studio, 1955. 116 p. Illus.

A "how to" book by this well-known artist. Includes reproductions of many of his own works, plus others by Aaron Bohrod, Doris Lee, Arnold Blanch and others. It remains a useful book on studio technique.

(Also see: IND. 20TH C. ARTISTS. Vol. 3: pp. 269-70, no. 11-12, pp. 83-84; A.A.A.)

\*     \*     \*     \*     \*

## DE KOONING, WILLEM 1904-

Bannard, Walter Darby. "Willem De Kooning's Retrospective at the Museum of Modern Art." ARTFORUM, vol. 7, April 1969, pp. 42-49. Illus., color plates.

> Lengthy review by a fellow artist. Bannard refers to De Kooning as an "old master," and discusses the development of his recent figural works.

Dali, Salvador. "De Kooning's 300,000,000th Birthday." ART NEWS, vol. 68, April 1969, p. 56. Illus.

> A madcap tribute to De Kooning by Dali, in which he declares that "Willem De Kooning is the greatest, the most gifted and the most authentic finial [sic] point of modern painting...."

Hess, Thomas B. DE KOONING: RECENT PAINTINGS. New York: Walker and Co., 1967. 63 p. Illus., with 8 color plates.

> Brief monograph by the (then) editor of ART NEWS. Most of the paintings discussed and reproduced here are from De Kooning's "Woman" series.

_____. WILLEM DE KOONING. New York: Braziller, 1959. 128 p. Illus., plates, some in color. Bibliography pp. 119-24. Indexes pp. 125-28.

> A brief, popular survey of De Kooning's work.

\*     _____. WILLEM DE KOONING. New York: Museum of Modern Art, 1968. 170 p. Illus., 16 color plates. Bibliography pp. 151-59. Index p. 167.

> This substantial monograph was written to accompany a major De Kooning exhibition at the Museum of Modern Art. Hess, who has written extensively on De Kooning, here provides a definitive work on the artist. The excellent bibliography is by Bernard Karpel.

Rosenberg, Harold. "Interview with Willem De Kooning." ART NEWS, vol. 71, September 1972, p. 54. Illus., color plate.

> Transcript of a lengthy interview in which De Kooning talks about the sources of his inspiration, his paintings, and his reactions to the work of other artists. (Rosenberg is currently preparing a monograph on De Kooning to be published by Abrams.)

(Also see: HUNTER, p. 458.)

\* \* \* \* \*

## DEMUTH, CHARLES 1883-1935

\*Farnham, Emily. CHARLES DEMUTH: BEHIND A LAUGHING MASK. Norman: University of Oklahoma Press, 1971. 238 p. Illus., plates, some in color. Bibliography pp. 212-20. Index pp. 221-38.

> A definitive biography of Demuth, with lots of social background and color. Title derives from Farnham's observation: "A charming aristocratic hedonist, a smiling witty man.... Behind his laughing mask, however, lived a man beset by cruel personal demons: he was lame, he was consumptive, he was diabetic, he was homosexual." His friends and associates included Eugene O'Neill, Steiglitz, the Stettheimer sisters, Gertrude Stein, Marsden Hartley, and other famous persons of the early twentieth century.

Gallatin, A.E., introduction. CHARLES DEMUTH. New York: Rudge, 1927. 10 p., plus plates, color frontispiece.

> An early, brief monograph written when Demuth was at the forefront of the modern movement. Rather muddy, undated black and white reproductions.

Ritchie, Andrew C. CHARLES DEMUTH. New York: Museum of Modern Art, 1950. 96 p. Illus., some color plates. Bibliography pp. 93-96, by Anne Bollman.

> Important scholarly exhibition catalog. Includes "A Tribute to the Artist" by Marcel Duchamp.

(Also see: HUNTER, p. 458; IND. 20TH C. ARTISTS. Vol 2: pp. 147-50, 25a. Vol. 3: no. 11-12, p. 63.)

\* \* \* \* \*

## DICKINSON, EDWIN 1891-

Goodrich, Lloyd. EDWIN DICKINSON. New York: Whitney Museum of American Art, 1965. 55 p. Illus., some color plates. Selected bibliography pp. 53-54.

> Written to accompany a major Dickinson exhibition held in 1965. The reproductions show his work from 1915 through the early 1960's. His style encompasses both abstraction and representation, and Goodrich's text is a satisfactory introduction to the artist's life and work.

(Also see: A.A.A.)

DIEBENKORN, RICHARD 1922–

Lanes, Jerrold. "Richard Diebenkorn: Cloudy Skies over Ocean Park." ART-FORUM, vol. 10, February 1972, pp. 61–63. Illus., color plate.

> Review of an exhibition at Marlborough Gallery, New York, of Diebenkorn's "Ocean Park" series of paintings; expresses disappointment in them.

RICHARD DIEBENKORN: THE OCEAN PARK SERIES. New York: Poindexter Gallery, 1969. Unpaged. Illus., some color plates.

> Very slim exhibition catalog, mostly pictures. One paragraph biography and list of exhibitions included.

RICHARD DIEBENKORN, THE OCEAN PARK SERIES: RECENT WORK. New York: Marlborough Galleries, 1971. 46 p. Illus., some color plates. Bibliography pp. 7–8.

> Exhibition catalog which includes an essay by Gerald Nordland and a lengthy bibliography.

<p align="center">*　*　*　*　*</p>

DILLER, BURGOYNE 1906–1965

Pincus-Whitten, Robert. "Minneapolis: Burgoyne Diller." ARTFORUM, vol. 10, February 1972, pp. 58–60. Illus., includes color plate.

> Brief review of a recent exhibition of work by Diller, an early American abstractionist who paints in the tradition of Mondrian.

(Also see: HUNTER, p. 458.)

<p align="center">*　*　*　*　*</p>

DINE, JAMES (JIM) 1935–

Gordon, John. JIM DINE. New York: published for the Whitney Museum of American Art by Praeger, 1970. Unpaged. Illus., some color plates. Bibliography at back of volume by Libby W. Seaberg.

> An intimate, whimsical portrait of Dine and his work. This includes a number of candid photos of Dine, his family and friends, as well as reproductions of his work.

NEW PAINTINGS, SCULPTURE AND DRAWING BY JIM DINE. New York: Sidney Janis, 1966. 24 p. Illus.

> A collection of black and white reproductions of Dine's lusty, strong works in the pop art style. No text.

(Also see: HUNTER, p. 458.)

DOVE, ARTHUR 1880-1946

Rylander, Dorothy. ARTHUR G. DOVE: THE YEARS OF COLLAGE; AN EX-
HIBITION OF THE COLLAGES OF ARTHUR DOVE TOGETHER WITH A SELECT-
ED GROUP OF HIS PAINTINGS; COLLAGES BY JOSEPH STELLA (AND OTH-
ERS)... College Park: University of Maryland, 1967. 51 p. Illus.

> Exhibition catalog which features Dove's collages, and contrasts
> them with his paintings, and collages by other contemporary art-
> ists, as well as some anonymous Victorian constructions.

Solomon, Alan. ARTHUR G. DOVE, 1880-1946: A RETROSPECTIVE EXHIBI-
TION. Ithaca: Cornell University, Andrew Dickson White Museum of Art,
1954. 40 p. Illus. Bibliography pp. 37-40, by Hannah Muller Applebaum.

> Dove was a Cornell graduate; his alma mater held this major ex-
> hibition eight years after his death. Two early landscapes are in-
> cluded, but most of the paintings shown are the more familiar ab-
> stractions.

Wight, Frederick S. ARTHUR G. DOVE. Berkeley: University of California
Press, 1958. Illus., some color. Bibliography pp. 91-92.

> Scholarly exhibition catalog, with a wealth of documentation.
> Duncan Philips, in the foreword, states: "Arthur G. Dove de-
> serves to be ranked with the dissimilar Kandinsky among the ear-
> liest abstract expressionists."

(Also see: HUNTER, p. 459; IND. 20TH C. ARTISTS. Vol. 3: pp. 219-20,
no. 11-12, p. 75.)

\*    \*    \*    \*    \*

DOW, ARTHUR WESLEY 1857-1922

Cox, George J. "The Horizon of A.W. Dow." INTERNATIONAL STUDIO,
June 1923, pp. 186-93. Illus., color plates.

> Lengthy article on this influential painter, who was for decades
> a teacher in various New York art schools; written just after his
> death.

Dow, Arthur W. COMPOSITION: A SERIES OF EXERCISES IN ART STRUC-
TURE FOR THE USE OF STUDENTS AND TEACHERS. New York: Baker and
Taylor, 1899--. 56 p. 9th ed: Doubleday, 1922. 128 p. Illus.

> Dow's textbook on composition was an early best-seller, and went
> through a remarkable nine editions over nearly a quarter of a cen-
> tury. His decorative, highly artificial designs show the influence
> of Oriental design, and we can see how his perception helped to
> shape the taste for art nouveau, and later, art deco.

DUBOIS, GUY PENE 1884-1958

Cortissoz, Royal. GUY PENE DUBOIS. New York: Whitney Museum of American Art, 1931. 56 p. Illus., plates. Bibliography pp. 12-15.

    A compilation of reproductions, described by Cortissoz as "thoughtful realism," with only the briefest text.

(Also see: IND. OF 20TH C. ARTISTS. Vol. 2: pp. 28-32, 6a. Vol. 3: no. 11-12, p. 42.)

\*    \*    \*    \*    \*

DUCHAMP, MARCEL 1887-1968

Cabanne, Pierre. DIALOGUES WITH MARCEL DUCHAMP. New York: Viking, 1971. Translated from the French. 136 p. Illus. Bibliography pp. 121-32, by Bernard Karpel.

    Interviews which took place largely in 1966; quite candid - full of opinions, provocative remarks and reminiscences. Lengthy bibliography.

Lebel, Robert. MARCEL DUCHAMP. New York: Grove Press, 1959. Translated from the French. 192 p. Illus., some color plates. Bibliography pp. 177-88.

    A useful monograph, this concentrates more on his painting than do many of the other books. Describes the scandalized reaction in the United States to his early work, particularly the "Nude Descending a Staircase," which shocked and outraged the general public.

Paz, Octavio. MARCEL DUCHAMP OR THE CASTLE OF PURITY. London: Cape Goliard Press, 1970. Translated from the Spanish. 50 p. Illus., some color plates.

    A leisurely discussion of Duchamp's major works. Compares Duchamp's unorthodox philosophy to other historical aesthetics, including Hindu.

Schwarz, Arturo. THE COMPLETE WORKS OF MARCEL DUCHAMP. New York: Abrams, 1969. 630 p. Illus., 75 color plates. Bibliographies pp. 583-617. Index pp. 619-30. Companion volume: NOTES AND PROJECTS FOR THE LARGE GLASS. New York: Abrams, 1969. 217 p.

    THE COMPLETE WORKS... is a major study, published shortly after the artist's death. Includes one of his famous chess games. NOTES AND PROJECTS... is a compilation of highly personal jottings, poems, musical compositions and elaborate diagrams, in French and English, in facsimile of Duchamp's notes.

\*Tomkins, Calvin. THE WORLD OF MARCEL DUCHAMP. New York: Time-Life, 1966. 192 p. Illus., many color plates. Bibliography pp. 185-86.

Index pp. 187-91.

A very good introduction to Duchamp's work, and his Dada and surrealist background. Helps to convey an understanding of the impact of the Armory Show in New York in 1913, and prior to that, of important cultural events in Europe. Includes a rather down-to-earth description of the activities of the Dadas--some hilarious pranks are described.

\*   \*   \*   \*   \*

DUNCANSON, ROBERT S.   1821-1872

ROBERT S. DUNCANSON: CENTENNIAL EXHIBITION. Cincinnati: Cincinnati Art Museum, 1972.   42 p. Illus., some color. Bibliography pp. 16-17.

A Cincinnati artist who worked in the Hudson River tradition painting landscapes, Duncanson is one of the earliest known important Black artists in this country. This is a brief but well-documented catalog.

\*   \*   \*   \*   \*

DUNLAP, WILLIAM   1766-1839

Dunlap, William. DIARY, 3 vols. New York: New York Historical Society, 1931. Illus., plates.

An artist himself, and author of A HISTORY OF THE RISE AND PROGRESS OF THE ARTS OF DESIGN IN THE UNITED STATES... (See Chapter 7). This gives a detailed picture of life in the early days of the Republic. Little about art, mostly notes about his business and activities.

WILLIAM DUNLAP, PAINTER AND CRITIC: REFLECTIONS ON AMERICAN PAINTING OF A CENTURY AGO. Andover: Phillips Academy, Addison Gallery of American Art, 1939. 46 p. Illus. Bibliography p. 46.

Exhibition catalog of Dunlap's portraits. Brief text details his versatile career.

\*   \*   \*   \*   \*

DURAND, ASHER BROWN   1796-1886

Durand, John. THE LIFE AND TIMES OF A.B. DURAND. New York: Scribner, 1894. Reprint: New York: Kennedy Graphics, 1970. 232 p. Illus. Index pp. 227-32.

Anecdotal biography of Durand, an important nineteenth-century portraitist and landscape artist, written by his son.

(Also see: N.Y. MET. 19TH C.; A.A.A.)

DURRIE, GEORGE HENRY 1820-1863

Cowdrey, Bartlett. GEORGE HENRY DURRIE, 1860-1863: CONNECTICUT PAINTER OF AMERICAN LIFE. Hartford, Conn.: Wadsworth Atheneum, 1947. 50 p. Illus. Includes bibliography.

> Several of Durrie's paintings served as models for Currier and Ives lithographs. This is a catalog of a major exhibition of this nineteenth-century landscape artist's paintings.

\*     \*     \*     \*     \*

DUVENECK, FRANK 1848-1918

Ashbery, John. "The Indian Summer of Frank Duveneck." ART NEWS, vol. 71, April 1972, p. 27. Illus., color plates.

> An article inspired by an exhibition held at Chapellier Gallery, New York, Ashbery calls Duveneck "An exponent of nineteenth century realism."

(Also see: N.Y. MET. 19TH C.)

\*     \*     \*     \*     \*

EAKINS, THOMAS COWPERTHWAIT 1844-1916

Goodrich, Lloyd. THOMAS EAKINS: HIS LIFE AND WORK. New York: Whitney Museum of American Art, 1933. Reprint: AMS Press, 1970. 225 p., plus 72 plates.

> The first major monograph on Eakins, this remains an important work.

_____. THOMAS EAKINS: RETROSPECTIVE EXHIBITION. New York: Whitney Museum of American Art, 1970. 72 p. Illus., some in color.

> Catalog of a major exhibition of Eakins' work, Goodrich's text provides an informative introduction to the artist's life and work.

\*Hoopes, Donelson F. EAKINS WATERCOLORS. New York: Watson Guptill, 1971. 87 p. Illus., 32 color plates. Bibliography p. 9. Index pp. 86-87.

> Eakins' paintings in oil are probably better known, but this excellent study of his watercolors shows their importance. A brief biographical sketch is included in the introduction, but the fine color plates with accompanying comments are the raison d'etre of this monograph.

McCaughey, Patrick. "Thomas Eakins and the Power of Seeing." ARTFORUM, vol. 9, December 1970, pp. 56-61. Illus., color.

> Lengthy article about Eakins' style, particularly as evidenced in his portraits.

Porter, Fairfield. THOMAS EAKINS. New York: Braziller, 1959. 127 p.

Illus., plates, some in color.  Bibliography pp. 121-22.  Index pp. 125-27.

> A slim introductory volume, with a sketch of the artist's life and an overview of his work, including the photography.  The reproductions are all a bit murky.

*Schendler, Sylvan.  EAKINS.  Boston: Little Brown, 1967.  300 p.  Illus. Index pp. 297-300.

> A biography written for the layman which includes numerous black and white reproductions of Eakins works.

See: RYDER.

(Also see: IND. 20TH C. ARTISTS.  Vol. 1: pp. 49-59, 15a.  Vol. 3: no. 11-12, p. 15; N.Y. MET. 19TH C.; A.A.A.)

<center>*    *    *    *    *</center>

EARL, RALPH  1751-1801

Goodrich, Laurence.  RALPH EARL: RECORDER FOR AN ERA.  Oneonta: The State University of New York, 1967.  96 p.  Illus., 1 color plate.  Notes pp. 95-96.

> Written as an introduction to the work of the eighteenth-century portrait and landscape artist, Ralph Earl.  Includes biographical and stylistic information.

Sawitzky, William.  RALPH EARL, 1751-1801.  New York: Whitney Museum of American Art, 1945.  46 p.  Illus.

> Catalog of an exhibition also held at the Worcester Art Museum, Worcester, Massachusetts.  Brief text details what is known of this early American artist.

<center>*    *    *    *    *</center>

EILSHEMIUS, LOUIS MICHEL  1864-1941

Karstrom, Paul.  THE ROMANTICISM OF EILSHEMIUS.  New York: Dannenberg Galleries, 1973.  20 p.  Illus.

> Brief exhibition catalog of the work of this artist who cultivated a "primitive" style, concentrated on landscapes and rather eccentric nudes.

Schack, William.  ...AND HE SAT AMONG THE ASHES.  New York: American Artists Group, 1939.  303 p.  Index pp. 295-303.

> Biography of Eilshemius, an artist born in New Jersey who spent a significant amount of time in France; written for the layman.

(Also see: A.A.A.)

<center>90</center>

## EVERGOOD, PHILIP 1901-1973

Baur, John I.H. PHILIP EVERGOOD. New York: Whitney Museum of American Art, 1960. 125 p. Illus., some in color. Bibliography pp. 122-23. Index pp. 124-25.

> Substantial exhibition catalog; a good survey of Evergood's work prior to 1960. The reproductions are muddy.

Larkin, Oliver. 20 YEARS: EVERGOOD. New York: A.C.A. Gallery. Bibliography pp. 103-8.

> Published in conjunction with a large exhibition. The essay by Larkin is titled "The Humanist Realism of Philip Evergood" and stresses social awareness. There is a statement by the artist included (pp. 25-27).

(Also see: HUNTER, p. 459.)

\* \* \* \* \*

## FEELEY, PAUL 1910-1966

Baro, Gene, introduction. PAUL FEELEY (1910-1966). New York: Solomon R. Guggenheim Museum, 1968. 73 p. Illus., some color plates.

> A large memorial exhibition, held two years after Feeley's death. Feeley's mature work, elegant abstractions, were the focus of the exhibition; most of the canvases dated from the mid-fifties through the mid-sixties.

(Also see: A.A.A.)

\* \* \* \* \*

## FEININGER, LYONEL 1871-1956

Feininger, T. Lux. LYONEL FEININGER: CITY AT THE EDGE OF THE WORLD. Photographs by Andreas Feininger. New York: Praeger, 1965. 124 p. Illus., some color plates.

> A charming little book produced by two of Lyonel Feininger's sons--Lux, an artist and educator, and Andreas, the well-known photographer. The subject here is a group of toys produced by Lyonel for his children, and the imaginative world created by a talented father for his sons. Observations are also made about Lyonel's life and work.

Hess, Hans. LYONEL FEININGER. New York: Abrams, 1961. 355 p. Illus., 30 in color. Bibliography pp. 319-40. Index pp. 352-55.

> The most substantial monograph on Feininger to date. He was born in the United States to German parents, and in his teens the family returned to Germany. Feininger remained there until

1937, when he returned to the United States. This book details his career, including his Bauhaus experiences. A lengthy bibliography is included.

LYONEL FEININGER. New York: Marlborough-Gerson, 1969. 120 p. Illus., many color plates.

A substantial catalog of an exhibition held by the gallery which is managing his estate. Includes an essay "The Precision of Fantasy" by Peter Selz, and a collection of handsome plates.

Miller, Dorothy, ed. LYONEL FEININGER-MARSDEN HARTLEY. New York: Museum of Modern Art, 1944. Reprint: Arno Press, 1966. Bibliographies: Feininger pp. 51-52, Hartley pp. 95-96, both by Hannah B. Muller.

Catalog of dual exhibitions held at the Museum of Modern Art of works by two (then) leading abstract artists. The documentation is important, and the bibliographies are extensive.

Scheyer, Ernst. LYONEL FEININGER: CARICATURE AND FANTASY. Detroit: Wayne State University, 1964. 196 p. Illus., some color plates. Bibliography pp. 189-91.

A monograph which surveys Feininger's contributions to the fields of cartooning and illustration, rather than painting. Includes a good biography, and substantial background material.

(Also see: A.A.A.)

\*　　\*　　\*　　\*　　\*

FEKE, ROBERT 1705?-1750?

Foote, Henry Wilder. ROBERT FEKE: COLONIAL PORTRAIT PAINTER. Cambridge: Harvard University Press, 1930. Reprint: Kennedy Galleries and DaCapo Press, 1969. 223 p. Illus. Index pp. 217-23.

The basic, scholarly monograph on Feke. Not a great deal is known about this artist, who was one of America's earliest portrait painters.

Goodrich, Lloyd. ROBERT FEKE. New York: Whitney Museum of American Art, 1946. 34 p. Illus.

Catalog of an exhibition also shown at the Heckscher Art Museum in Huntington, Long Island, and the Boston Museum of Fine Arts. Thirty portraits were shown and documented. In his brief text, Goodrich acknowledges the Foote book (above) as the basic source.

\*　　\*　　\*　　\*　　\*

FRANCIS, SAM 1923-

Alloway, Lawrence. "Sam Francis: From Field to Arabesque." ARTFORUM, vol. 11, February 1973, pp. 37-41. Illus., color plates. Bibliographical notes.

> An article discussing Francis' relationship to the abstract expressionist movement and color field painting. Written upon the occasion of the exhibition at the Albright-Knox Art Gallery (catalog, below).

Belz, Carl. "Fitting Sam Francis into History." ART IN AMERICA, vol. 61, January-February 1973, pp. 40-45. Illus., color plates.

> A lengthy discussion of Francis' stylistic development and his relationship to the abstract expressionists and other major artists of the past 20 years.

Plagens, Peter. "A Sam Francis Retrospective in Houston." ARTFORUM, vol. 6, January 1968, pp. 38-46.

> Francis "has been, all along, five years ahead of his time" is Plagens conclusion in this article inspired by a large exhibition in Houston.

Ratcliff, Carter. "Sam Francis; Universal Painter." ART NEWS, vol. 71, December 1972, pp. 56-59. Illus., color plate.

> Ratcliff states that Francis "has come close to the source of the light that has obsessed him from the beginning," as seen in the exhibition at the Albright-Knox (catalog, below).

SAM FRANCIS. Amsterdam: Stedelijk Museum, 1968. 38 p. Illus. In Dutch and English. Bibliography p. 36.

> Exhibition catalog with essays by E. de Wilde and Wieland Schmied. Francis' paintings had been more seriously received in Europe than in America until recently.

SAM FRANCIS; PAINTINGS, 1947-1972. Buffalo: Albright-Knox Art Gallery, 1972. 152 p. Illus., several color plates. Bibliography pp. 140-41.

> A handsome and substantial exhibition catalog of a major show of Francis' brilliantly colored lyrical abstractions. Extensive documentation and a biographical sketch of the artist included in essays by Wieland Schmied and Franz Meyer. Exhibition was organized by Robert T. Buck and will travel to Washington's Corcoran Gallery, The Whitney Museum of American Art, New York, and the Dallas Museum of Fine Arts.

Sweeney, James Johnson. SAM FRANCIS. Houston Museum of Fine Arts, 1967. 53 p. Illus.

> An informative though brief exhibition catalog. Unfortunately, no color reproductions included.

(Also see: HUNTER, p. 459.)

FRANKENTHALER, HELEN  1928-

Alloway, Lawrence.  "Frankenthaler as Pastoral."  ART NEWS, vol. 70, November 1971.  p. 67.  Illus., color plate.

> Discussion of Frankenthaler's painting, occasioned by an exhibition at Emmerich Gallery, New York.

Goosen, E.C.  HELEN FRANKENTHALER.  New York:  Whitney Museum of American Art, 1969.  72 p.  Illus., some color plates.  Bibliography pp. 68-72.

> Catalog of a major exhibition of Frankenthaler's large, lyrical abstractions.  Includes lengthy bibliography.

*Rose, Barbara.  FRANKENTHALER.  New York:  Abrams, 197?  272 p.  Illus., 54 color plates.  Bibliography pp. 265-72.

> An important monograph by critic Rose.  Includes lengthy essay on Frankenthaler, substantial documentation, and handsome reproductions of the artist's abstract works.  Many photographs of the artist and her surroundings are included, and there is a fine bibliography.

_____ .  "Painting within the Tradition:  The Career of Helen Frankenthaler."  ARTFORUM, vol. 7, April 1969, pp. 28-33.  Illus.  Bibliographical notes.

> Article on Frankenthaler's development as a painter, occasioned by the exhibition held at the Whitney Museum (catalog above).

(Also see:  HUNTER, p. 459.)

\*     \*     \*     \*     \*

GATCH, LEE  1902-1968

Rathbone, Perry T.  LEE GATCH.  New York:  American Federation of Arts, 1960.  28 p.  Illus., some color plates.  Bibliography pp. 22-24.

> Monograph written to accompany a major retrospective exhibition of Gatch's abstract paintings.  The brief essay is by Rathbone, who was then the director of the Museum of Fine Arts, Boston.

(Also see:  A.A.A.)

\*     \*     \*     \*     \*

GIFFORD, SANFORD ROBINSON  1823-1880

Weiss, Ila Joyce Solomon.  SANFORD ROBINSON GIFFORD, 1823-1880.  New York:  Columbia University PhD. thesis, 1968.  Mounted photographs included.

> Lengthy scholarly study, to date unpublished, on the paintings by this nineteenth-century academic landscape painter.

(Also see: N.Y. MET. 19TH C.; A.A.A.)

\* \* \* \* \*

GIKOW, RUTH 1915-

Josephson, Matthew, introduction. RUTH GIKOW. New York: Maecenas Press, Random House, 1970. 32 p., plus 131 plates, 24 in color.

Largely a picture book, with a brief biographical sketch of Gikow's career. The paintings reproduced are mainly figural works in a rather slick, slightly abstract, illustrative style.

(Also see: A.A.A.)

\* \* \* \* \*

GLACKENS, WILLIAM 1870-1938

Du Bois, Guy Pene. WILLIAM GLACKENS. New York: Whitney Museum of American Art, 1931. 56 p. Illus. Bibliography pp. 15-16.

Brief tribute written by a fellow artist. This is a slim monograph meant to be an introduction to the work of Glackens, one of "The Eight," or the group more popularly known as "The Ash Can Group."

Glackens, Ira. WILLIAM GLACKENS AND THE ASHCAN GROUP: THE EMERGENCE OF REALISM IN AMERICAN ART. New York: Crown, 1957. 267 p. Illus., some color plates. Index pp. 263-67.

A biography of Glackens, and his association with "The Eight," written by his son. Intimate, written for the layman, this includes numerous letters and reproductions of Glackens' work.

Watson, Forbes. WILLIAM GLACKENS. New York: Duffield 1923. 23 p. Illus.

Brief tribute written at the height of Glackens' career. The reproductions are undated and blurred.

WILLIAM GLACKENS IN RETROSPECT. St. Louis: City Art Museum, 1966. Unpaged. Illus., 3 color plates.

A good pictorial survey of Glackens' works included in this catalog of a major exhibition, which was also shown at the National Collection of Fine Arts and the Whitney Museum of American Art. Includes a foreword by Charles E. Buckley and an essay "The Pertinence of William Glackens" by Leslie Katz.

(Also see: IND. 20TH C. ARTISTS. Vol. 2: pp. 61-64, 12a. Vol. 3: no. 11-12, p. 48.)

GOLUB, LEON 1922-

Elsen, Albert. LEON GOLUB: PAINTINGS FROM SIX YEARS. New York: Allan Frumkin Gallery, 1963. 16 p. Illus.

Limited catalog of an exhibition of figural works, here reproduced in brown and white.

LEON GOLUB: COLOSSI. London: Hanover Gallery, 1962. Unpaged. Illus.

Catalog of an exhibition of large figural paintings, with an introduction by Lawrence Alloway.

(Also see: A.A.A.)

\* \* \* \* \*

GOODNOUGH, ROBERT 1917-

ROBERT GOODNOUGH: NEW WORK. New York: Tibor de Nagy Gallery, 1960. Unpaged. Illus.

Exhibition catalog with no text, simply reproductions of the artist's work and a photograph of Goodnough.

\* \* \* \* \*

GORKY, ARSHILE 1905-1948

*Levy, Julien. ARSHILE GORKY. New York: Abrams, 1966? 235 p. Illus., 40 color plates. Bibliography pp. 234-35.

The major book on Gorky, who was born Vosdanig Manoog Adoian, in Turkish Armenia, and emigrated to America in 1920 at age 15. His career reached its peak in the 1940's but was abruptly stilled by his tragic suicide in 1948. His painting found new popularity in the late 1960's. Extensive bibliography and numerous good reproductions included.

Rosenberg, Harold. ARSHILE GORKY: THE MAN, THE TIME, THE IDEA. New York: Grove Press, 1962. 144 p. Bibliography pp. 138-43.

A biography of Gorky, written for the non-specialist. Intelligently discusses Gorky's work in relation to the important artists and movements of the 1930's and 1940's.

Schwabacher, Ethel. ARSHILE GORKY. New York: published for the Whitney Museum of American Art by Macmillan, 1957. 159 p. Illus., some color plates. Bibliography pp. 153-55. Index pp. 157-59.

Schwabacher was a pupil of Gorky's and later a close friend. Her text is biographical and largely anecdotal. This monograph includes a preface by Lloyd Goodrich and an introduction by Meyer Schapiro.

Seitz, William C. ARSHILE GORKY: PAINTINGS, DRAWINGS, STUDIES. New York: Museum of Modern Art in collaboration with the Washington Gallery of Modern Art, distributed by Doubleday, 1962. 56 p. Illus. Bibliography p. 52. Reprint: Arno, 197?

> Well-documented exhibition catalog of a major Gorky show held in New York and Washington, D.C. Foreword is by Julien Levy who recalls having told Gorky: "Your work is so very much like Picasso's . . . not imitating but all the same, too Picassoid" (p. 7). Bibliography by Bernard Karpel.

(Also see: HUNTER, p. 460.)

\* \* \* \* \*

GOTTLIEB, ADOLPH 1903-1974

ADOLPH GOTTLIEB: MARZO, 1970. Rome: Marlborough Galleries, 1970. Unpaged. Illus., color plates.

> A slim collection of attractive plates reproducing Gottleib's recent works. No text except a biographical outline and a list of exhibitions at the back.

ADOLPH GOTTLIEB: PAINTINGS, 1959-71. London: Marlborough, 1971. 66 p. Illus., many color plates.

> A handsome collection of color plates, issued by Gottlieb's dealer. Includes a brief introduction by Harold Rosenberg.

Cone, Jane Harrison. "Adolph Gottlieb." ARTFORUM, April 1968, pp. 36-39. Illus., color plates.

> Review of a major exhibition which was held at the Whitney Museum of American Art (catalog, below) and the Guggenheim Museum simultaneously.

Doty, Robert and Waldman, Diane. ADOLPH GOTTLIEB. New York: Praeger, for the Whitney Museum of American Art and the Solomon R. Guggenheim Museum, 1968. 121 p. Illus., 19 color plates. Bibliography pp. 116-21, by Patricia FitzGerald Mandel.

> Brief text, but an extensive collection of good reproductions accompanied by scholarly documentation and a lengthy bibliography.

Friedman, Martin. ADOLPH GOTTLIEB: AN EXHIBITION ORGANIZED BY THE WALKER ART CENTER . . . AND SHOWN IN THE AMERICAN SECTION OF THE VII BIENAL DE SAO PAULO...1963. Minneapolis: Walker Art Center, 1963. Unpaged. Illus. Bibliography included.

> Catalog of paintings from 1950-62, there is little text, mostly stylistic analysis. Friedman refers to Gottlieb as "a leading progenitor of recent New York Painting."

Waldman, Diane. "Gottlieb: Signs and Suns." ART NEWS, vol. 66, February 1968, p. 26. Illus., includes color plates.

> Review of the 1968 exhibition held jointly by the Whitney and Guggenheim Museums, New York (catalog, above).

(Also see: HUNTER, p. 460; A.A.A.)

\*     \*     \*     \*     \*

## GRAHAM, JOHN D. 1881-1961

Graham, John D. SYSTEM AND DIALECTICS OF ART. New York: Delphic Studios, 1937. Reprint: Johns Hopkins Press, 1971. 213 p. Illus. Bibliography pp. 203-7. Index pp. 209-13.

> A compilation of Graham's art theories, which attempt to answer straightforwardly such questions as, What is art? A section "Names and words misspelled or mispronounced in English" is omitted in the reprint. The reprint includes a lengthy footnoted introduction by Marcia Epstein Allentuck and a foreword on Graham by Dorothy Dehner, plus a substantial bibliography. The question and answer format of Graham's text was meant to be in the Socratic tradition.

JOHN D. GRAHAM, 1881-1961. New York: Andre Emmerich Gallery, 1966. 12 p. Illus.

> A slim exhibition catalog, consisting mostly of reproductions of Graham's paintings from the 1940's and 1950's. Brief introduction by Everett Elsen outlines what is known of Graham's life and work.

Sandler, Irving. "John D. Graham: The Painter as Esthetician and Connoisseur." ARTFORUM, vol. 7, October 1968, pp. 50-53. Illus. Bibliographic notes.

> An informative article on Graham's life and work, occasioned by an exhibition held at the Museum of Modern Art, New York.

\*     \*     \*     \*     \*

## GRAVES, MORRIS 1910-

Wight, Frederick S. MORRIS GRAVES. Berkeley and Los Angeles: University of California Press, 1956. 64 p. Illus., some color plates. Bibliography pp. 61-62.

> A brief introductory monograph on Graves, with essays by Wight, John I.H. Baur, and Duncan Philips. Reproductions are only fair, and those in color are poor.

(Also see: HUNTER, p. 458.)

\*     \*     \*     \*     \*

## GREENE, BALCOMB 1904-

Baur, John I.H. BALCOMB GREENE. New York: American Federation of Arts, 1961. 28 p. Illus., some in color. Bibliography pp. 12-20.

"In the days of American scene painting he was an abstractionist, at the height of the abstract tide, he has been a figurative painter," begins Baur in his brief essay in this exhibition catalog. The reproductions are all quite small, and in black and white. The bibliography, however, is helpful.

\* \* \* \* \*

GROPPER, WILLIAM 1897-

Freundlich, August L. WILLIAM GROPPER: RETROSPECTIVE. Los Angeles: Ward Ritchie Press in conjunction with the Joe and Emily Lowe Art Gallery of the University of Miami, 1968. 128 p. Illus., some color. Bibliography p. 33.

Gropper was a cartoonist early in his career, and his work has long been known for its social commentary. In the 1930's he participated in federal art projects and since has sustained a long career as a painter. This is the most extensive monograph on Gropper, but the text is written in a rather simplistic, journalistic style.

\* \* \* \* \*

GROSZ, GEORGE 1893-1959

Baur, John I.H. GEORGE GROSZ. New York: published for the Whitney Museum of American Art by Macmillan, 1954. 67 p. Illus. Bibliography pp. 65-67. Research by Rosalind Irvine.

A biography and survey of this German-American's work, written in conjunction with a major retrospective exhibition. All of the reproductions are in black and white.

GROSZ, GEORGE. A LITTLE YES AND A BIG NO: THE AUTOBIOGRAPHY OF GEORGE GROSZ. New York: Dial, 1946. 343 p. Illus., plates, some in color. Translation from the German.

Grosz's narration of his early life in Germany, his involvement in art and politics, and his decision to come to the United States.

\* \* \* \* \*

GUSTON, PHILIP 1913-

Ashton, Dore. PHILIP GUSTON. New York: Grove Press, 1960. 63 p. Illus., 12 color plates.

A small monograph, meant to be an inexpensive introduction to the work of a recognized young abstract expressionist.

Berkson, Bill. "The New Gustons." ART NEWS, vol. 69, October 1970, p. 44. Illus., color plates.

A review of figurative works shown at the Marlborough Gallery,
New York (catalog, below).

PHILIP GUSTON. New York: Marlborough Gallery, 1970. 44 p. Illus.,
some color plates. Bibliography p. 8.

Exhibition catalog produced by Guston's dealer, showing works
from 1969 to 1970. These are a series of Ku Klux Klan-like
hooded figures, crudely drawn and yet rather enigmatic.

PHILIP GUSTON. New York: Solomon R. Guggenheim Museum, 1962. 125 p.
Illus. Bibliography pp. 120-25.

Includes an essay on Guston's work by H.H. Arnason. The works
included in this exhibition were figurative paintings from the 1940's
and abstract expressionist canvases from the 1950's and early 1960's.

(Also see: HUNTER, p. 460.)

\* \* \* \* \*

HARDING, CHESTER  1792-1866

White, Margaret E. A SKETCH OF CHESTER HARDING, ARTIST, DRAWN BY
HIS OWN HAND: NEW EDITION WITH ANNOTATIONS BY HIS GRANDSON,
W.P.G. HARDING. Boston: Houghton Mifflin: 1929. (Original ed.,
Houghton Mifflin, 1890.) 264 p. Illus.

Diary of a nineteenth-century portrait painter, describing his daily
life and travels. Narrative continuity is supplied by his daughter,
and some of his portraits are reproduced.

(Also see: N.Y. MET. 19TH C.)

\* \* \* \* \*

HARNETT, WILLIAM MICHAEL  1848-1892

See: Frankenstein, Alfred. AFTER THE HUNT...

(Also see: N.Y. MET. 19TH C.)

\* \* \* \* \*

HART, GEORGE OVERBURY  1868-1933

Cahill, Holger. GEORGE O. "POP" HART: TWENTY-FOUR SELECTIONS
FROM HIS WORK. New York: Downtown Gallery, 1928. 25 p. Illus.

A brief introduction to Hart's work, presenting him as a charming
naïve painter. The text consists mostly of quotations from Hart,
simple cheerful pronouncements. Black and white reproductions
from 1903 to 1925 works reveal a variety of sophisticated influences.

(Also See: IND. 20TH C. ARTISTS. Vol. 3: pp. 209-11, no. 11-12, pp. 73-74.)

\* \* \* \* \*

HARTLEY, MARSDEN 1877-1943

Plagens, Peter. "Marsden Hartley Revisited: Or Were We Ever Really There." ARTFORUM, vol. 7, May 1969, pp. 40-43. Illus. Biographical notes.

Re-evaluation of Hartley's work upon the occasion of a major exhibition at the University of Texas, Austin.

McCausland, Elizabeth. MARSDEN HARTLEY. Minneapolis: University of Minnesota Press, 1952. 80 p. Illus. Bibliography pp. 76-80.

A slim but important monograph on Hartley. Biographical text tells us that Hartley exhibited at Stieglitz's "291" Gallery, in New York, and was one of the first Americans to absorb the European influences at the beginning of this century. His work was more truly international in style than other artists of his generation. This book contains a lengthy bibliography.

MARSDEN HARTLEY: A RETROSPECTIVE EXHIBITION. New York: Dannenberg Galleries, 1969. 32 p. Illus.

A collection of black and white reproductions of paintings exhibited in 1969, with only the briefest essay by Frederick S. Wight, and "Art and the Personal Life" by Hartley.

See: FEININGER, LYONEL.

(Also see: IND. 20TH C. ARTISTS. Vol. 3: pp. 221-23, no. 11-12, p. 75.; HUNTER, p. 460.; A.A.A.)

\* \* \* \* \*

HASSAM, CHILDE 1859-1935

Adams, Adeline V.P. CHILDE HASSAM. New York: American Academy of Arts and Letters, 1938. 144 p. Illus., 1 in color. Index pp. 139-43.

A biography written as a tribute to the artist shortly after his death. Several of his paintings are reproduced with dates, but sizes and locations are not given.

Hassam, Childe. THREE CITIES. New York: Russell, 1899. Unpaged. Illus.

A folio-size collection of Hassam's paintings and drawings of New York, Paris, and London. No text.

Pousette-Dart, Nathaniel. CHILDE HASSAM. New York: Frederick A. Stokes, 1922. 69 p. Illus.

Hassam is considered by many critics to be one of America's few impressionist painters. This is a small picture book, with undated reproductions of his paintings and a brief tribute written by Ernest Haskell.

Steadman, William E. CHILDE HASSAM, 1859-1935. Tucson: University of Arizona Museum of Art, and Santa Barbara (California) Museum of Art, 1972. 150 p. Illus., some color plates. Bibliography p. 150.

An excellent exhibition catalog, and the most scholarly publication on Hassam to date. Includes extensive documentation, lists of awards and honors, exhibitions, and a good bibliography. The essay by Steadman is a brief biography.

(Also see: IND. 20TH C. ARTISTS. Vol. 3: pp. 169-83, no. 11-12, p. 67; N.Y. MET. 19TH C.)

\* \* \* \* \*

HAWTHORNE, CHARLES 1872-1930

Sadik, Marvin S. THE PAINTINGS OF CHARLES HAWTHORNE. Storrs: The University of Connecticut Museum of Art, 1968. Unpaged. Illus.

Hawthorne founded the Cape Cod School of Art in Provincetown in 1899, and was an influential educator and painter at the beginning of the twentieth century. His portraits, landscapes, and seascapes reveal a prodigious talent, although he is little-known today.

(Also see: A.A.A.)

\* \* \* \* \*

HEADE, MARTIN JOHNSON 1819-1904

McIntyre, Robert G. MARTIN JOHNSON HEADE. New York: Pantheon, 1948. 71 p. Illus.

Basic monograph on one of the most prolific artists of the nineteenth century who produced a great variety of work, particularly landscapes. This book has rather poor reproductions printed on low-quality paper, which at this date has turned bright yellow.

Stebbins, Theodore E. "Introducing Martin Johnson Heade." ART NEWS, vol. 69, December 1969, p. 52. Illus.

Review of a large exhibition at the Whitney Museum of American Art (catalog below, also written by Stebbins). Refers to Heade as "a lost master of the first New York School."

_____. MARTIN JOHNSON HEADE. College Park: Art Department, University of Maryland, 1969. Unpaged. Illus., some color plates. Bibliographical references.

An attractive and informative catalog of an exhibition which was also shown at the Whitney Museum of American Art, New York, and the Boston Museum of Fine Arts. Includes examples of Heade's landscapes, floral studies and portraits.

(Also see: N.Y. MET. 19TH C.; A.A.A.)

\* \* \* \* \*

HELD, AL 1928–

AL HELD: NEW PAINTINGS. New York: Andre Emmerich Gallery, 1970. 4 p. Illus.

The briefest of catalogs, with no text, merely reproductions of some of his geometrical abstractions.

Burton, Scott. "Big H." ART NEWS, vol. 67, March 1968, p. 50. Illus., color plate.

Review of a retrospective held at the Corcoran Gallery, originated by the San Francisco Museum. The paintings exhibited were simple geometric shapes painted on "billboard" size canvases (catalog, below).

Green, Eleanor. AL HELD. San Francisco: Museum of Art, 1968. 24 p. Illus. Bibliography pp. 23-24.

Slim exhibition catalog, with some color reproductions. The works are those described above, and paradoxically, the opening sentence of the text states that "Al Held considers himself a realist painter."

\* \* \* \* \*

HELIKER, JOHN 1909–

Goodrich, Lloyd and Mandel, Patricia Fitzgerald. JOHN HELIKER. New York: Praeger for the Whitney Museum of American Art, 1968. 48 p. Illus., 3 color plates. Bibliography p. 17.

Catalog of the first retrospective of Heliker's paintings. "Through the years his style has passed through varying degrees of abstraction but has never become purely abstract. From the first it has been based on design--on the physical structure of the work of art, its form, color, line and movement, and the total harmony achieved by sensitive command of the interrelations and interplay of these elements" (p. 5).

(Also see: A.A.A.)

\* \* \* \* \*

HENRI, ROBERT 1865–1929

CATALOGUE OF A MEMORIAL EXHIBITION OF THE WORK OF ROBERT
HENRI. New York: Metropolitan Museum of Art, 1931. 19 p., plus 78
plates. Index pp. 17-19.

A brief essay by John Sloan on Henri is included in this catalog
of a retrospective exhibition, held two years after Henri's death.

Geske, Norman A. ROBERT HENRI, 1865-1929-1965: AN EXHIBITION HELD
IN OBSERVANCE OF THE CENTENNIAL OF THE ARTIST'S BIRTH. Lincoln:
Sheldon Memorial Art Gallery, University of Nebraska, 1965. 35 p. Illus.,
mounted plates. Bibliography pp. 13-14.

Exhibition catalog which includes a biographical sketch by Geske
and several quotations from Henri.

Henri, Robert. THE ART SPIRIT. Philadelphia: Lippincott, 1923. 292 p.
Compiled by Margery Ryerson. Introduction by Forbes Watson.

In addition to being an important painter, and member of the
"Ash Can Group," Henri was a noted educator. He taught at
the Art Student's League for many years, and this book is a col-
lection of "Notes, articles, fragments of letters, and talks to
students bearing on the concept and technique of picture making,
the study of art generally, and on appreciation" (title page).
Included are "Notes taken by Margery Ryerson from Robert Henri's
criticisms and class talks" (pp. 245-81).

*Homer, William Innes. ROBERT HENRI AND HIS CIRCLE. Ithaca: Cornell
University Press, 1969. 308 p. Illus., some in color. Bibliography pp. 291-
300. Index pp. 301-8. Contributions by Violet Organ.

A good biography of Henri, one of the most influential artists of
the first part of the twentieth century. His "Circle," which in-
cluded "The Eight," or "The Ash Can Group," of which he was
a leader, is also well documented. Violet Organ, his sister-in-law,
who has written an as yet unpublished biography, has contributed
selections to this book.

Pousette-Dart, Nathaniel. ROBERT HENRI. New York: Frederick A. Stokes,
1922. 68 p. Illus. Bibliography included.

Largely a collection of reproductions of Henri's portraits and land-
scapes, with a brief essay by Pousette-Dart.

Read, Helen Appleton. ROBERT HENRI. New York: Whitney Museum of
American Art, 1931. 58 p. Illus. Bibliography pp. 16-18.

Read has written a brief sketch of Henri's life for this monograph
published as a tribute shortly after the artist's death.

Yarrow, William and Bouche, Louis, eds. ROBERT HENRI: HIS LIFE AND
WORKS, WITH FORTY REPRODUCTIONS. New York: Boni and Liveright,
1921. (Privately printed for subscribers only.) 115 p. Illus.

An early monograph on Henri, with an assessment of his impor-

tance as a modern painter. The reproductions are all of figural works, all black and white and undated.

(Also see: HUNTER, p. 460.; IND. 20TH C. ARTISTS. Vol. 2: pp. 49-60, 11a. Vol. 3: no. 11-12, p. 47.; A.A.A.)

\*   \*   \*   \*   \*

HICKS, EDWARD   1780-1849

Ford, Alice.   EDWARD HICKS: PAINTER OF THE PEACEABLE KINGDOM. Philadelphia:   University of Pennsylvania Press, 1952.   161 p.   Illus., some color plates.   Bibliography pp. 123-26.   Index pp. 129-36.

A biography of the "primitive" painter Hicks, who is best known for his versions of "The Peaceable Kingdom," variants of which are in several museum collections.   This narrative emphasizes the years during which he was a preacher for the Society of Friends. Lengthy bibliography included.

(Also see:   N.Y. MET. 19TH C.)

\*   \*   \*   \*   \*

HOFMANN, HANS   1880-1966

Baker, Elizabeth C.   "Tales of Hofmann:   The Renate Series."   ART NEWS, vol. 71, November 1972.   p. 39.   Illus., includes color plate.

Review of an exhibition of late works by Hofmann.

Bannard, Darby.   "Hoffmann's Rectangles."   ARTFORUM, vol. 7, Summer 1969, pp. 38-47.   Illus., some color.

Lengthy article on Hofmann's use of color and shape.

HANS HOFMANN: TEN MAJOR WORKS.   New York:   Andre Emmerich Gallery, 1972.   8 p.   Illus., color plates.

Handsome reproductions of works painted from 1959 to 1963. Documentation includes list of exhibitions and chronology, but there is no text.

HANS HOFMANN: THE RENATE SERIES.   New York:   Metropolitan Museum of Art, 1972.

Catalog of an exhibition of nine large abstract works painted in the summer of 1965, just before his death, and dedicated to his wife, Renate.

Hofmann, Hans.   SEARCH FOR THE REAL, AND OTHER ESSAYS.   Edited by Sara T. Weeks and Bartlett H. Hayes, Jr.   Cambridge:   M.I.T. Press, 1967. (First ed.:   1948.)   73 p., plus appendix.   Illus.

Philosophical essays by Hofmann, this monograph was first pub-

lished in conjunction with a large exhibition of his work held at
the Addison Gallery of American Art, Phillips Academy, Andover,
Massachusetts. The brief introduction is a biographical sketch,
and there are many small black and white reproductions included.

Hunter, Sam. HANS HOFMANN. New York: Abrams, 1964. (2nd ed.)
227 p. Illus., 50 color plates.

The most comprehensive monograph on Hofmann, one of the most
noted of the American abstract expressionists. Lavish reproduc-
tions are the main feature of the book, but the essay by Hunter
is thoughtful, and a good introduction. Also included are five
essays by Hofmann.

Jaffe, Irma B. "A Conversation with Hans Hofmann." ARTFORUM, vol. 9,
January 1971, pp. 34–37. Illus., includes color.

Transcript of an interview held just one month prior to the artist's
death in 1966. Discussion of his "push-pull" theory, the role of
the accident in art, and other topics.

Seitz, William C. HANS HOFMANN. New York: Museum of Modern Art,
distributed by Doubleday, 1963. 64 p. Illus., 8 color plates. Bibliography
pp. 60–62. Reprint: Arno, 197?

Catalog of a major exhibition, organized by the Museum of Mod-
ern Art, which traveled to Europe and South America. Includes
an informative essay on Hofmann by Seitz, extensive documenta-
tion, and a lengthy bibliography by Inga Forslund.

Wight, Frederick. HANS HOFMANN. Berkeley: University of California
Press, 1957. 66 p. Illus., some in color. Bibliography pp. 64–65.

A monograph issued to accompany a large traveling exhibit, or-
ganized by the Whitney Museum of American Art. It is a good
introduction to the work of this major abstract expressionist. Some
of the plates are blurred.

(Also see: HUNTER, p. 461.)

*    *    *    *    *

HOMER, WINSLOW   1836–1910

*Beam, Philip C. WINSLOW HOMER AT PROUT'S NECK. Boston: Little,
Brown, 1966. 282 p. Illus. Bibliography pp. 265–72. Index pp. 273–82.

An excellent biography of Homer, which focuses on his late years
spent at Prout's Neck, on the Maine coast. The reproductions
could be better--they are all small, and black and white. Good
bibliography included.

Downes, William Howe. THE LIFE AND WORKS OF WINSLOW HOMER.
Boston: Houghton Mifflin, 1911. 306 p. Illus. Bibliography pp. 291–95.

The first biography of Homer, written by the art critic of the
BOSTON TRANSCRIPT, whom Homer had politely declined to aid.
"It may seem ungrateful to you that after your twenty-five years
of hard work in booming my pictures that I should not agree with
you in regard to that proposed sketch of my life. But I think that
it would probably kill me to have such a thing appear, and as the
most interesting part of my life is of no concern to the public I
must decline to give you any particulars in regard to it." (Good-
rich. WINSLOW HOMER, 1945, p. 1) An important early source.

Flexner, James Thomas. "The Homer Show: Few Painters Have So Powerfully
Expressed the Vastness of the World." ART NEWS, vol. 72, May 1973, p. 65.
Illus., color plate.

Review of a major Homer exhibition, organized by the Whitney
Museum of Art, which will travel to the Los Angeles County Mu-
seum and the Chicago Art Institute.

* _____, and the editors of Time-Life Books. THE WORLD OF WINSLOW
HOMER. New York: Time-Life, 1966? 190 p. Illus., many color plates.
Bibliography p. 185. Index pp. 187-90.

An excellent introduction to Homer's life and work. Written for
the educated layman, with very good reproductions. Includes com-
mentary on some of his contemporaries, particularly Ryder and
Eakins.

Gardner, Albert Ten Eyck. WINSLOW HOMER, AMERICAN ARTIST: HIS
WORLD AND HIS WORK. New York: Potter, 1961. 263 p. Illus., some
color plates. Bibliography p. 235. Index pp. 251-62.

An attractive and informative monograph. The biographical mate-
rial is largely based on Downes' and Goodrich's writings. Traces
the artist's career from his early years as an illustrator to the late
years when his work had become highly individualistic. Stresses
the importance of his trip to Paris in 1866-67.

Goodrich, Lloyd. WINSLOW HOMER. New York: published for the Whitney
Museum of American Art by Macmillan, 1945. Bibliography pp. 234-36. In-
dex pp. 237-41.

A substantial biography, largely based on Downes' material, plus
extensive papers and letters. "Recollections of an Intimate Friend-
ship," by John W. Beatty, included (pp. 207-26). Black and
white plates at the back of the volume.

* _____. WINSLOW HOMER. New York: Braziller, 1959. 127 p. Illus.,
some color plates. Bibliography pp. 117-22. Index pp. 125-27.

A slim introductory volume, abridged from the earlier edition.
Combines biographical information with admiring descriptions of
Homer's works. Includes reproductions of his better-known paint-
ings, and an extensive bibliography.

_____. WINSLOW HOMER. New York: Whitney Museum of American Art, 1973. 143 p. Illus., several color plates.

> A handsome catalog of a major exhibition. The essay by Goodrich is derived largely from his 1959 Braziller monograph. The reproductions, howerver, are better than in that book. Most of his best-known works are included.

*Hoopes, Donelson F. WINSLOW HOMER WATERCOLORS. New York: Watson Guptill, 1969. 87 p. Illus., 32 color plates. Bibliography p. 10. Index pp. 86-87.

> Published in cooperation with the Brooklyn Museum and the Metropolitan Museum of Art, this includes selections from those two distinguished collections. Brief, introductory text and an exceptionally handsome collection of reproductions.

*Wilmerding, John. WINSLOW HOMER. New York: Praeger, 1972. 224 p. Illus., some color plates. Bibliography pp. 221-22. Index pp. 223-24.

> A heavily illustrated biography and survey of Homer's art. Discusses various influences, including that of photography. The preface briefly summarizes several monographs on Homer. Good color plates, many of which are of unfamiliar works.

WINSLOW HOMER: A RETROSPECTIVE EXHIBITION. Boston: Museum of Fine Arts in collaboration with the National Gallery of Art and the Metropolitan Museum of Art 1959. 104 p. Illus., some color plates.

> An important exhibition catalog, with an essay by Albert Ten Eyck Gardner.

WINSLOW HOMER AT PROUT'S NECK. Brunswick, Maine: Bowdoin College, 1966. 93 p. Illus.

> Philip C. Beam, whose book of the same title (above) had been published earlier in 1966, wrote the introduction to this exhibition catalog. Primarily late works by Homer (1880-1909), done while he was living at Prout's Neck, Maine, or during this period while he was on trips. Many of these works are in the Bowdoin College collection, others on loan.

See: RYDER.

(Also see: INDEX OF 20TH C. ARTISTS. Vol. 1: pp. 17-30, 5a, 7a, 33a. Vol. 3: no. 11-12, pp. 9-10; N.Y. MET. 19TH C.; A.A.A.)

<p style="text-align:center">*　*　*　*　*</p>

HOPPER, EDWARD  1882-1967

Campbell, Lawrence. "Edward Hopper and the Melancholy of Robinson Crusoe." ART NEWS, vol. 70, October 1971, p. 36. Illus., color plates.

> Review of a major exhibition held at the Whitney Museum of

American Art, New York, of works left to the museum upon the
death of the artist (catalog, below).

Du Bois, Guy Pene. EDWARD HOPPER. New York: Whitney Museum, 1931.
55 p. Illus. Bibliography pp. 13-14.

> A brief monograph affectionately written by Hopper's friend and
> colleague. DuBois' characterization of Hopper's work as "Anglo-
> Saxon" reminds us that this work is from another era.

EDWARD HOPPER: RETROSPECTIVE EXHIBITION. New York: Museum of
Modern Art, 1933. 83 p. Illus. Bibliography p. 22. Reprint included in:
THREE PAINTERS OF AMERICA: CHARLES DEMUTH, CHARLES SHEELER, ED-
WARD HOPPER. New York: Arno, 1972.

> A major and early exhibition of Hopper's work, which marked the
> beginning of his enormous popularity. Many of his best-known
> works were shown, "Early Sunday Morning" (1930) and "House by
> the Railroad" (1925), in particular. Includes essays on Hopper by
> Charles Burchfield and Alfred H. Barr, Jr., with notes by Hopper.

Goodrich, Lloyd. EDWARD HOPPER. New York: Whitney Museum of Amer-
ican Art, 1964. 72 p. Illus., some in color. Bibliography pp. 69-71, by
Irma Jaffe.

> Catalog of a traveling exhibition, organized by the Whitney, and
> also shown at the Detroit Institute of Arts, Chicago Art Institute
> and City Art Museum, St. Louis. Includes most of his better-
> known works.

_____. EDWARD HOPPER. New York: Abrams, 1971. 306 p. 246 Illus.,
88 color plates. Bibliography pp. 297-300. Index p. 201.

> An oversized book ("wingspan" of 2-1/2 feet), made up primarily
> of reproductions of Hopper's most important works. Although it is
> awkward to handle, the reproductions are excellent, and the text
> by Goodrich, who knew Hopper well, is an intimate yet compre-
> hensive view of the artist's life and career. The bibliography in-
> cludes major publications through 1968.

_____. EDWARD HOPPER: SELECTIONS FROM THE HOPPER BEQUEST TO
THE WHITNEY MUSEUM OF AMERICAN ART. New York: Whitney Museum
of American Art, 1971. 66 p. Illus., some in color.

> An important supplement to Goodrich's 1971 Abrams monograph
> (above). A few of the paintings from this major bequest upon the
> death of the artist were included in that book, but this is an over-
> view of the gift. Since the works are unfamiliar, and date from
> 1906 through the 1940's, this is an informative source for the re-
> searcher.

_____. A SILENT WORLD: WATERCOLORS AND DRAWINGS. New York:
Art in America, 1967? 3 p., 8 plates.

> A large portfolio of eight reproductions, five in color, apparently

meant for framing. Very brief introductory essay by Goodrich is included.

Lanes, Jerrold. "Edward Hopper: French Formalist, Ashcan Realist; Neither or Both?" ARTFORUM, vol. 7, October 1968, pp. 44-49. Illus.

Substantial article on Hopper, in which Lanes concludes that Hopper's work "transcends the American or any other scene."

(Also see: Seitz, William C. and Goodrich, Lloyd. SAO PAULO 9...; HUNTER, p. 461; IND. 20TH C. ARTISTS. Vol. 1: pp. 157-60, 27a. Vol. 3: no. 11-12, p. 33.)

\*   \*   \*   \*   \*

HUNT, WILLIAM MORRIS   1824-1879

Knowlton, Helen M.   ART-LIFE OF WILLIAM MORRIS HUNT.   Boston: Little, Brown, 1899.   219 p.   Illus.

Old-fashioned, chatty biography of Hunt, but an early source, and there is little recent material.

Shannon, Martha A.S.   BOSTON DAYS OF WILLIAM MORRIS HUNT.   Boston: Marshall Jones, 1923.   165 p.   Illus.

Hunt, an academic Boston artist whose reputation has faded somewhat in the twentieth century, was much in demand for his portraits and murals. This biography is one of the best sources of information about Hunt's life and career. Includes photographs of the artist.

(Also see:   N.Y. MET. 19TH C.)

\*   \*   \*   \*   \*

INDIANA, ROBERT   1928-

McCoubrey, John W., introudction.   ROBERT INDIANA: AN INTRODUCTION BY JOHN W. MCCOUBREY, WITH STATEMENTS BY THE ARTIST.   Philadelphia: Institute of Contemporary Art, University of Pennsylvania, in collaboration with the Marion Koogler McNay Art Institute, San Antonio, Texas; and the Herron Museum of Art, Indianapolis, Indiana, 1968.   63 p.   Illus., some color.   Bibliography pp. 60-61.

An excellent exhibition catalog of works by Indiana, who established himself as a major "pop" artist. He has written an "Auto-chronology" (pp. 51-59) which is whimsical and pokes fun at the "chronology" sections compulsively included in most exhibition catalogs. The ubiquitous "LOVE" is reproduced on the cover in black and white, and in color as the frontispiece.

(Also see:   HUNTER, p. 461.)

INNESS, GEORGE  1825-1894

*Cikovsky, Nicolai.  GEORGE INNESS.  New York: Praeger, 1971.  159 p.
Illus., some in color.  Bibliography pp. 155-56.  Index pp. 157-59.

> An excellent biography and survey of Inness' paintings.  Discusses
> the influence of Swedenborg on this major American landscape artist.

Inness, George.  LETTER TO RIPLEY HITCHCOCK.  Mount Vernon, New York:
William Edwin Rudge, 1928.  10 p.

> Facsimile of a lengthy letter by Inness which is largely auto-
> biographical and discusses his art training and philosophy.

Inness, George, Jr.  LIFE, ART, AND LETTERS OF GEORGE INNESS.  New
York:  Century Co., 1917.  Reprint: Kennedy Galleries and DaCapo Press,
1969.  290 p.  Illus.

> A fond memoir and biography by Inness' son.

Ireland, Leroy.  THE WORKS OF GEORGE INNESS:  AN ILLUSTRATED CAT-
ALOGUE RAISONNE.  Austin: University of Texas Press, 1965.  476 p.
Illus., frontispiece in color.  Bibliography pp. 455-59.  Index pp. 461-76.

> The most important scholarly monograph on Inness.  Documents all
> known works in a chronological arrangement.  There is a preface
> by Donald B. Goodall and a foreword by Robert B. McIntyre.
> Part 2 lists works to which Ireland found references but was unable
> to locate.  Extensive bibliography included.

McCausland, Elizabeth.  GEORGE INNESS:  AN AMERICAN LANDSCAPE
PAINTER, 1825-1894.  New York: American Artists Group, 1946.  87 p.
Illus., color frontispiece.  Bibliography pp. 84-87.

> Catalog of an exhibition held in Brooklyn, New York, Springfield,
> Massachusetts, and Montclair, New Jersey.  A substantial work
> with a brief biography by McCausland included.

THE PAINTINGS OF GEORGE INNESS, 1844-94.  Austin:  University of
Texas, University Art Museum, 1965.  48 p.  Illus.  Bibliography pp. 45-48.

> This more recent exhibition catalog has a preface by Leroy Ire-
> land, an introduction by Nicolai Cikovsky, Jr., and notes by
> Donald B. Goodall.  Lengthy bibliography.

See:  CROPSEY.

(Also see:  IND. 20TH C. ARTISTS.  Vol. 4:  pp. 353-65; N.Y. MET.
19TH C.)

<p align="center">*    *    *    *    *</p>

JARVIS, JOHN WESLEY  1780-1840

Bolton, Theodore and Groce, George C.  JOHN WESLEY JARVIS:  AN AC-

COUNT OF HIS LIFE AND THE FIRST CATALOGUE OF HIS WORK. Reprinted from the ART QUARTERLY, Autumn 1938. pp. 299-321. Illus. Includes bibliographical references.

The first scholarly study of Jarvis' work as a portrait artist, with a brief sketch of his life.

Dickson, Harold E. JOHN WESLEY JARVIS, AMERICAN PAINTER, 1780-1840: WITH A CHECK LIST OF HIS WORKS. New York: New York Historical Society, 1949. 476 p. Illus. Bibliography pp. 384-99.

The basic monograph on Jarvis, a prolific but not well known portrait painter in the early nineteenth century, with an exhaustive bibliography.

\* \* \* \* \*

JENKINS, PAUL 1923-

Elsen, Albert E. PAUL JENKINS. New York: Abrams, 1973. 284 p. Illus., 56 color plates.

A major work on Jenkins to be published in the near future.

Nordland, Gerald. PAUL JENKINS. New York: Universe Books in cooperation with the Museum of Fine Arts, Houston, and the San Francisco Museum of Art, 1971. 69 p. Illus., some color plates. Bibliography pp. 67-69.

A handsome and informative monograph, published as an accompaniment to an exhibition. Jenkins' lyrical abstractions are well reproduced, and there is a good bibliography.

\* \* \* \* \*

JOHNS, JASPER 1930-

Kozloff, Max. JASPER JOHNS. New York: Abrams, 1968. 195 p. Illus., 41 color plates. Bibliography p. 195.

Johns, a major figure in the pop art movement, is the subject of this large, handsome book. Kozloff is a well known art critic, who often contributes articles to such magazines as ARTFORUM. The text is informative but the reproductions dominate the book.

_____. JASPER JOHNS. New York: Abrams, 1973. 83 p. Illus., several color plates. Bibliography p. 83.

An abridged edition of the 1968 book. Though published in 1973, the most recent painting reproduced dates from 1967.

Raynor, Vivien. "Jasper Johns: 'I Have Attempted to Develop My Thinking in Such a Way That the Work I've Done is Not Me.'" ART NEWS, vol. 72, March 1973, p. 20. Illus.

Transcription of a conversation with Johns.

Solomon, Alan and Cage, John. JASPER JOHNS. New York: The Jewish Museum, 1964. 63 p. Illus. Bibliography pp. 61-62.

Written to accompany an exhibition, the essay by Solomon provides a detailed analysis of Johns' style. The section by Cage, who is a friend of Johns', is a free-flowing portrait of the artist from his book, STORIES AND IDEAS.

Steinberg, Leo. JASPER JOHNS. New York: Wittenborn, 1963. 45 p. Illus., some in color. Bibliography pp. 43-44, by James P. Hardy.

An enlarged, revised version of an article published in METRO: INTERNATIONAL MAGAZINE OF CONTEMPORARY ART, 4/5 (Milan, Italy), May 1962. Excellent, perceptive article.

(Also see: HUNTER, p. 461.)

\*     \*     \*     \*     \*

JOHNSON, EASTMAN  1824-1906

Baur, John I.H. AN AMERICAN GENRE PAINTER, EASTMAN JOHNSON, 1824-1906. New York: Brooklyn Institute of Arts and Sciences, 1940. 82 p. Reprint included in: THREE NINETEENTH CENTURY AMERICAN PAINTERS: JOHN QUIDOR, EASTMAN JOHNSON AND THEODORE ROBINSON, Arno, 1969.

Written to accompany a retrospective exhibition, which signaled the beginning of a new interest in Johnson's work, which had been largely ignored during the early twentieth century. This remains a basic study, and Baur has quoted at length from Johnson's unpublished autobiography.

Hills, Patricia. EASTMAN JOHNSON. New York: Clarkson N. Potter in association with the Whitney Museum of American Art, distributed by Crown Publishers, 1972. 126 p. Illus., some color plates. Bibliography pp. 124-26.

An exhibition catalog for a show which traveled from the Whitney to the Cincinnati Art Museum, the Detroit Institute of Arts, and the Milwaukee Art Center. This is the best publication to date on Johnson, whose landscapes and genre works are being more highly valued lately.

————. "Painter of the New Eden." ART NEWS, vol. 71, March 1972, p. 36. Illus., color plates.

A lengthy article on Eastman Johnson, portions of which are based on Hills' exhibition catalog (above).

(Also see: N.Y. MET. 19TH C.)

\*     \*     \*     \*     \*

KANE, JOHN  1860-1934

Arkus, Leon Anthony. JOHN KANE, PAINTER. Pittsburgh: University of Pittsburgh Press, 1971. 343 p. Illus., some color plates. Bibliography pp. 337-38. Index pp. 339-43.

> Arkus wrote the foreword, catalogue raisonne, and compiled this important study. Included also is SKY HOOKS: THE AUTOBIOGRAPHY OF JOHN KANE, as told to Marie McSwigan (pp. 7-119), originally published in 1938 by Lippincott. Kane was a self-taught "primitive" or "naive" painter who achieved little recognition in his lifetime, but whose work is now regarded with respect. The bibliography includes not only works on Kane but other studies of American "primitive" artists.

(Also see: IND. 20TH C. ARTISTS. Vol. 3: pp. 213-14, no. 11-12, p. 74.)

\* \* \* \* \*

KAPROW, ALLAN 1927-

ALLAN KAPROW: AN EXHIBITION SPONSORED BY THE ART ALLIANCE OF THE PASADENA ART MUSEUM. Pasadena, 1967. 53 p. Illus., plates. Bibliography pp. 46-51.

> Kaprow is better known today for his "happenings," but he began as a painter in the abstract expressionist tradition. This is a catalog of a one-man show of his paintings.

Kaprow, Allan. ASSEMBLAGE, ENVIRONMENTS AND HAPPENINGS. Text and design by Allan Kaprow. Selection of scenarios by nine Japanese of the Gutai Group, Jean-Jacques Lebel, and others. New York: Abrams, 1966. 341 p. Illus. (Title on pp. 146-47.)

> A large picture book showing various "happenings," and other participatory avant-garde activities, giving an impression of general chaos. Text is Kaprow's philosophy and descriptions of the activities.

\* \* \* \* \*

KARFIOL, BERNARD 1886-1952

Slusser, Jean Paul. BERNARD KARFIOL. New York: Whitney Museum of American Art, 1931. 54 p. Illus. Bibliography p. 13.

> Brief monograph, meant as an introduction to the work of Karfiol, a Hungarian-born painter of nudes. Says Slusser: "The mellow paganism of his attitude towards the nude figure was never native to Anglo-Saxon soil....Karfiol is in no sense in protest against Protestantism, he simply has never heard of it." (pp. 7-8)

(Also see: A.A.A.)

KATZ, ALEX  1927-

Antin, David.  "Alex Katz and the Tactics of Representation."  ART NEWS, vol. 70, April 1971, p. 44.  Illus.

Review of a traveling retrospective of Katz's paintings.

*Sandler, Irving and Berkson, Bill, eds.  ALEX KATZ.  New York:  Praeger, 1971.  129 p.  Illus., some color plates.  Bibliography pp. 126-29.

Written to accompany an exhibition (review, above), which was held at the University of Utah, the University of California at San Diego, Minnesota Museum of Art at St. Paul, and the Wadsworth Atheneum, Hartford.  Katz's mostly figurative painting is included with most surveys of "new realist" work.

\*     \*     \*     \*     \*

KELLY, ELLSWORTH  1923-

Coplans, John.  "The Earlier Work of Ellsworth Kelly."  ARTFORUM, vol. 7, Summer 1969.  pp. 48-55.

Kelly's work from the 1940's and 1950's.  This article is extracted from a book to be published by Abrams in the near future.

Elderfield, John.  "Color and Area:  New Paintings by Ellsworth Kelly."  ARTFORUM, vol. 10, November 1971, pp. 45-49.  Illus., including color plates.

Discussion of Kelly's handsome minimalist abstracts on exhibit at Sidney Janis Gallery, New York.

Waldman, Diane.  ELLSWORTH KELLY:  DRAWINGS, COLLAGES, PRINTS.  Greenwich, Conn.:  New York Graphic Society, 1971.  288 p.  Illus., many color plates.  Bibliography pp. 284-87.

Although not a book on Kelly's painting, this is the major publication on the artist to date.  Many of the collages include painted passages, and several other graphic works are studies for paintings.

_____.  "Kelly Color."  ART NEWS, vol. 67, October 1968, p. 40.  Illus., includes color plates.

Review of a show at the Sidney Janis Gallery, New York.  Kelly's "intensely colored, strangely shaped paintings play optical and architectural tricks."

(Also see:  HUNTER, p. 461.)

\*     \*     \*     \*     \*

KENSETT, JOHN FREDERICK  1816-1872

Howat, John K.  JOHN FREDERICK KENSETT, 1816-1872.  New York:

American Federation of Arts, 1968. Unpaged. Illus. Bibliography at back of catalog.

> Kensett was an important nineteenth-century landscape painter, one of the second generation of the Hudson River School. This brief catalog is of a traveling exhibition, with small black and white illustrations.

Lanes, Jerrold. "Kensett at the Whitney." ARTFORUM, vol. 7, December 1968, pp. 51-53.

> A discussion of Kensett's style and its influences, prompted by an exhibit held at the Whitney Museum of American Art, New York.

(Also see: N.Y. MET. 19TH C.; A.A.A.)

\* \* \* \* \*

KENT, ROCKWELL 1882-1971

Kent, Rockwell. ROCKWELLKENTIANA: FEW WORDS AND MANY PICTURES BY ROCKWELL KENT AND, BY CARL ZIGROSSER, A BIBLIOGRAPHY AND LIST OF PRINTS. New York: Harcourt, Brace, 1933. 64 p. plus unpaged reproductions.

> A book designed by Kent which is quite handsome, and reflects the "art deco" style. Several essays by Kent are included, many of which have been published elsewhere. There are black and white reproductions of his paintings, drawings, and prints. They are simplified, stylized landscapes and figure studies.

ROCKWELL KENT. New York: American Artists Group, 1945. Unpaged. Illus. Brief biography on last page. (American Artists Monograph no. 2.)

> The introduction is a description by Kent of various travels. The reproductions, as in the other small monographs of this series, are not very good.

ROCKWELL KENT: THE EARLY YEARS. Brunswick, Maine: Bowdoin College, Museum of Art, 1969. Unpaged.

> A catalog of paintings and drawings done by Kent between 1903 and 1935, with a brief text by Richard V. West. Preface by Carl Zigrosser and an introduction by Kent.

(Also see: IND. 20TH C. ARTISTS. Vol. 1: pp. 104-10, 21a, 46a. Vol. 3: pp. 23-24; A.A.A.)

\* \* \* \* \*

KERKHAM, EARL 1891-1965

Nordland, Gerald. EARL KERKHAM: MEMORIAL EXHIBITION. Washington, D.C.: Gallery of Modern Art, 1966. 32 p. Illus. Bibliography p. 29.

Figurative works and quiet still lifes reflect the influence of
Cezanne, of whom Kerkham was an admirer.

\*     \*     \*     \*     \*

KLINE, FRANZ   1910-1962

Dawson, Fielding. AN EMOTIONAL MEMOIR OF FRANZ KLINE. New York:
Pantheon, 1967. 147 p.

> A rather brief, personal recollection of time spent in Kline's com-
> pany, first at Black Mountain College, then later in New York.
> Written in the first person by a friend.

FRANZ KLINE. New York: Marlborough-Gerson Gallery, 1967? 39 p. Illus.,
some color plates.

> Catalog consisting primarily of reproductions of Kline's bold ab-
> stractions, there are 62 paintings from 1951 to 1961. A brief in-
> troduction by Robert Goldwater is in the front of this catalog is-
> sued by the dealers handling Kline's estate.

Goldwater, Robert. "Franz Kline: Darkness Visible." ART NEWS, vol. 66,
March 1967, p. 38. Includes color plates.

> Review of a posthumous show (catalog, above) at Marlborough-Gerson
> Gallery, New York.

Gordon, John. FRANZ KLINE, 1910-1962. New York: Whitney Museum of
American Art, 1968. Illus., some color plates. Bibliography pp. 64-67.

> Exhibition catalog of a major traveling show, held six years after
> the death of Kline, an important abstract expressionist. The show
> was seen first at the Whitney, then traveled to Dallas, San Fran-
> cisco, and Chicago. The best publication to date on Kline, with
> extensive documentation.

(Also see:  HUNTER, p. 462; A.A.A.)

\*     \*     \*     \*     \*

KNATHS, KARL   1891-1971

Mocsanyi, Paul. KARL KNATHS. Washington, D.C.: The Phillips Gallery,
1957. 101 p. Illus., some color plates.

> Knaths, who was born in Wisconsin and studied at the Chicago
> Art Institute, was an influential abstract artist who spent most of
> his working life in Provincetown, Massachusetts. This book was
> put out by his gallery, and has color plates which are slightly
> out of register.

(Also see:  A.A.A.)

KRASNER, LEE 1909-

Campbell, Lawrence. "Of Lilith and Lettuce." ART NEWS, vol. 67, March 1968, p. 42. Illus., color plates.

> Review of exhibition at Marlborough-Gerson (catalog, below). Campbell states that Krasner's newer work suggests something growing in the sun."

LEE KRASNER. New York: Marlborough Gallery, 1968. 16 p. Illus.

> Brief catalog of an exhibition of Krasner's paintings in an abstract expressionist style. They bear a family resemblance to the work of her late husband, Jackson Pollock.

\* \* \* \* \*

KROLL, LEON 1884-

LEON KROLL. New York: American Artists Group, 1946. 64 p. Illus.

> A small picture book, with a brief introduction by Kroll and a chronology at the back. The paintings are landscapes and figure studies in the realist tradition, but the reproductions are only mediocre.

(Also see: A.A.A.)

\* \* \* \* \*

KRUSHENICK, NICHOLAS 1929-

NICHOLAS KRUSHENICK. Minneapolis: Walker Art Center, 1968. 20 p. Illus., some color plates.

> Catalog of a major exhibition of Krushenick's large, powerful abstractions, which show some influence of the pop art movement.

Perreault, John. "Krushenick's Blazing Blazons." ART NEWS, vol. 66, March 1967, p. 34. Illus.

> Review of Krushenick's work at the Pace Gallery, New York, described as "sunshine bright and formalistically seductive."

KUHN, WALT 1877-1949

Adams, Philip Rhys. WALT KUHN, 1877-1949. Cincinnati: Art Museum, 1960. Unpaged. Illus., some color plates.

> A substantial and handsome catalog of a major exhibition of still lifes and figure studies from 1910 through the 1940's.

Getlein, Frank, introduction. WALT KUHN, 1877-1949. New York: Kennedy Galleries, 1967. Unpaged. Illus.

A collection of fifty black and white plates of his still-lifes and figure paintings--particularly solitary frontal characters from the circus. The early works show a strong European influences, especially from Cezanne. Getlein's introduction is a biographical sketch.

(Also see: IND. 20TH C. ARTISTS. Vol. 4: pp. 345-48; A.A.A.)

\* \* \* \* \*

## KUNIYOSHI, YASUO 1893-1953

Goodrich, Lloyd. YASUO KUNIYOSHI. New York: published for the Whitney Museum of American Art by the Macmillan Co., 1948. 56 p. Illus. Bibliography p. 50.

This monograph was published in conjunction with an exhibition of Kuniyoshi's work, and is the most extensive book to date. It is dated, however, and hostilities toward the Japanese felt in the United States during and just after the Second World War surface occasionally: "Because of his Japanese birth he can never be an American citizen..." (p. 42).

A SPECIAL LOAN RETROSPECTIVE EXHIBITION OF WORKS OF YASUO KUNIYOSHI, 1893-1953. Gainesville: University of Florida, 1969. Unpaged. Illus., 2 color plates.

This is a good supplement to the Goodrich catalog (above). The exhibition concentrated on works created after 1948, and there are essays by Lloyd Goodrich and Roy Craven. Includes extensive documentation, and "Some remarks made to his students" by Yasuo Kuniyoshi, Art Student's League, 1949-50.

YASUO KUNIYOSHI. New York: American Artists Group, 1945. 64 p. Illus. (Monograph no. 11)

The text is a rather lengthy autobiographical essay reprinted from the MAGAZINE OF ART, March 1940. Biographical note on last page. The reproductions of the sketchy, semi-abstract paintings are small and not very good.

(Also see: IND. 20TH C. ARTISTS. Vol. 1: pp. 110-12, 22a, 46a. Vol. 3: no. 11-12, p. 24; A.A.A.)

\* \* \* \* \*

## LADERMAN, GABRIEL 1929-

Campbell, Lawrence. "Gabriel Laderman: A World Inside Itself." ART NEWS, vol. 71, October 1972, p. 88. Illus., color plate.

Lengthy article on the work of one of the more subtle and intellectual of the "new realist" school, occasioned by a one-man exhibition at Schoelkopf Gallery.

LAFARGE, JOHN 1835-1910

Cortissoz, Royal. AN EXHIBITION OF THE WORK OF JOHN LAFARGE. New York: Metropolitan Museum of Art, 1936. 16 p., plus 74 plates. Preface by H.E. Winlock.

> Catalog of an exhibition of this academic American painter, best known for his murals and stained glass designs, both of which were featured in this show. The essay by Cortissoz is a biographical sketch, based on his biography (below).

_____. JOHN LAFARGE, A MEMOIR AND A STUDY. Boston: Houghton Mifflin, 1911. 268 p. Illus. Index pp. 265-68.

> Leisurely biographical memoir, written by a friend and published the year following LaFarge's death.

LaFarge, John. CONSIDERATIONS ON PAINTINGS: LECTURES BEING GIVEN IN THE YEAR 1893 AT THE METROPOLITAN MUSEUM OF ART. New York: Macmillan, 1896. 270 p.

> LaFarge's thoughts on painting, with emphasis on the importance of composition and the integrity of materials used.

Waern, Cecilia. JOHN LAFARGE, ARTIST AND WRITER. New York: Macmillan, 1896. 104 p. Illus. Index pp. 103-4.

> A hopelessly outdated sentimental work, yet Waern had access to LaFarge's journals and memoranda, and therefore it contains much useful material.

(Also see: IND. 20TH C. ARTISTS. Vol. 3: pp. 233-41, no. 11-12, pp. 77-78; N.Y. MET. 19TH C.)

<p align="center">*   *   *   *   *</p>

LANE, FITZ HUGH 1804-1865

Wilmerding, John. FITZ HUGH LANE, 1804-1865: AMERICAN MARINE PAINTER. Gloucester, Mass.: Peter Smith, 1967. (First published by the Essex Institute, 1964.) 100 p. Illus. Bibliography pp. 90-92. Index pp. 93-100.

> An excellent study of the little that is known of Lane, painter of exquisite seascapes, often with brilliant or eerie colors. The poor black and white reproductions do not do justice to Lane's paintings.

(Also see: N.Y. MET. 19TH C.)

<p align="center">*   *   *   *   *</p>

LAWRENCE, JACOB 1917-

Saarinen, Aline B. JACOB LAWRENCE. New York: American Federation

of Arts, 1960. 14 p. Bibliography pp. 12-14.

> Lawrence is one of our best-known Black artists. This small exhibition catalog includes an essay on Lawrence's work by Saarinen, and numerous black and white reproductions.

\* \* \* \* \*

LEBRUN, RICO (FEDERICO) 1900-1964

RICO LEBRUN, 1900-1964: AN EXHIBITION OF DRAWINGS, PAINTINGS, AND SCULPTURE ORGANIZED FOR THE LOS ANGELES COUNTY MUSEUM OF ART BY HENRY J. SELDIS. Los Angeles: Los Angeles County Museum of Art, distributed by New York Graphic Society, 1967. 82 p. Illus. Bibliography pp. 67-75.

> Lebrun's highly skillful figure studies fall outside of the various "isms" or movements of twentieth-century art. This is an excellent survey of his work with extensive documentation.

RICO LEBRUN: PAINTINGS AND DRAWINGS. Los Angeles: University of Southern California, 1961. 31 p. Illus.

> A handsome catalog of an exhibition held "In commemoration of the centenary of Italian unification," as LeBrun was born in Naples, Italy, and fought in the Italian Army 1917 to 1918, before he came to the United States in 1924. The works included are paintings from his Crucifixion series, and illustrations from Dante's DIVINE COMEDY.

\* \* \* \* \*

LEE, DORIS 1905-

DORIS LEE. New York: American Artists Group, 1946. Unpaged. Illus. (Monograph no. 16).

> Picture book in this undistinguished series of small books. Lee's work was more highly regarded in the 1940's when this was published. In retrospect, the paintings seem overly pretty and the "primitive" style looks very contrived.

\* \* \* \* \*

LEVINE, JACK 1915-

Getlein, Frank. JACK LEVINE. New York: Abrams, 1966. 26 p., plus 167 plates, many in color.

> Getlein includes an essay on Levine's life and career but this is primarily a picture book, with handsome reproductions. Levine's rich, figurative painting, often replete with social commentary, has its roots in the social realism of the 1930's.

Wight, Frederick S.  JACK LEVINE.  Boston:  Institute of Contemporary Art, 1955.  15 p.  Illus.

> Brief exhibition catalog with a biographical essay by Wight and a foreword by Lloyd Goodrich.  The exhibition was also shown at the Whitney Museum of American Art, New York.

(Also see:  HUNTER, p. 462; A.A.A.)

<p align="center">*　*　*　*　*</p>

LIBERMAN, ALEXANDER  1912–

Campbell, Alexander.  "The Great Circle Route."  ART NEWS, vol. 69, April 1970, p. 52.  Illus.

> Review of a large exhibition of Liberman's abstract paintings and sculpture at the Corcoran Gallery (catalog, below).

Pilgrim, James, introduction.  ALEXANDER LIBERMAN:  PAINTING AND SCULPTURE, 1950–1970.  Washington, D.C.:  The Corcoran Gallery, 1970. 96 p.  Illus., some in color.  Bibliography pp. 49–51.

> Many of the works in this exhibition were on the theme of the circle.  This is a substantial catalog, with extensive documentation and "Notes for an Interview with Alexander Liberman" by Thomas B. Hess.

<p align="center">*　*　*　*　*</p>

LICHTENSTEIN, ROY  1923–

Alloway, Lawrence.  "On Style: An Examination of Roy Lichtenstein's Development, Despite a New Monograph of the Artist."  ARTFORUM, vol. 10, March 1972, pp. 53–59.  Illus.  Bibliographic notes.

> Title refers to Waldman's book (below).  This is a lengthy discussion of Lichtenstein's style and his sources.

Baker, Elizabeth C.  "The Glass of Fashion and the Mold of Form."  ART NEWS, vol. 70, April 1971, p. 40.  Illus. including color plate.

> Review of an exhibition of paintings by Lichtenstein based on mirrors.  They are more abstract than his earlier pop art paintings, and have a strong art deco stylization.

Coplans, John.  ROY LICHTENSTEIN.  Pasadena:  Pasadena Art Museum in collaboration with the Walker Art Center, Minneapolis, 1967.  63 p.  Illus., some color plates.  Bibliography pp. 56–62.

> Catalog of Lichtenstein's first major one-man museum show.  Itself a pop art object, it is designed to look like one of the student composition books which have been the subject of Lichtenstein's paintings.  Includes an extensive and annotated bibliography.

<p align="center">122</p>

Fry, Edward. "Inside the Trojan Horse." ART NEWS, vol. 68, October 1969, p. 36. Illus.

> Lengthy article occasioned by a large exhibition held at the Guggenheim Museum, New York.

"Talking with Roy Lichtenstein." ARTFORUM, May 1967, pp. 34-37. Illus., color plate.

> Interview with Lichtenstein conducted by John Coplans.

Waldman, Diane. ROY LICHTENSTEIN. New York: Solomon R. Guggenheim Museum, 1969. 112 p. Illus., many color plates. Bibliography pp. 104-12.

> An extensive exhibition catalog, this is heavily illustrated and includes much of the familiar pop art paintings: the blown-up sections of comic strips, the school composition book, etc. An excellent bibliography is at the back.

_____. ROY LICHTENSTEIN. New York: Abrams, 1971. 248 p. Illus., 86 color plates. Bibliography pp. 240-41.

> A large, lavish monograph based on Waldman's catalog for the Guggenheim show (above). Many more reproductions are added, and also the text of an interview with Lichtenstein.

(Also see: HUNTER, p. 462.)

<p style="text-align:center">*　*　*　*　*</p>

LINDNER, RICHARD 1901-

Ashton, Dore. RICHARD LINDNER. New York: Abrams, 1969. 217 p. Illus., 52 color plates. Bibliography pp. 215-17.

> Lindner was born in Germany and did not come to the United States until 1941. He made his reputation first as an illustrator in the 1940's, and did not begin to paint seriously until the 1950's. His imagery is violent, erotic and disturbing. This is an attractive, heavily illustrated book with a biographical text by Ashton.

Dienst, Rolf-Gunter. LINDNER. New York: Abrams, 1970? xxi p., plus 50 plates, 8 in color. Bibliography included.

> Primarily a picture book, with good reproductions of Lindner's disturbing figurative paintings. The text is brief, and translated from the German.

Tillim, Sidney. LINDNER. Chicago: William and Noma Copley Foundation, 1961. 34 p. Illus., some color plates.

> The first brief monograph on Lindner, written by another artist who is a friend. Good reproductions.

(Also see: HUNTER, p. 462.)

LOUIS, MORRIS 1912-1962

Alloway, Lawrence. MORRIS LOUIS, 1912-1962. New York: Solomon R. Guggenheim Museum, 1963. 38 p. Illus., some color plates. Bibliography included.

> A catalog consisting mostly of color reproductions of Louis' vertical-striped and chevron-striped painting, and a few looser "color field" abstractions.

Baker, Elizabeth. "Morris Louis: Veiled Illusions." ART NEWS, vol. 69, April 1970, p. 36. Illus., color plates.

> A stylistic analysis of Louis' paintings, inspired by several concurrent exhibitions of his work.

Fried, Michael, introduction. MORRIS LOUIS, 1912-1962. Boston: Museum of Fine Arts, 1967. 84 p. Illus., many color plates. Bibliography pp. 76-78.

> Catalog of an extensive exhibition of Louis' paintings, which traveled from Boston to St. Louis and Los Angeles. Fried has provided an excellent biographical summary and description of Louis' style and influences. Heavily illustrated.

_____. MORRIS LOUIS. New York: Abrams, 1970. 220 p. Illus., many color plates. Bibliography p. 220.

> An enlargement and expansion of the exhibition catalog (above). Many more color plates are included, although the text is only slightly increased--many sections read word-for-word the same. The bibliography is briefer.

Goldin, Amy. "Morris Louis: Thining the Unwordable." ART NEWS, vol. 67, April 1968, p. 48. Illus., color plate.

> Goldin describes a group of abstract paintings by Louis on exhibit at the Emmerich Gallery, New York, as "utterly clear, lovely, and mindless as a birdsong."

Moffett, Kenworth. "Morris Louis: Omegas and Unfurled." ARTFORUM, vol. 8, May 1970, pp. 44-47. Illus., color plates.

> Stylistic analysis of late paintings by Louis.

MORRIS LOUIS. New York: Andre Emmerich Gallery, 1972? Unpaged. Illus., color plates.

> Similar in format to earlier catalogs issued by Emmerich; a collection of handsome color plates, portrait of Louis and a brief bibliography.

Rose, Barbara. "Quality in Louis." ARTFORUM, vol. 10, October 1971, pp. 62-65. Illus., color plate.

> Rose considers Louis to have been one of America's most important artists. She explains her position in this article, particularly

stressing those abstract paintings she refers to as "veils."

(Also see: HUNTER, p. 463.)

\* \* \* \* \*

LUKS, GEORGE BENJAMIN 1867-1933

Cary, Elisabeth Luther. GEORGE LUKS. New York: Whitney Museum of American Art, 1931. Bibliography p. 12.

> A slim monograph with a brief biographical essay and several portraits and figure studies by this member of "The Eight," or more popularly, "The Ash Can Group." The paintings date from 1905 to 1930.

CATALOGUE OF AN EXHIBITION OF THE WORK OF GEORGE BENJAMIN LUKS. Newark: Newark Museum of Art, 1934. 57 p. Illus., plates. Bibliographical note p. 15.

> Catalog of a memorial exhibition, held a year after the artist's death. Brief text, composed of short essays by critics and friends. Many black and white reproductions of figurative paintings.

(Also see: IND. 20TH C. ARTISTS. Vol. 1: pp. 97-104, 21a, 45a. Vol. 3: no. 11-12, p. 23; HUNTER, p. 463.)

\* \* \* \* \*

MACDONALD-WRIGHT, STANTON 1890-1973

Scott, David W., introduction. THE ART OF STANTON MACDONALD-WRIGHT. Washington, D.C.: published for the National Collection of Fine Arts by the Smithsonian Press, 1967. 100 p. Illus., some color plates. Bibliography pp. 62-64.

> To date, this is the best publication on Macdonald-Wright and his work. He was an important early abstract artist, and one of the first Americans whose style was truly international. Together with Morgan Russell he began the "Synchromist" movement, based on his understanding of color theories. This catalog includes many selections from his writing, and the whole of "A Treatise on Color," written in 1924.

STANTON MACDONALD-WRIGHT: A RETROSPECTIVE EXHIBITION, 1911-1970. Los Angeles: The U.C.L.A. Galleries and The Grunwald Graphic Arts Foundation, 1970. Unpaged. Illus., a few color plates.

> A slim catalog of an important exhibit. Included is an interview of Macdonald-Wright by Frederick Wight. "The absence of a bibliography, list of catalogues, articles, reviews, etc. is at the artist's request" (last page).

(Also see: Agee, W.C. SYNCHROMISM AND COLOR...; HUNTER, p. 463.)

MACIVER, LOREN 1909-

Baur, John I.H. LOREN MACIVER--I. RICE PEREIRA. New York: published for the Whitney Museum of American Art by Macmillan, 1953. 71 p. Illus., 2 color plates. Includes bibliographies.

> Written to accompany a double exhibition of the works of these two well-known abstract artists. Extensive documentation and brief biographies included.

\* \* \* \* \*

MCNEIL, GEORGE 1908-

Burton, Scott. "George McNeil and the Figure." ART NEWS, vol. 66, October 1967, p. 38. Illus., color plate on cover.

> Article on an important artist in the abstract expressionist movement, whose later figurative painting was at this time being exhibited at the Howard Wise Gallery, New York.

GEORGE MCNEIL. Austin: University of Texas Art Museum, 1966. 16 p. Illus. Bibliography p. 14.

> Small exhibition catalog of the work of this abstract expressionist. An essay by McNeil, "Sensation and modern painting" is included.

\* \* \* \* \*

MAN RAY 1890-

Langsner, Jules. MAN RAY: AN EXHIBITION ORGANIZED BY THE LOS ANGELES COUNTY MUSEUM OF ART.... Los Angles, 1966. 148 p. Illus., some color plates. Bibliography pp. 144-48.

> Man Ray, a prominent surrealist, is better known for his experimental photography, particularly the "Rayographs." However, he has done a great deal of painting, and some of them were included in this exhibition, along with constructions, drawings, photographs, films and collages spanning from 1908 to 1965.

*Man Ray. SELF-PORTRAIT. Boston: Little, Brown, 1963. 402 p. Illus.

> A lighthearted autobiography, detailing the artist's rich and varied life in the art worlds of the twentieth century, from Paris to Hollywood.

(Also see: HUNTER, p. 463.)

\* \* \* \* \*

MARCA-RELLI, CONRAD 1913-

Agee, William C. MARCA-RELLI. New York: published for the Whitney

Museum of American Art by Praeger, 1967.  80 p.  Illus., some color plates.
Bibliography pp. 78-80.

Marca-Relli was a major figure in the lively New York School of
the 1950's and 1960's, and although his work is abstract, it can-
not accurately be called abstract expressionism.  This catalog is of
an exhibit of paint and canvas collages.  Good bibliography and
other documentation included.

Arnason, H.H.  MARCA-RELLI.  New York:  Abrams, 1963.  Unpaged.  Illus.,
many color plates.

A large, handsome picture book with many color reproductions of
Marca-Relli's paintings and collages.  Essay on his life and career
by Arnason explains that "his work has characteristically been more
figurative than abstract, more classical than expressionistic... at
times an architectural theme replaces the figuration.

*     *     *     *     *

MARIN, JOHN   1870-1953

Benson, E.M.  JOHN MARIN: THE MAN AND HIS WORK.  New York:
American Federation of Arts, 1935.  111 p.  Illus.

An early biography of Marin written for the non-specialist, this
includes selections from his letters.

Curry, Larry.  JOHN MARIN, 1870-1953.  Los Angeles:  Los Angeles County
Museum of Art, 1970.  100 p.  Illus., some color plates.

Catalog of a major exhibition which was also seen at the Whitney
Museum, New York; M.H. DeYoung Museum, San Francisco; The
Fine Arts Gallery, San Diego; and the National Collection of
Fine Arts, Washington, D.C.  Lengthy text about Marin and his
painting; good bibliography and documentation.

Davidson, Abraham.  "John Marin: Dynamism Codified."  ARTFORUM, vol.
10, April 1971, pp. 37-41.  Illus., color plates.

A discussion of Marin's stylistic relationship to abstract expressionism.

*Gray, Cleve, ed.  JOHN MARIN BY JOHN MARIN.  New York:  Holt,
Rinehart and Winston, 1970?  176 p.  Illus., several color plates.  Biblio-
graphic notes pp. 174-76.

An attractive book made up of reproductions of Marin's paintings
and selections from his published and unpublished writings.  Marin's
colorful, abstracted landscapes and seascapes are considered by
many critics to be among the very best of American paintings.

_____.  "John Marin: Graphic and Calligraphic."  ART NEWS, vol. 71,
September 1972, p. 48.  Illus., color plates.

Article on Marin's style by Grey, who feels that Marin's painting

is related "both to ancient Oriental art and the modern tradition which it pioneered."

Helm, Mackinley. JOHN MARIN. Boston: Pellegrini and Cudahy in association with the Institute of Contemporary Art, 1948. 255 p. Illus., color plates.

A biography with a foreword by Marin. Includes quotes from letters, particularly letters to Steiglitz. The color plates are blurred, and are exactly the same ones used in the 1936 Museum of Modern Art catalog, plus three additional ones.

JOHN MARIN MEMORIAL EXHIBITION. Boston: Museum of Fine Arts, 1955. 72 p. Illus., 3 color plates.

Major traveling exhibition. Catalog has a foreword by Duncan Phillips, an appreciation by William Carlos Williams and Dorothy Norman. "Conclusion to a biography" by Mackinley Helm.

JOHN MARIN: WATERCOLORS, OIL PAINTINGS, ETCHINGS. New York: Museum of Modern Art, 1936. 100 p. Illus., 6 color plates. Reprint: Arno Press, 1966. (All plates black and white.) Bibliography pp. 99-100.

Catalog of a large retrospective exhibition, with essays on Marin and his painting by Henry McBride, Marsden Hartley, and E.M. Benson. Good documentation, and a checklist of Marin's etchings by E.M. Benson.

McCaughey, Patrick. "Where Preface Meets Redskin." ART NEWS, vol. 70, May 1971, p. 30. Illus., color plates.

Lengthy article on Marin, prompted by a large exhibition at the National Gallery, Washington, in honor of the centennial of the artist's birth.

Norman, Dorothy, ed. SELECTED WRITINGS (of John Marin). New York: Pellegrini and Cudahy, 1947. 241 p. Illus.

Includes selections from LETTERS OF JOHN MARIN (below), and an essay "Marin signs his letters" by Dorothy Norman.

Reich, Sheldon. JOHN MARIN: OILS, WATERCOLORS AND DRAWINGS, WHICH RELATE TO HIS ETCHINGS. Philadelphia: Museum of Art, 1969. Unpaged. Illus.

Second part of an exhibition which did an intensive study of Marin's work. The first part was devoted exclusively to the etchings. Documentation of each work included.

_____. JOHN MARIN: A STYLISTIC ANALYSIS AND CATALOGUE RAISONNE, 2 vols. Tucson: The University of Arizona Press, 1970. 891 p. Illus., plates, some in color. Bibliography pp. 273-97.

The most extensive and scholarly study of Marin's oeuvre to date. The first volume is a biography and a stylistic analysis; the second is the catalogue raisonne, with small reproductions of nearly all

of Marin's work. The lengthy bibliography indicates scholarly publications with an asterisk.

Seligmann, Herbert J., ed. LETTERS OF JOHN MARIN. New York: published privately for An American Place, 1931. 121 p.

An important collection of Marin's letters; a substantial number were addressed to Stieglitz.

(Also see: HUNTER, p. 463; IND. 20TH C. ARTISTS. Vol. 1: pp. 12-16, 3a-7a. Vol. 3: no. 11-12, pp. 7-8; A.A.A.)

\* \* \* \* \*

MARSH, REGINALD 1898-1954

EAST SIDE, WEST SIDE, ALL AROUND THE TOWN: A RETROSPECTIVE EXHIBITION OF PAINTINGS, WATERCOLORS AND DRAWINGS BY REGINALD MARSH. Tucson: University of Arizona Museum of Art, 1969. 175 p. Illus., some color plates.

Primarily a picture book of reproductions of paintings which were exhibited at the University of Arizona. Brief text.

Goodrich, Lloyd. REGINALD MARSH. New York: Abrams, 1972. 307 p. Illus., 85 color plates. Bibliography pp. 299-304. Index to the plates pp. 305-6.

An oversized picture book, consisting largely of reproductions of the artist's figurative paintings. The text by Goodrich is quite short, but the typeface is so big that it is difficult to read. Marsh's "The Human Figure" is devoted to anatomical drawings. The passion for anatomical drawings is inexplicable, since many appear inept and distorted, as do many figures in the paintings, especially the women.

(Also see: INDEX OF 20TH C. ARTISTS. Vol. 3: pp. 193-95, no. 11-12, p. 70; HUNTER, p. 464; A.A.A.)

\* \* \* \* \*

MARTIN, AGNES 1912-

Alloway, Lawrence. "Agnes Martin." ARTFORUM, vol. 11, April 1973, pp. 32-37. Illus., one color plate. Bibliographic notes.

Martin's square, abstract canvases are described by Alloway as "reserved in appearance and unassuming in their means...."

Borden, Lizzie. "Agnes Martin: Early Work." ARTFORUM, vol. 11, April 1973, pp. 39-43.

Discussion of Martin's development as a painter up to the early 1960's.

Martin, Agnes. "Reflections." ARTFORUM, vol. 11, April 1973, p. 38.

> Statement by Martin about her work, transcribed and edited by Lizzie Borden.

Ratcliff, Carter. "Agnes Martin and the Artificial Infinite." ART NEWS, vol. 72, May 1973, pp. 26-27. Illus.

> Review of a large traveling exhibition of Martin's paintings, which originated at the Pasadena Museum of Modern Art.

\* \* \* \* \*

## MARTIN, HOMER DODGE 1836-1897

Martin, Elizabeth Gilbert Davis. HOMER MARTIN: A REMINISCENCE. New York: MacBeth, 1904. 58 p. Illus.

> A biographical memoir written by Martin's wife. Black and white reproductions of his landscape paintings are included, but they are undated.

\* \* \* \* \*

## MASON, ALICE TRUMBULL 1904-1971

Pincus-Whitten, Robert. ALICE TRUMBULL MASON. New York: Whitney Museum of American Art, 1973. 8 p. Illus., color plate on cover.

> A small pamphlet issued by the Whitney to accompany an exhibit of Mason"s pioneering abstractions. This gives only sketchy information about the artist and her work.

(Also see: A.A.A.)

\* \* \* \* \*

## MAURER, ALFRED HENRY 1868-1932

McCausland, Elizabeth. A.H. MAURER. New York: published for the Walker Art Center (Minneapolis) by A.A. Wyn, 1951. 289 p. Illus. Bibliography pp. 279-82. Index pp. 283-89.

> The most important work on Maurer, who was one of the first abstract artists in America. He was the son of Louis Maurer who designed successfully for Currier and Ives, and did not think much of his son's "modernistic" paintings (p. 216). This is based on McCausland's important exhibition catalog (below), although greatly expanded.

_____. A.H. MAURER, 1868-1932. Minneapolis: Walker Art Center, 1949. 43 p. Illus., frontispiece in color. Bibliography p. 39.

> Excellent exhibition catalog, with a good introductory text on

Maurer by McCausland.

Reich, Sheldon. ALFRED H. MAURER, 1868-1932. Washington, D.C.: published for the National Collection of Fine Arts by the Smithsonian Institution, 1973. 167 p. Illus. Bibliography included.

> Catalog of a major exhibition, with scholarly documentation. Updates the materials found in the McCausland publications.

(Also see: HUNTER, p. 464.)

<div align="center">*  *  *  *  *</div>

## MILLER, KENNETH HAYES 1876-1952

Burroughs, Alan. KENNETH HAYES MILLER. New York: Whitney Museum of American Art, 1931. 15 p., plus plates.

> Miller was an influential painter and teacher at the Art Students League in the early decades of the twentieth century. This brief monograph is mostly a collection of paintings from the 1920's and a text by Burroughs, which compares Miller's work to that of Italian Renaissance painters, a comparison which seems farfetched today.

Goodrich, Lloyd. KENNETH HAYES MILLER. New York: The Arts Publishing Co., 1930. 13 p. 64 plates.

> Brief introductory text on an artist much admired during the 1920's and 1930's.

(Also see: A.A.A.)

<div align="center">*  *  *  *  *</div>

## MITCHELL, JOAN 1926-

Harithas, James. "Weather Paint." ART NEWS, vol. 71, May 1972, p. 40. Illus., color.

> Discussion of Mitchell's work inspired by an exhibition of her paintings of the past five years on view at the Everson Museum, Syracuse, New York.

Mitchell, Joan. MY FIVE YEARS IN THE COUNTRY. Syracuse, New York: Everson Museum of Art, 1972. 30 p. pamphlet boxed with 6 color plates, folio size. Bibliography included p. 30.

> Handsome color plates, with a brief text by James Harithas; "Joan Mitchell is a terrific painter..." of the "second generation of abstract expressionism." The paintings are from 1966 to 1971.

<div align="center">*  *  *  *  *</div>

## MORAN, EDWARD 1829-1901

Sutro, Theodore. THIRTEEN CHAPTERS OF AMERICAN HISTORY, REPRESENT-
ED BY THE EDWARD MORAN SERIES OF THIRTEEN HISTORICAL MARINE
PAINTINGS. New York: T. Sutro and Baker and Taylor, 1905. 113 p.
Index pp. 111-13.

> An old-fashioned book on a historical painter much-admired in the
> late nineteenth century. Most of the text is a description of the
> subject matter in the paintings.

\* \* \* \* \*

MORAN, THOMAS 1837-1926

Fryxell, Fritiof Melvin. THOMAS MORAN, EXPLORER IN SEARCH OF BEAU-
TY: A BIOGRAPHICAL SKETCH, AN ACCOUNT OF THE HISTORY AND NA-
TURE OF THE THOMAS MORAN BIOGRAPHICAL ART COLLECTION IN THE
PENNYPACKER LONG ISLAND COLLECTION AT THE EAST HAMPTON FREE
LIBRARY, N.Y. AND SELECTED ARTICLES AND ILLUSTRATIONS RELATING
TO THE LIFE AND WORK OF THOMAS MORAN. East Hampton, New York:
Free Library, 1958. 84 p. Illus.

> Moran's daughter donated a substantial amount of material to the
> East Hampton Library. A brief biography of Moran and several
> essays on him are included in this catalog.

Wilkins, Thurman. THOMAS MORAN: ARTIST OF THE MOUNTAINS. Nor-
man: University of Oklahoma Press, 1966. 315 p. Illus. Bibliography pp.
261-93. Index pp. 295-315.

> Moran, a noted landscape painter, was born in Britain. Although
> his work is distinctly American, it is discernibly in the grand Brit-
> ish landscape tradition. This is a well-documented and extensive
> study of Moran's life and work.

(Also see: N.Y. MET. 19TH C.; A.A.A.)

\* \* \* \* \*

MORSE, SAMUEL FINLEY BREESE 1791-1872

Larkin, Oliver W. SAMUEL F.B. MORSE AND AMERICAN DEMOCRATIC
ART. Boston: Little, Brown, 1954. 215 p. Illus. Index pp. 182-215.

> A biography written for the layman by Larkin, and edited by Os-
> car Handlin. Morse, inventor of the telegraph and other items,
> was a highly respected painter and a pioneer in the use of the
> daguerrotype in America. This book emphasizes social and per-
> sonal aspects of Morse's life rather than the artistic.

Mabee, Carleton. THE AMERICAN LEONARDO: A LIFE OF SAMUEL F.B.
MORSE. New York: Knopf, 1943. 420 p. Illus.

> This is based on a Ph.D. thesis accepted in 1942 by Columbia
> University, and is a basic biography of Morse.

MORSE EXHIBITION OF ARTS AND SCIENCES: PRESENTED BY THE NATIONAL ACADEMY OF DESIGN IN COMMEMORATION OF THE 125TH ANNIVERSARY OF ITS FOUNDING, AND IN RECOGNITION OF THE GENIUS OF SAMUEL FINLEY BREESE MORSE, ONE OF THE FOUNDERS AND THE FIRST PRESIDENT. New York: National Academy of Design, 1950. 181 p. Illus.

> Large exhibition catalog, heavily illustrated. There is only a brief essay on "Morse the artist" (pp. 29-32) among the rest of the text, which includes substantial information about the National Academy of Design, New York.

(Also see: N.Y. MET. 19TH C.)

*     *     *     *     *

MOSES, ANNA MARY ROBERTSON  1860-1961

Kallir, Otto, ed. ART AND LIFE OF GRANDMA MOSES. New York: Gallery of Modern Art, 1969, and New York: A.S. Barnes. 168 p. Illus.

> A compilation of writing by and about Moses, along with numerous reproductions; published to accompany an exhibition.

_____, ed. GRANDMA MOSES: AMERICAN PRIMITIVE. Garden City, New York: Doubleday, 1947. 136 p. Illus., color plates.

> Kallir has written a brief essay on Moses' life and her paintings, but the majority of this book is composed of plates reproducing her paintings, and facsimile handwritten comments describing the subjects of the paintings by Moses. Kallir compares her "primitive" work with the decorative qualities of "Persian and Indian Moslem painting."

_____, ed. GRANDMA MOSES: MY LIFE HISTORY. New York: Harper, 1948. 140 p. Illus., 16 color plates.

> An unpretentious autobiography of this self-taught artist who enjoyed immense popularity late in her life. Homely details of country living included, and the excitement she felt with her late recognition.

_____. GRANDMA MOSES. New York: Abrams, 1973. 352 p. Illus., many color plates.

> Announced by the publisher to be in preparation.

*     *     *     *     *

MOTHERWELL, ROBERT  1915-

Arnason, H.H. "Motherwell, the Window and the Wall." ART NEWS, vol. 68, Summer 1969, p. 48. Illus., color plates.

> Review of exhibition at Marlborough-Gerson Gallery, New York.

Krauss, Rosalind. "Robert Motherwell's New Paintings." ARTFORUM, vol. 7, May 1969, pp. 26-28. Illus.

> Article also inspired by the Marlborough show of the "Open" series: large minimal abstractions.

ROBERT MOTHERWELL, SELECTIONS FROM A CURRENT SERIES: "OPEN," 1967-69. New York: Marlborough-Gerson Gallery, 1969. Unpaged. Illus., some color plates.

> The first New York exhibition of Motherwell's work since the 1965 Museum of Modern Art Retrospective (catalog, below). This catalog has a brief half-page outline of Motherwell's career as the only text, and is primarily a collection of mounted, color reproductions of large abstract canvases of the simplest rectangular themes.

O'Hara, Frank. ROBERT MOTHERWELL: WITH SELECTIONS FROM THE ARTIST'S WRITINGS. New York: Museum of Modern Art, distributed by Doubleday, 1965. 96 p. Illus., 10 color plates. Bibliography pp. 86-93, by Bernard Karpel.

> A substantial exhibition catalog; the best publication to date on Motherwell and his work. The text by O'Hara is informative, and at this time Motherwell was called a leading abstract expressionist. There is a letter from Motherwell to O'Hara included, and excerpts from several other published writings. O'Hara, a noted critic and a poet, intimate friend of many of the artists of the New York school, died tragically a year after this publication.

(Also see: HUNTER, p. 464.)

* * * * *

MOUNT, WILLIAM SIDNEY 1807-1868

Cowdrey, Bartlett and Williams, Hermann W., Jr. WILLIAM SIDNEY MOUNT: 1807-1868. New York: published for the Metropolitan Museum by Columbia University Press, 1944. 54 p. Illus. Bibliography pp. 43-47. Indexes pp. 49-54.

> The first major exhibition of Mount's work was held at the Brooklyn Museum in 1942. This monograph was published to accompany the second major exhibition, held in 1945, at the Metropolitan Museum of Art, New York, and it remains a basic source for information about Mount. Includes 78 paintings, reproduced in black and white, and a good bibliography.

Davidson, Abraham A. "William S. Mount: The Mysterious Stranger." ART NEWS, vol. 68, March 1969, p. 34. Illus., color plate.

> In an article inspired by a show of Mount's work at the Whitney Museum of American Art, New York, Davidson calls Mount "the founder of American genre."

Frankenstein, Alfred. PAINTER OF RURAL AMERICA: WILLIAM SIDNEY
MOUNT, 1807-1868. Washington, D.C.: printed by H.K. Press, sponsored
by the Suffolk Museum, Stony Brook, Long Island, and circulated by the Inter-
national Exhibitions Foundation, 1968. 70 p. Illus., some color.

> An exhibition held at the National Gallery of Art, Washington,
> D.C., and three other museums. The catalog is mostly composed
> of good reproductions of Mount's genre scenes and portraits, with
> detailed information about each painting and a brief introductory
> text.

(Also see: N.Y. MET. 19TH C.; A.A.A.)

\*   \*   \*   \*   \*

MURCH, WALTER TANDY 1907-1967

WALTER MURCH: A RETROSPECTIVE EXHIBITION. Providence, R.I.: Rhode
Island School of Design, 1966. Unpaged. Illus. Includes bibliography.

> Murch was born in Canada, but had lived in the United States
> since 1927. His work is usually described as surrealist, magic re-
> alist or romantic realist. This is a substantial and useful catalog,
> and an excellent survey of his work, although one could wish for
> good color plates.

(Also see: A.A.A.)

\*   \*   \*   \*   \*

NATKIN, ROBERT 1930-

Nordland, Gerald. "Robert Natkin: Color Saturated Elastic Space." ART
NEWS, vol. 72, February 1973, p. 54. Illus., color plate.

> Article reviewing paintings on exhibit at the Emmerich Gallery,
> New York. Nordland says that "Natkin has brought together his
> need for a formal unity and his craving for over-all patterning in
> an important synthesis."

Tucker, Marcia. "Natkin: Overtones at Outskirts." ART NEWS, vol. 66,
March 1967. p. 48. Illus., color plate.

> Review of a show at the Poindexter Gallery, New York. Tucker
> describes the paintings as "Vibrating paintings, composed of verti-
> cal grids."

\*   \*   \*   \*   \*

NEWMAN, BARNETT 1905-1970

Alloway, Lawrence. BARNETT NEWMAN: THE STATIONS OF THE CROSS,
LEMA SABACHTHANI. New York: Solomon R. Guggenheim Museum, 1966.

39 p. Illus. Bibliography pp. 34-35.

> Catalog of an exhibition of Newman's paintings which are titled symbolically, but are totally abstract vertical stripes on canvas. Alloway explores the religious theme in his text; there are a number of quotes from Newman's own writing also included. Good bibliography.

_____. "Color, Culture, The Stations; Notes on the Barnett Newman Memorial Exhibition." ARTFORUM, vol. 10, December 1971, pp. 31-39. Illus., color plates. Bibliographic notes.

> Lengthy article inspired by a retrospective held at the Museum of Modern Art, shortly after the artist's death. Alloway praises the artist's works but not the installation.

Baker, Elizabeth. "Barnett Newman in a New Light." ART NEWS, vol. 67, February 1969, p. 38. Illus.

Hess, Thomas B. BARNETT NEWMAN. New York: Walker and Co., 1969. 92 p. Illus., many color plates. Bibliography pp. 86-91, by Helmut Ripperger.

> Hess, the former editor of ART NEWS, wrote this rather modest yet informative monograph on Newman, one of America's leading painters and sculptors, just prior to the artist's death.

* _____. BARNETT NEWMAN. New York: Museum of Modern Art, distributed by New York Graphic Society, 1971.

> Greatly expanded version of Hess' monograph, published to accompany a large memorial exhibition at the Museum of Modern Art. Contains many more reproductions, and the bibliography has been updated by Annalee Newman.

Siegel, Jeanne. "Around Barnett Newman." ART NEWS, vol. 70, October 1971, p. 42.

> Statements about Newman and his work by 12 prominent artists and sculptors, upon the occasion of the memorial exhibition at the Museum of Modern Art.

(Also see: HUNTER, p. 465.)

<div align="center">*   *   *   *   *</div>

NOLAND, KENNETH 1924-

Bannard, Walter Darby. "Noland's New Paintings." ARTFORUM, vol. 10, November 1971, pp. 50-53. Illus., color.

> Review of "a really beautiful" show at the Andre Emmerich Gallery, New York.

Brunelle, Al. "The Sky-Colored Popsicle." ART NEWS, vol. 66, November

1967, p. 42. Illus., color.

Article on an earlier show of Newman's work at the Andre Emmerich Gallery, New York; canvases with stripes of pure color.

Fried, Michael. KENNETH NOLAND. New York: The Jewish Museum, 1965. Unpaged. Illus., some color plates. Bibliography at back of catalog.

A small catalog of a Noland show, with an introduction by Hans van Weeren-Griek and an informative essay on Noland by Fried. The canvases are all abstracts; some of the series resemble targets, others are of the chevron theme. Extensive bibliography of materials to 1965.

_____. "Recent Works by Kenneth Noland." ARTFORUM, vol. 7, Summer 1969, p. 36.

Brief review of an exhibition at Emmerich Gallery, New York, where Noland's paintings were canvases with horizontal bands of color.

KENNETH NOLAND: NEW PAINTINGS. New York: Andre Emmerich Gallery, 1973. 6 p. Illus., 3 color plates. Bibliography.

A mere slip of a thing, issued by Noland's gallery, but it contains, in addition to the handsome color reproductions, a remarkably lengthy bibliography.

Moffett, Kenworth. "Noland Vertical." ART NEWS, vol. 70, October 1971, p. 48. Illus.

Noland's vertical striped "color paintings" on view at Emmerich Gallery, New York, reviewed.

(Also see: HUNTER, p. 465.)

\* \* \* \* \*

NORDFELDT, BROR JULIUS OLSSON 1878-1955

Coke, Van Deren. NORDFELDT, THE PAINTER. Albuquerque: University of New Mexico Press, 1972. 149 p. Illus., some color. Bibliography pp. 145-46. Index pp. 147-49.

A concise, well written biography and critical analysis of the paintings by Nordfeldt, a Swedish-born artist. His paintings are semi-abstract landscapes, figure studies and still lifes, and show influences of Cezanne and Picasso.

\* \* \* \* \*

O'KEEFFE, GEORGIA 1887-

Crimp, Douglas. "Georgia is a State of Mind." ART NEWS, vol. 69, October 1970, p. 48. Illus., color plates.

Review of the large retrospective held at the Whitney Museum of American Art, New York.

*Goodrich, Lloyd and Bry, Doris. GEORGIA O'KEEFFE. New York: Praeger for the Whitney Museum of American Art, 1970. 195 p. Illus., 13 color plates. Bibliography pp. 191-95.

This is the best and most extensive publication on O'Keeffe to date. It was published to accompany a large retrospective of O'Keeffe's spare handsome paintings of abstracted American land-scapes, and her understated still lifes. The text is brief, but gives an adequate summary of her life and career, which included marriage to Stieglitz. Bibliography is helpful, but as Bry states: "...both O'Keeffe and her work have been magnets for an emo-tional and largely uninformative literature of vast dimensions."

Lane, James W., introduction. THE WORK OF GEORGIA O'KEEFFE: A PORTFOLIO OF TWELVE PAINTINGS. New York: Dial Press, 1939. Unpaged.

A large portfolio of poster-size color reproductions which are quite good, and apparently meant for framing. Little text: brief intro-duction by Land and an adulatory "Appreciation" by Leo Katz.

Rich, Daniel Catton. GEORGIA O'KEEFFE. Chicago: Art Institute, 1943. 45 p. Illus., color frontispiece.

An exhibition catalog with a brief biographical text by Rich. In-cludes many black and white reproductions.

Rose, Barbara. "Georgia O'Keeffe: The Painting of the Sixties." ARTFO-RUM, vol. 9, November 1970, p. 42. Illus.

Rose appraises O'Keeffe's latest works, on view with the earlier works at the Whitney exhibition, and finds them of major importance.

Wilder, Mitchell A., ed. GEORGIA O'KEEFFE: AN EXHIBITION OF THE WORK OF THE ARTIST FROM 1915-1966. Fort Worth: Amon Carter Museum of Western Art, 1963. 30 p. Illus.

The text of this exhibition catalog is composed entirely of excerpts from earlier writings about O'Keeffe and her work, plus documen-tation. Only a few paintings are reproduced, in black and white.

(Also see: HUNTER, p. 465.; IND. 20TH C. ARTISTS. Vol. 3: pp. 225-28, no. 11-12, p. 76.)

\*     \*     \*     \*     \*

OLITSKI, JULES  1922-

Fried, Michael. "Olitski and Shape." ARTFORUM, vol. 5, January 1967, pp. 20-21. Illus.

Article in which Fried discusses the degree to which Olitski's paintings are dependent upon proportion of height to width.

Krauss, Rosalind E. JULES OLITSKI: RECENT PAINTINGS. Philadelphia: University of Pennsylvania in collaboration with the Hayden Gallery, Massachusetts Institute of Technology, Cambridge, 1968. Unpaged. Illus., several color plates.

> Informative, if brief, exhibition catalog of a large show held both in Cambridge and Philadelphia. Color reproductions of the "color field" canvases by this Russian-born artist.

Moffett, Kenworth. JULES OLITSKI. Boston: Museum of Fine Arts, distributed by the New York Graphic Society, 1973. 71 p. Illus., many color plates. Bibliography pp. 58-61, by Elinor L. Woron.

> A large attractive exhibition catalog, with extensive documentation and an essay about Olitski and his work. His large abstract paintings are quite subtle, and difficult to reproduce. The illustrations in this publication succeed quite well, particularly the extreme closeup on the cover. Useful and up-to-date bibliography.

Siegel, Jeanne. "Olitski's Retrospective: Infinite Variety." ART NEWS, vol. 72, Summer 1973, p. 61. Illus., color plate.

> Review of the large exhibition which opened in Boston (catalog, above) and will travel to the Albright-Knox in Buffalo and the Whitney Museum of American Art, New York.

(Also see: HUNTER, p. 465.)

* * * * *

OSSORIO, ALFONSO 1916-

Friedman, B.H. ALFONSO OSSORIO. New York: Abrams, 1972. 269 p. Illus., many color plates. Bibliography pp. 267-69.

> Ossorio, a Philippines-born artist, is better known today for his multi-colored constructions which sometimes resemble collage, sometimes are sculpture. However, prior to 1960 he produced a considerable number of influential abstract paintings, many of which are reproduced in this substantial and informative monograph.

* * * * *

PAGE, WILLIAM 1811-1885

Taylor, Joshua C. WILLIAM PAGE: THE AMERICAN TITIAN. Chicago: University of Chicago Press, 1957. 292 p., plus illustrations. Bibliography pp. 281-86. Index pp. 287-92.

> Scholarly, in-depth study of Page, an important nineteenth-century American portraitist. The subtitle seems a bit grand but Taylor does his best to substantiate the comparison with Titian. Lengthy bibliography included.

(Also see: A.A.A.)

\* \* \* \* \*

PEALE FAMILY

CATALOGUE OF AN EXHIBITION OF PORTRAITS BY CHARLES WILLSON
PEALE AND JAMES PEALE AND REMBRANDT PEALE. Philadelphia: Pennsyl-
vania Academy of the Fine Arts, 1923. 239 p. Illus.

> Although the catalog is quite dated, it is a lengthy and in-depth
> survey of the work of three of the members of this distinguished
> family of artists, and remains a useful source.

Dwight, Edward, introduction. PAINTINGS BY THE PEALE FAMILY. Cincin-
nati: Art Museum, 1954. 28 p. Illus.

> A catalog of an exhibition, illustrated with works by: Charles
> Willson Peale, Raphaelle Peale, Rembrandt Peale, Rubens Peale,
> James Peale, James Peale, Jr., Anna Claypoole Peale, Marga-
> retta Angelica Peale, and Sarah Miriam Peale. Over 100 paint-
> ings were exhibited.

*Elam, Charles H., ed. THE PEALE FAMILY: THREE GENERATIONS OF
AMERICAN ARTISTS. Detroit: Detroit Institute of Arts and Wayne State
University Press, 1967. 150 p. Illus., some in color. Geneaology p. 140.
References p. 143.

> This remarkable family produced 20 artists during the eighteenth
> and nineteenth centuries. This is a catalog of a major exhibition,
> and serves as an excellent introduction to the work of these art-
> ists. There is substantial documentation included, and a great
> many illustrations, most of which are in black and white. The
> color reproductions are not very good.

(Also see: A.A.A.)

\* \* \* \* \*

PEALE, CHARLES WILLSON 1741-1827

Briggs, Berta N. CHARLES WILLSON PEALE: ARTIST AND PATRIOT. New
York: McGraw Hill, 1952. 262 p. Illus. "Further reading" p. 258. In-
dex pp. 259-62.

> A biography of the best-known member of the Peale family, writ-
> ten for the layman. There is more emphasis on his political and
> personal life than on his experiences as an artist.

Sellers, Charles Coleman. CHARLES WILLSON PEALE, 2 vols. Philadelphia:
American Philosophical Society, 1952. 510 p. Illus., some color plates.
Reprint: Scribners, 1969 (one volume). Bibliography pp. 485-90. Index pp.
491-510.
> A scholarly study of Peale's life and his painting. Many of his

portraits and history paintings are illustrated. Much of this mat-
erial was first published in the MEMOIRS OF THE PHILOSOPHI-
CAL SOCIETY, vol. 23, 1947.

(Also see: N.Y. MET. 19TH C.; Flexner. AMERICA'S OLD MASTERS.)

\* \* \* \* \*

PEALE, JAMES 1749-1831. See: PEALE, CHARLES WILLSON and PEALE
FAMILY.

(Also see: N.Y. MET. 19TH C.)

\* \* \* \* \*

PEALE, RAPHAELLE 1774-1825. See: PEALE FAMILY.

(Also see: N.Y. MET. 19TH C.)

\* \* \* \* \*

PEALE, REMBRANDT 1778-1860. See: PEALE, CHARLES WILLSON and
PEALE FAMILY.

(Also see: N.Y. MET. 19TH C.)

\* \* \* \* \*

PEARLSTEIN, PHILIP 1924-

Midgette, Willard. "Philip Pearlstein: The Naked Truth." ART NEWS, vol.
66, October 1967, pp. 54-55. Illus., color plate.

> Review of an exhibition of paintings, mostly of nudes, at the
> Frumkin Gallery, New York.

Nochlin, Linda. PHILIP PEARLSTEIN. Athens: Georgia Museum of Art,
University of Georgia, 1970. Unpaged. Illus. Includes bibliography.

> This slim exhibition catalog is the most extensive publication to
> date on the work of this important "new realist." His formal,
> stylized figure studies and nudes usually seem to be posed in a
> very harsh light. There are 80 reproductions in this catalog, all
> in black and white.

_____. "The Ugly American." ART NEWS, vol. 69, September 1970, p.
55. Illus.

> Review of the exhibition at the Georgia Museum of Art (catalog,
> above). Nochlin observes that Pearlstein "revitalizes the realist
> tradition...."

(Also see: HUNTER, p. 465.)

PELHAM, Henry 1749-1806. See: COPLEY, JOHN SINGLETON.

\* \* \* \* \*

PEREIRA, IRENE RICE 1901-1971

I. RICE PEREIRA. New York: Amel Gallery, 1962. 28 p. Illus.

> Black and white reproductions of abstract paintings (undated) by Pereira, accompanied by her poetry. A philosophical essay by the artist is also included, and a list of her published works.

THE LAPIS. Washington, D.C.: Corcoran Gallery, 1970. Unpaged. Illus., some in color.

> A large folio, issued in limited edition, illustrating a dream Pereira has had about a lapis lazuli monument.

See: MACIVER, LOREN.

(Also see: A.A.A.)

\* \* \* \* \*

PERLIS, DON 1941-

Kurtz, Stephen. "Can You Still Become an Old Master at 28?" ART NEWS, vol. 69, March 1970, p. 54. Illus., color plate.

> Article about the paintings of Don Perlis, whose work was being shown at that time among the 22 REALISTS show at the Whitney Museum of American Art, (see catalog p. 50).

PIPPIN, HORACE 1888-1946

Rodman, Selden. HORACE PIPPIN: A NEGRO PAINTER IN AMERICA. New York: Quadrangle Press, 1947. 88 p. Illus., some color plates.

> Pippin's paintings in the "naive" or "primitive" style were immensely popular in the 1940's, and he was one of the first Black Americans to achieve fame as an artist. This rather brief monograph was written as a tribute shortly after the artist's death; it is attractive and informative.

(Also see: A.A.A.)

\* \* \* \* \*

POLLOCK, JACKSON 1912-1956

\*Friedman, B.H. JACKSON POLLOCK: ENERGY MADE VISIBLE. New York: McGraw-Hill, 1972. 293 p. Illus. Bibliography pp. 263-78. Index pp. 279-93.

A popular, intimate biography of one of the most famous abstract expressionists, the original "action painter." This is full of interesting anecdotes; reflects the New York art scene in the 1950's and earlier, Pollock's studies at the Art Students League, and particularly his relationship with Thomas Hart Benton. Includes an extensive bibliography.

Hunter, Sam. JACKSON POLLOCK. New York: Museum of Modern Art, distributed by Simon and Schuster, 1956. 36 p. Illus. Bibliography p. 36, by Bernard Karpel.

Catalog of a major exhibition which was shown just after the artist's sudden death.

"Jackson Pollock: An Artists' Symposium." ART NEWS, vol. 66, April 1967, p. 28.

Discussion of Pollock and the importance of his paintings by several prominent artists who knew him well.

JACKSON POLLOCK: BLACK AND WHITE. New York: Marlborough-Gerson Gallery, 1969. 60 p. Illus.

A series of black and white paintings done in 1951 which are more figural, less abstract than the more familiar "action" paintings. There are some graphic works included, and there is little text: an interview with Pollock by B.H. Friedman and a short introduction by William S. Lieberman. Most of the reproductions are mounted on glossy black paper. Marlborough handles the Pollock estate.

O'Connor, Francis V. JACKSON POLLOCK. New York: Museum of Modern Art, 1967. 148 p. Illus., 1 in color. Bibliography pp. 137-43. Index pp. 144-48.

The "Chronology" by O'Connor is very lengthy, and comprises most of the text of this exhibition catalog. It is a kind of skeletal biography, pp. 11-78. Additionally, there is an interview with Pollock and a large number of reproductions of his work.

O'Hara, Frank. JACKSON POLLOCK. New York: Braziller, 1959. 125 p. Illus., some color plates. Bibliography pp. 119-20. Index pp. 123-25.

A slim introductory monograph put out by Braziller as part of a series called "Great American Artists." The book is largely reproductions, with a text by O'Hara, who emphasizes various influences on Pollock's work: "The Mexicans," "Surrealism," and "Totemism."

POLLOCK. New York: International Council at the Museum of Modern Art, 1957. (Representacao do Estados Unidos a IV Bienal do Museu de Arte Moderna de Sao Paulo, 1957.) Unpaged. Illus.

A selection of Pollock's work was sent to the 1957 Sao Paulo Bienal, and this is the brief accompanying catalog. The text, by Sam Hunter, is substantially the same as for the 1956 Museum of

Modern Art catalog, and the color reproductions are the same, although some of the black and white ones differ.

*Robertson, Bryan. JACKSON POLLOCK. New York: Abrams, 1960. 215 p. Illus., 36 color plates. Bibliography pp. 195-96. Index pp. 211-15.

Pollock's widespread publicity and his sudden death at the height of his career, in 1956, resulted in his becoming an almost mythical figure. This handsome picture book, issued shortly after the artist's death, has a perceptive text which discusses Pollock's sources in depth. The bibliography is "based on the short (one) prepared by Bernard Karpel and the Museum of Modern Art, New York, with additions drawn mainly from the Press reaction to the Pollock Exhibition circulated in Europe...1958-59.

Rose, Bernice. JACKSON POLLOCK: WORKS ON PAPER. New York: Museum of Modern Art, published in association with the Drawing Society, Inc., and distributed by the New York Graphic Society, 1969. 106 p. Illus., some color plates.

This book was begun as an outgrowth of the Pollock retrospective held at the Museum of Modern Art in 1966. Included are drawings, collages, and paintings on paper. The text is primarily devoted to stylistic analysis, with little biographical information.

Rubin, William S. "Jackson Pollock and the Modern Tradition." ARTFORUM, vol. 5. Part 1: February 1967, pp. 14-22; part 2: March 1967, pp. 28-37; part 3: April 1967, pp. 18-31; part 4: May 1967, pp. 28-33.

A series of major articles placing Pollock's work in the context of modern art history. Includes bibliographical references and illustrations.

Wysuph, C.L. JACKSON POLLOCK: PSYCHOANALYTIC DRAWINGS. New York: Horizon Press, 1970. 123 p. Illus., some in color. Bibliography pp. 117-21.

Drawings from the collection of Dr. Joseph Henderson, whom Pollock consulted. He did these drawings as part of his psychoanalytic treatment; they were not meant for publication. As they are poorly documented and undated, and the text of this book is heavily dependent upon other sources, the volume is of questionable value.

(Also see: HUNTER, pp. 465-66.)

*     *     *     *     *

POONS, LARRY 1936-

Fried, Michael. "Larry Poon's New Painting." ARTFORUM, vol. 10, March 1972, pp. 50-52. Illus., color plate.

Brief article admiring Poon's large abstract canvases, particularly his use of color, and comparing his work with that of Olitski.

Tuchman, Phyllis. "An Interview with Larry Poons." ARTFORUM, vol. 9, December 1970, pp. 44-50. Illus., color plates.

> Poons answers questions about his career, background and painting, particularly about his use of color and space.

(Also see: HUNTER, p. 466.)

\* \* \* \* \*

POOR, HENRY VARNUM 1888-1970

Boswell, Peyton. VARNUM POOR. New York: Hyperion Press, Harper and Bros., 1941. 77 p. Illus., some color plates. Bibliography p. 77.

> Artist of landscapes and slightly abstracted figure paintings which were fashionable in the 1940's, Poor is less well-known today than when this monograph was published. The text is introductory, written for the layman, and the color reproductions are muddy and blurred.

\* \* \* \* \*

PORTER, RUFUS 1792-1884

Lipman, Jean. RUFUS PORTER: YANKEE PIONEER. New York: Potter, distributed by Crown, 1968. 202 p. Illus., some color. Bibliography pp. 189-92. Index pp. 199-202.

> Porter painted decorative wall murals in many New England houses, as well as a number of portraits. What is known of him and his work is detailed in this monograph. Lengthy bibliography included.

\* \* \* \* \*

POUSETTE-DART, NATHANIEL 1886-1965

Spicer, Clayton, foreword. PAINTINGS, WATERCOLORS AND LITHOGRAPHS. New York: Clayton Spicer Press, American Creative Art, 1946. 61 p. Illus.

> Brief monograph on this landscape and figurative artist who studied under Henri. Includes a chapter written by the artist, "Appreciating art."

\* \* \* \* \*

POUSETTE-DART, RICHARD 1916-

Gordon, John. RICHARD POUSETTE-DART. New York: published for the Whitney Museum of American Art by Praeger, 1963. 55 p. Illus., some color plates.

> An exhibition catalog "published on the occasion of the first retrospective exhibition of the artist's work," with a foreword by Lloyd Goodrich. Richard is the son of Nathaniel Pousette-Dart,

and an abstract artist of note.   Included are reproductions of works from 1939 to 1963.

Perreault, John.   "Yankee Vedanta."   ART NEWS, vol. 66, November 1967, p. 54.   Illus., color plate.

Review of a large show at the Betty Parson's Gallery, New York. Perreault describes Pousette-Dart as "A tough independent abstractionist who refuses to disguise his mystical vision."

\* \* \* \* \*

PRATT, MATTHEW   1734-1805

Sawitzky, William.   MATTHEW PRATT, 1734-1805.   New York:  New York Historical Society, 1942.   103 p.   Illus., plates.   Index pp. 93-103.

A scholarly study of Pratt, a Philadelphia portraitist, and his work. Autobiographical notes (pp. 17-24) and a descriptive catalog of his works are included.

\* \* \* \* \*

PRENDERGAST, CHARLES   1863-1948

Wattenmaker, Richard J.   THE ART OF CHARLES PRENDERGAST.   Boston: Museum of Fine Arts, and New Brunswick, New Jersey: Rutgers University Art Gallery; distributed by New York Graphic Society, 1968.   119 p.   Illus., plates, some in color.   Bibliography p. 38.

Younger brother of the more famous Maurice Prendergast, Charles was also an artist.   He began his career as a frame-maker but his charming, eclectic paintings are an important part of his artistic output.   They are seemingly "primitive" but show sophisticated influences, particularly of Persian miniatures.

\* \* \* \* \*

PRENDERGAST, MAURICE AND CHARLES

THE PRENDERGASTS:  RETROSPECTIVE EXHIBITION OF THE WORK OF MAURICE AND CHARLES PRENDERGAST.   Andover: Philips Academy, 1938. 53 p.   Illus., color frontispiece.   Bibliography p. 52.

Brief exhibition catalog of works by the Prendergast brothers. "Anecdotes of Maurice Prendergast," by Van Wyck Brooks, pp. 33-45, and brief texts by several other critics.

\* \* \* \* \*

PRENDERGAST, MAURICE   1859-1924

Breuning, Margaret.   MAURICE PRENDERGAST.   New York:  Whitney Museum of American Art, 1931.   59 p.   Illus.   Bibliography p. 17.

The first monograph to appear on Prendergast, one of the U.S.
artists whose work is traditionally considered to be of the "impres-
sionist" school. This is still a good introduction to the artist's
work, and although the reproductions are all black and white, they
are adequate.

*MAURICE PRENDERGAST: WATER COLOR SKETCHBOOK. Boston: Museum
of Fine Arts, and Cambridge: Harvard University Press, 1960. 95 p. 20 p.
Pamphlet: "Critical note by Peter A. Wick," in back pocket. Color facsimiles.

A sensitive reproduction of a marvelous sketchbook kept by Mau-
rice Prendergast in the late 1890's. Most of the pages are filled
with watercolor sketches of beach scenes, probably from the Boston
north shore area. The brief "Critical note" is unobtrusively tucked
in the back, and is minimal and straightforwardly explanatory.

Rhys, Hedley Howell. MAURICE PRENDERGAST, 1859-1924. Cambridge:
Harvard University Press, 1960. 156 p. Illus., many color plates. Bibliog-
raphy p. 64.

Written originally to accompany a major exhibition of Prendergast's
work, held first at the Museum of Fine Arts, Boston, and later
traveled across the United States; this remains the definitive work
on the artist.

(Also see: HUNTER, p. 466; IND. 20TH C. ARTISTS. Vol. 2: pp. 93-96,
15a. Vol. 3: no. 11-12, p. 52.)

<center>*　*　*　*　*</center>

PYLE, HOWARD 1853-1911. See: Pitz, H. THE BRANDYWINE TRADITION.

<center>*　*　*　*　*</center>

QUIDOR, JOHN 1801-1881

Baur, John I.H. JOHN QUIDOR, 1801-1881. New York: Brooklyn Institute
of Arts and Sciences, 1942. Reprint: Baur, John I.H. THREE NINETEENTH
CENTURY AMERICAN PAINTERS... New York: Arno, 1969 (listed, above).
57 p. Illus.

Catalog of an important exhibition which rescued Quidor from ob-
scurity. Included besides a brief biography is a catalog of nearly
all known paintings by this artist of history and genre scenes.

_____. JOHN QUIDOR. Utica: Munson-Williams-Proctor Institute, spon-
sored by the New York State Council on the Arts, 1965. 71 p. Illus.,
some color plates.

In the 23 years since he first compiled an exhibition and catalog
of Quidor's work, 18 additional paintings were discovered. Baur
contributed a lengthy essay on Quidor for this catalog, and there
are 20 reproductions included. The exhibition was also shown at
the Whitney Museum, the Albany Institute of History and Art,

<center>147</center>

and the Rochester Memorial Art Gallery.

(Also see: N.Y. MET. 19TH C.)

\* \* \* \* \*

RATTNER, ABRAHAM 1895–

Getlein, Frank. ABRAHAM RATTNER. New York: American Federation of Arts, 1960. 28 p. Illus., color frontispiece. Bibliography pp. 13-14, 17-23, by Jean Campbell Jones.

Catalog of an exhibition of abstract paintings, many with biblical or religious subject matter. Brief text and an extensive bibliography, but largely a collection of black and white reproductions.

_____. ABRAHAM RATTNER. New York: Kennedy Galleries, 1969. 47 p. Illus., 13 color reproductions.

Fine color reproductions are included in this exhibition catalog with a brief text by Gettlein, who refers to Rattner as "an American expressionist."

Weller, Allen S. ABRAHAM RATTNER: TWENTY FOUR PLATES. Urbana: University of Illinois Press, 1956. 19 p. Illus., color plates.

Large handsome reproductions issued in a case.

(Also see: A.A.A.)

\* \* \* \* \*

RAUSCHENBERG, ROBERT 1925–

Forge, Andrew. RAUSCHENBERG. New York: Abrams, 1969. 231 p. Illus., many in color. Bibliography pp. 230-31.

An unsatisfactory book, made useful only because of the numerous color reproductions of Rauschenberg's work. The title page is on p. 221, and the text begins on the front cover--not very helpful to libraries which might need to rebind the volume. The text is superimposed on reproductions of photographs, and the type face is very large, resulting in a book which is almost impossible to read. Rauschenberg deserves better but so far this is the major monograph. The publisher is currently offering a smaller, 87-page, version of this book, and it may be a more successful presentation of the life and work of this artist who was closely identified with the pop art movement, but whose abstract collages and paintings defy classification.

Garver, Thomas, introduction. ROBERT RAUSCHENBERG IN BLACK AND WHITE: PAINTINGS 1962-3, LITHOGRAPHS 1962-7. Balboa, California: Newport Harbor Art Museum, 1969. Unpaged. Illus.

Paintings and graphic works done in 1962 and 1963 by "an artist who is regarded as one of the bridge figures between abstract expressionism and the new formalism of pop art that was to follow. In 1962, having worked in New York for slightly more than ten years, Rauschenberg abandoned his combination synthesis of painting, collage and construction, replacing them with commercially produced photographic silk screens, returning to an entirely flat surface on which images are produced by paint alone. At the time of this major shift in technique and in order to gauge more accurately their effect and quality, Rauschenberg eliminated all color, producing paintings only in black and white" (introduction).

Solomon, Alan R. ROBERT RAUSCHENBERG. New York: The Jewish Museum, 1963. 65 p. Illus. Bibliography pp. 63–64.

Major exhibition of Rauschenberg's paintings and collages or "combinations."

Swanson, Dean. ROBERT RAUSCHENBERG: PAINTINGS, 1953–1964. Minneapolis: Walker Art Center, 1965. Unpaged. Includes bibliography.

Slim exhibition catalog with a brief introductory essay on Rauschenberg and his work, and only a few black and white reproductions of paintings and assemblages.

(Also see: HUNTER, p. 466.)

\*     \*     \*     \*     \*

REINHARDT, ADOLPH FREDERICK   1913–1967

AD REINHARDT, 1960: TWENTY-FIVE YEARS OF ABSTRACT PAINTING. New York: The Betty Parsons Gallery, 1960. 16 p. Illus., some color plates.

A pamphlet issued to accompany a show of Reinhardt's paintings in 1960 at Betty Parsons Gallery. The reproductions included are adequate. The text is a reprint of three articles by Reinhardt which appeared in ART NEWS in 1954, 1957, and 1960. Two of the articles are essays on Asian art, the third philosophical.

AD REINHARDT, BLACK PAINTINGS, 1951–1967. New York: Marlborough Gallery, 1970. 27 p. Illus.

Reinhardt is best known for these large abstract canvases in varying tones of black done late in his life. He had been, however, one of the pioneer figures in American abstract art--as a member of the Artists Union and the American Abstract Artists, in 1937. This is an informative catalog but the reproductions only vaguely convey the power and subtlety of the paintings. The essays are by H.H. Arnason and Barbara Rose.

Fuller, Mary. "An Ad Reinhardt Monologue." ARTFORUM, vol. 9, October 1970, pp. 36–41. Illus.

Transcript of a tape recording of Reinhardt's reminiscences about his life and art, made in 1966, a year prior to the artist's death.

Lippard, Lucy. AD REINHARDT: PAINTINGS. New York: The Jewish Museum, 1966. Illus., some color. Bibliography pp. 73-76.

A substantial and informative essay by Lippard, and an introduction by Sam Hunter contribute with the careful documentation to make this a valuable exhibition catalog. There are a few color reproductions, but Reinhardt's work is extremely difficult to reproduce and the black and white illustrations are not successful. Works from the late 1930's to the 1960's are included; the bibliography is lengthy.

(Also see: HUNTER, p. 466; A.A.A.)

\*    \*    \*    \*    \*

REMINGTON, FREDERIC SACKRIDER 1861-1909

Allen, Douglas. FREDERIC REMINGTON AND THE SPANISH AMERICAN WAR. New York: Crown, 1971.

There is far more information in this book about the Spanish-American War than about Remington's work. However, since he is known primarily for his paintings of the American West, this is a survey of a lesser-known period of his work. The paintings are undated, however, and locations are not given.

Hassrick, Peter H. FREDERIC REMINGTON. New York: Abrams, 1973. 192 p. Illus., 60 color plates.

An attractive, well-illustrated introductory work on Remington and his paintings.

McCracken, Harold. FREDERIC REMINGTON: ARTIST OF THE OLD WEST. Philadelphia and New York: J.B. Lippincott, 1947. 157 p. Illus., many color plates. "Bibliographic check list of Remingtoniana" pp. 123-55. Index pp. 156-57.

A popularly written biography of the artist, whose work is admired more for its subject matter and documentary value than for his style or artistic influence. A number of his drawings and paintings of the American West, including cowboys and Indians, are reproduced. Very lengthy "bibliographic check list" appended.

\*_____. THE FREDERIC REMINGTON BOOK. Garden City: Doubleday, 1966. 284 p. Illus., many color plates. Index of pictures pp. 275-84.

An attractively illustrated biography of Remington, directed toward those with an interest in the history of the American West rather than toward the art historian. Lacks the extensive bibliography of the earlier edition.

Pitz, Henry C. FREDERIC REMINGTON: 173 DRAWINGS AND ILLUSTRA-TIONS. New York: Dover, 1972. 140 p. of illustrations, some in color.

> A brief survey of Remington's work, with pictures reproduced from other published works.

(Also see: N.Y. MET. 19TH C.; A.A.A.)

\* \* \* \* \*

RICHARDS, WILLIAM TROST 1833-1905

Ferber, Linda S. WILLIAM TROST RICHARDS: AMERICAN LANDSCAPE AND MARINE PAINTER, 1833-1905. New York: Brooklyn Museum, 1973. 105 p. Illus., cover reproduction in color. Bibliography pp. 104-5.

> Catalog of an exhibition also to be shown at the Pennsylvania Academy of the Fine Arts, Philadelphia. Richards was a Pennsylvania artist who traveled often to Europe, and was an accomplished landscape artist. "Like his near-contemporaries Bierstadt (d. 1902), Church (d.1900), and Cropsey (d. 1900), he lived to see his style, which like theirs was steeped in the ideas and attitudes of the mid-nineteenth century, lose currency the the face of new styles and new attitudes that developed in the course of the second half of the century" (p. 38). The black and white reproductions are adequate.

(Also see: N.Y. MET. 19TH C.)

\* \* \* \* \*

RIMMER, WILLIAM 1816-1879

Bartlett, Truman Howe. THE ART LIFE OF WILLIAM RIMMER, SCULPTOR, PAINTER AND PHYSICIAN. New York: Kennedy Graphics, 1970. 147 p. Illus. Reprint of the 1890 edition.

> Biography, unfortunately dated in style and information, of a most versatile nineteenth-century personality. Rimmer practiced type-setting, lithography, soap-making, shoe-making, and became a doctor by way of an apprenticeship in Massachusetts. His painting was prolific, and shows an awareness of European academic styles, plus the influence of William Blake. Later in his life, he became "The Director of the School of Design for Women at the Cooper Institute, New York."

Kirstein, Lincoln. WILLIAM RIMMER. New York: Whitney Museum of American Art, and Boston: Museum of Fine Arts, 1946. 42 p. Illus. Bibliography pp. 33-34.

> Brief monograph written to accompany a large exhibition held in Boston and New York. Includes several reproductions of his paintings and sculpture, and a useful bibliography.

RINDISBACHER, PETER 1806-1834

Josephy, Alvin M., Jr. THE ARTIST WAS A YOUNG MAN: THE LIFE STORY OF PETER RINDISBACHER. Fort Worth, Texas: Amon Carter Museum, 1970. 101 p. Illus., some color plates.

> Rindisbacher was born in Switzerland, immigrating first to Canada at the age of 15, and then to the United States. His drawings and paintings are sensitive renderings of American Indians, portraits, various animals, and ships. This is a fine monograph of an artist who lived only a brief time, and it accompanied a large exhibition held in 1970.

\* \* \* \* \*

RIVERS, LARRY 1923-

Hunter, Sam. LARRY RIVERS. New York: Abrams, 1969. 261 p. Illus., many color plates. Bibliography pp. 257-61.

> A large, attractive picture book with good color reproductions of Rivers' paintings. Hunter's text is thoughtful and a good introduction to the work of this facile painter, best known for his having been grouped with the pop artists of the 1960's. "A memoir by Frank O'Hara" is included, reprinted from the LARRY RIVERS exhibition catalog, published by the Poses Institute of Fine Arts, Brandeis University, Waltham, Massachusetts, 1965 (pp. 51-54).

\*_____. RIVERS. New York: Abrams, 1973. 102 p. Illus., several color plates. Bibliography pp. 98-102.

> Abridged edition of Hunter's large monograph (above), with fewer reproductions, although five dating from 1970 have been added.

LARRY RIVERS: 1965-70. New York: Marlborough, 1970. 44 p. Illus., several color plates. Monographs p. 5.

> Catalog issued by Rivers' dealer, with handsome color plates and minimal text which includes brief documentation of the illustrated works, lists of exhibitions, monographs, a chronology, and a brief statement by the artist.

Shapiro, David. "Strawberry Cake with the Psyche of a Good Camera." ART NEWS, vol. 69, December 1970, p. 30. Illus., color plates.

> Lengthy review of a Rivers exhibit at the Marlborough Gallery, New York.

(Also see: HUNTER, p. 466.)

\* \* \* \* \*

ROBINSON, BOARDMAN 1876-1952

Christ-Janer, Albert. BOARDMAN ROBINSON. Chicago: University of

Chicago Press, 1946. 132 p., plus 126 plates, some in color. Bibliography pp. 79-80.

A biography of Robinson with a catalog of his works. Some portions of the biography read rather like fiction, with apparently invented conversations and motivations. There are chapters by Arnold Branch and Adolf Dehn included.

(Also see: IND. 20TH C. ARTISTS. Vol. 2: pp. 106-8, 19a. Vol. 3: no. 11-12, p. 56.)

* * * * *

ROBINSON, THEODORE 1852-1896

Baur, John I.H. THEODORE ROBINSON, 1852-1896. New York: Brooklyn Museum, 1946. 95 p. Illus. Bibliographic references included. Reprinted in: Baur, John, I.H., THREE NINETEENTH CENTURY AMERICAN ARTISTS.., Arno, 1969 (above).

This remains the basic monograph on Robinson, and was compiled to accompany a large exhibition. Robinson is considered by many critics to be one of America's authentic impressionist painters. The reproductions in both the original and the reprint are black and white, and leave much to be desired.

(Also see: N.Y. MET. 19TH C.)

* * * * *

ROSENQUIST, JAMES 1933-

Alloway, Lawrence. "Derealized Epic." ARTFORUM, vol. 10, June 1972, pp. 35-41. Illus., color plate. Bibliographic notes.

Lengthy critical article on Rosenquist's work. Alloway describes some of Rosenquist's latest large projects as "closer to leisure architecture and science fiction tripping than it is to abstract art" (p. 40).

METROPOLITAN MUSEUM OF ART BULLETIN, vol. 26, March 1968, pp. 277-88. Illus.

This issue is devoted to Rosenquist and contains three major articles: "James Rosenquist's F-111" by Henry Geldzahler, "Re: The F-111: A Collector's Notes" by Robert Scull, and "An Interview with James Rosenquist" by Gene Swenson.

Siegel, Jeanne. "An Interview with James Rosenquist." ARTFORUM, vol. 10, June 1972, pp. 30-34. Illus.

Rosenquist answers questions about his work, his use of imagery, influences and the pop movement of the 1960's.

Smith, Brydon, foreword. JAMES ROSENQUIST. Ottawa: National Gallery of Canada, 1968. 92 p. Illus., some color plates. Bibliography p. 92.

Smith organized this exhibition of Rosenquist's work, and wrote the informative foreword to the catalog. There is also a statement by gallery owner, Ivan Karp, which is reprinted from a 1967 Art Students League catalog: AMERICAN MASTERS. The text is in both English and French. Most of the works included and discussed are from the pop art era.

Tillim, Sidney. "Rosenquist at the Metropolitan." ARTFORUM, vol. 6, April 1968, p. 46.

Critical essay on Rosenquist's huge pop art mural then on exhibit at the Metropolitan Museum of Art, entitled: "F-111."

Tucker, Marcia. JAMES ROSENQUIST. New York: Whitney Museum of American Art, 1972. 135 p. Illus., some color plates. Bibliography pp. 123-25, by Libby Seaberg.

A substantial exhibition catalog of Rosenquist's pop art. Text and pictures describing the influence of his previous career as a billboard artist, as well as a good deal of critical and documentary information.

(Also see: HUNTER, p. 467.)

*     *     *     *     *

ROTHKO, MARK   1903-1970

Hess, Thomas B. "Rothko: A Venetian Souvenir." ART NEWS, vol. 69, November 1970, p. 40. Illus., color plate.

Article reviewing a show at Marlborough Gallery, New York, which had previously been shown in Venice (catalog, below).

_____. "The Rothko Donnybrook." ART NEWS, vol. 71, November 1972, pp. 24-25. Illus.

Hess describes the lawsuit which involves the Rothko estate.

MARK ROTHKO. Venice: Museuo d'Arte Moderna Ca'Pesaro, 1970. (Under the auspices of the International Biennale d'Arte, Venice, and the collaboration of the Marlborough Gallery, New York.) Unpaged. Illus., 27 color plates.

Rothko died in February, 1970, and this major exhibition was held during the following summer in Venice. The catalog produced for the exhibition is really a sumptuous picture book, with attractive color reproductions of Rothko's luminous abstracts mounted on heavy gray paper. No text.

Selz, Peter. MARK ROTHKO. New York: Museum of Modern Art, distributed by Doubleday, 1961. 44 p. Illus., some color plates. Bibliography

pp. 40-41, by Annaliese Munetic. Reprint: Arno Press, 1973?

> Brief exhibition catalog, with a short critical text by Selz. "Color,
> although not a final aim in itself, is his primary carrier, serving
> as the vessel which holds the content. The color may be savage,
> at times burning intensely...Areas often seem to fade into each
> other, or they may be most emphatically separate; the relation-
> ships between Rothko's shapes in space, however, are never explic-
> itly defined." This essay, plus a brief biography, the reproduc-
> tions (only fair in quality), and the documentation make this among
> the most informative of the publications to date, although by no
> means the definitive work.

(Also see: HUNTER, p. 467.)

<div align="center">*    *    *    *    *</div>

## RUSSELL, CHARLES MARION  1864-1926

Adams, Ramon Frederick and Britzman, Homer E.  CHARLES M. RUSSELL: THE
COWBOY ARTIST.  Pasadena, California: Trails' End Publishing Co., 1948.
350 p.  Bibliographic check list by Karl Yost.

> A biography of the artist, written for the general reader.  There
> is a distracting amount of invented (remembered?) conversation.
> There are many photographs of the artist; the reproductions of his
> paintings are poor.

Renner, Frederic G.  CHARLES M. RUSSELL: PAINTINGS, DRAWINGS, AND
SCULPTURE IN THE AMON CARTER COLLECTION, A DESCRIPTIVE CATA-
LOGUE.  Fort Worth, Texas: Amon Carter Museum of Western Art, by the
University of Texas Press, Austin and London, 1966.  148 p.  Illus., many
color plates.  Bibliography pp. 143-44.  Index pp. 145-48.

> Russell, like Remington, Catlin, and Audubon, is generally appre-
> ciated for his documentary rather than stylistic contributions.  His
> careful depiction, particularly of nineteenth-century American In-
> dians and western American life, is widely admired.  This catalog
> of a major collection of his work includes a good biography and
> handsome reproductions.

Yost, Karl and Renner, Frederic G.  A BIBLIOGRAPHY OF THE PUBLISHED
WORKS OF CHARLES M. RUSSELL.  Lincoln: University of Nebraska Press,
1971.  317 p.  Illus., some color plates.  Index pp. 279-317.

> A compilation of about 3,500 references to books, periodical ar-
> ticles, and other publications by or about Russell.  The reproduc-
> tions vary in quality from quite good to poor.

<div align="center">*    *    *    *    *</div>

RUSSELL, MORGAN  1886-1953.  See: STANTON MACDONALD WRIGHT.

(Also see: Agee, William.  SYNCHROMISM AND COLOR PRINCIPLES.)

RYDER, ALBERT PINKHAM 1847-1917

Goodrich, Lloyd. ALBERT P. RYDER: CENTENARY EXHIBITION. New York: Whitney Museum of American Art, 1947. 48 p. Illus.

> Catalog of an extensive show of Ryder's work, the text is brief but is a good introduction to his rather eccentric landscapes, seascapes, and figurative works.

_____. ALBERT P. RYDER. New York: Braziller, 1959. 128 p. Illus., some color plates. Bibliography pp. 123-26. Index pp. 127-28.

> A brief biography and critical analysis of Ryder's painting, written for the layman. Expanded from the previously written exhibition catalog (above). The reproductions are very poor, although one must take into consideration the fact that the paintings lack sharp definition and are deteriorating badly.

(Also see: IND. 20TH C. ARTISTS. Vol. 1: pp. 65-72, 17a, 41a. Vol. 3: no. 11-12, p. 17; N.Y. MET. 19TH C.; A.A.A.)

\* \* \* \* \*

SALEMME, ATTILIO 1911-1955

ATTILIO SALEMME. Boston: Institute of Contemporary Art, 1959. 24 p. Illus., some color plates. Bibliography p. 29.

> Small catalog of an exhibition which was also held at the Whitney Museum of American Art, New York. Includes work from 1943 to 1955, rather sharp geometric abstractions. A number of quotations from the artist are included.

(Also see: A.A.A.)

\* \* \* \* \*

SARGENT, JOHN SINGER 1856-1925

Charteris, The Hon. Evan. JOHN SARGENT. New York: Scribner's, 1927. 308 p. Illus. Index pp. 297-300.

> An early biography of Sargent, which draws heavily from his letters.

Coolidge, Templeman, introduction. A CATALOGUE OF THE MEMORIAL EX-HIBITION OF THE WORKS OF THE LATE JOHN SINGER SARGENT. Boston: Museum of Fine Arts, 1925. 26 p. Illus.

> This was one of the most extensive exhibitions of Sargent's paint-ings ever held. The catalog is interesting, but the introduction is brief and superficial and the reproductions are quite poor by today's standards.

DECORATIONS OVER THE MAIN STAIRWAY AND LIBRARY: JOHN SINGER

SARGENT: HISTORY AND DESCRIPTION WITH PLAN. Boston: Museum of Fine Arts, 1925. 21 p. Illus.

> The text of this pamphlet is almost exclusively devoted to explaining the Greek mythological subject matter, rather than information about Sargent or the very academic style he adopted here. (These "decorations," plus the very impressive murals on the third floor of the Boston Public Library lack adequate reproduction or documentation.)

Downes, William Howe. JOHN S. SARGENT: HIS LIFE AND WORK. Boston: Little, Brown, 1925. 313 p. Illus.

> An extensive monograph published the year of Sargent's death. Includes three parts: "Outline Sketch of Sargent's Life," "Oil Paintings, Studies and Sketches, Watercolors and Drawings, with Notes," and "Bibliography." The prose is now quite dated, but there is careful documentation of many of Sargent's works, and a lengthy bibliography of early writings on Sargent.

*Hoopes, Donelson F. SARGENT WATERCOLORS. New York: Watson Guptill in cooperation with the Metropolitan Museum of Art and the Brooklyn Museum of Art, 1970. 87 p. Illus., 32 color plates. Bibliography p. 10. Index pp. 86-87.

> Written as a companion volume to Hoopes' WINSLOW HOMER WATERCOLORS (see HOMER), this brief volume is a very attractive compilation of good color plates. The watercolors are all from the Metropolitan Museum and the Brooklyn Museum, and are among Sargent's most appealing works. There is an abbreviated summary of Sargent's life and career; a brief explication faces each reproduction.

McKibbin, David. SARGENT'S BOSTON: WITH AN ESSAY AND A BIOGRAPHICAL SUMMARY AND A COMPLETE CHECK LIST OF SARGENT'S PORTRAITS. Boston: Museum of Fine Arts, 1956. 132 p. Illus., plates, frontispiece in color.

> Catalog which accompanied an extensive exhibition celebrating the centennial of Sargent's birth. Contains a biographical summary, checklist of his portraits, and a number of adequate reproductions.

*Mount, Charles Merrill. JOHN SINGER SARGENT: A BIOGRAPHY. London: The Cresset Press, 1957. 371 p. Illus. Index pp. 364-71.

> This is considered by many critics to be the standard biography of Sargent. Mount is esteemed as an authority on Sargent, and has also been accused of unfairly taking advantage of this fact (NEW YORK TIMES, September 23, 1967, p. 27, column 3).

*Ormond, Richard. JOHN SINGER SARGENT: PAINTINGS, DRAWINGS, WATERCOLORS. New York: Harper, 1970. 264 p. Illus., many color plates.

A heavily illustrated biography. Many good full-page plates, and many details of paintings included.

(Also see: IND. 20TH C. ARTISTS. Vol 2: pp. 65-86, 13a. Vol. 3: no. 11-12, pp. 49-50; N.Y. MET. 19TH C.; A.A.A.)

\*  \*  \*  \*  \*

SAUL, PETER 1934-

Zack, David. "That's Saul Folks." ART NEWS, vol. 68, November 1969, p. 56. Illus., color.

Brief introductory article about an artist whose canvases are often outrageous, often controversial. Zack calls Saul the "Funk art father figure."

\*  \*  \*  \*  \*

SCHAMBERG, MORTON LIVINGSTON 1882-1918

Wolf, Ben. MORTON LIVINGSTON SCHAMBERG: A MONOGRAPH. Philadelphia: University of Pennsylvania Press, 1963. 125 p. Illus., one in color. Bibliography p. 125.

Schamberg was close to Duchamp and the New York Dada movement before he died in the influenza epidemic of 1918. This is an excellent monograph which revives his reputation as a significant American painter.

\*  \*  \*  \*  \*

SCHNAKENBERG, HENRY ERNEST 1892-1971

Goodrich, Lloyd. H.E. SCHNAKENBERG. New York: Whitney Museum of American Art, 1931. 54 p. Illus.

Monograph consisting of a brief essay on the artist and reproductions of landscapes, figurative paintings, and still lives painted in in the 1920's and early 1930's. Goodrich refers to Schnakenberg as a "modern realist."

(Also see: A.A.A.)

\*  \*  \*  \*  \*

SHAHN, BEN 1898-1969

BEN SHAHN. Tokyo: The National Museum of Modern Art, 1970. 182 p. Illus., many color plates.

A handsome and rather large exhibition catalog consisting mostly of excellent reproductions of Shahn's paintings and posters from the 1930's through the 1960's. The small amount of text is in English

and Japanese.

*Bush, Martin H. BEN SHAHN: THE PASSION OF SACCO AND VANZETTI; WITH AN ESSAY AND COMMENTARY BY BEN SHAHN. Syracuse: Syracuse University , 1968. 87 p. Illus., some color plates. Bibliography pp. 78-85. Index pp. 86-87.

Shahn did a mosaic mural for Syracuse University on the theme of the Sacco and Vanzetti trial, a subject which fascinated and outraged Shahn. This book traces his interest in the trial, and includes early works as well as the final mosaic and studies for it. An essay by Shahn, "American Painting at Mid-Century," is included (pp. 48-76).

Morse, John D., ed. BEN SHAHN. New York: Praeger, 1972. 228 p. Illus., some in color. Bibliography pp. 219-26.

A well-illustrated monograph, with a chronology and brief essay on Shahn by Morse and a lengthy bibliography. Most of the text, however, consists of previously published statements and essays by the artist.

Rodman, Selden. PORTRAIT OF THE ARTIST AS AN AMERICAN: BEN SHAHN: A BIOGRAPHY WITH PICTURES. New York: Harper, 1951. 180 p. Illus., some in color.

A popularly written biography, with a stout defense of the artist's political and social involvement. Much of the text is devoted to the subject matter of Shahn's works. The defense is no longer necessary, and the viewpoint now dated.

Shahn, Ben. THE BIOGRAPHY OF A PAINTING. New York: Paragraphic-Grossman, 1966. Unpaged. Illus., many color facsimiles.

One of a number of books illustrated and hand-lettered by Shahn. In this he describes his painting processes.

_____. ECCLESIASTES: OR THE PREACHER. New York: Grossman, 1967. Unpaged. Illus., facsimiles.

Handsome hand-lettered and illustrated chapter from the Old Testament, in facsimile.

_____. LOVE AND JOY ABOUT LETTERS. New York: Grossman, 1963. 79 p. Illus., color facsimiles.

Lavishly illustrated book on lettering, most done by Shahn.

_____. THE SHAPE OF CONTENT. Cambridge: Harvard University Press, 1967 (c. 1957). 131 p. Illus., color frontispeice.

Begun as a lecture to Harvard students (Charles Eliot Norton Lectures, 1956-57), Shahn discusses his own painting as well as that of many contemporaries, particularly abstract expressionists, and his philosophy of modern art.

Shahn, Bernarda Bryson.  BEN SHAHN.  New York:  Abrams, 1972.  373 p.
Illus., many color plates.  Bibliography pp. 357-63.  Index pp. 365-69.

> A mammoth picture book.  This is a tribute to Shahn by his wife.
> Excellent reproductions.

Soby, James Thrall.  BEN SHAHN:  PAINTINGS.  New York:  Braziller,
1963.  Illus., many in color.  Bibliography pp. 139-44.

> The brief introductory text by Soby (chairman of the Committee on
> the Museum Collections, Museum of Modern Art, New York) is a
> good summary of Shahn's career from 1929 to the early 1960's.
> Gives an excellent bibliography, and a chronology, but most of
> this book is composed of reproductions.  There is a companion vol-
> ume written by Soby:  BEN SHAHN; HIS GRAPHIC ART.  (New
> York:  Braziller, 1963.)

(Also see:  HUNTER, p. 467; A.A.A.)

\* \* \* \* \*

SHARPLES FAMILY

Knox, Katherine McCook.  THE SHARPLES:  THEIR PORTRAITS OF GEORGE
WASHINGTON AND HIS CONTEMPORARIES.  New Haven:  Yale University
Press, 1930.  133 p.  Illus.  Index pp. 127-33.

> A scholarly study of a family which immigrated to the United
> States from England, several of whom became sought-after portrait-
> ists.  This quotes at length from the diary of Ellen Wallace Sharples
> (1769-1849), portraitist and wife of James Sharples (1750?-1811),
> and mother of James, Jr. (1788-1839) and Rolinda (1793?-1838),
> also portraitists.  After the death of the elder James the family
> returned to England, except for Felix Thomas Sharples (1786?-
> 1824), James' son by a previous marriage.

\* \* \* \* \*

SHEELER, CHARLES  1883-1965

Dochterman, Lillian.  THE QUEST OF CHARLES SHEELER:  83 WORKS HON-
ORING HIS 80TH YEAR.  Iowa City:  The University of Iowa, 1963.  53 p.
Illus., some color plates.  Bibliography pp. 45-46.

> Most of the text of this exhibition catalog is devoted to stylistic
> analysis.  There are three essays appended:  "Sheeler's Cubist
> Milieu, 1910-1918"; "Origins of Cubist Realist Style"; "Photog-
> raphy as a Stylistic Influence."

Friedman, Martin et al.  CHARLES SHEELER.  Washington, D.C.:  published
for the National Collection of Fine Arts by the Smithsonian Institution Press,
1968.  155 p.  Illus., some color plates.  "Exhibitions and Related Refer-
ences" pp. 100-7.

Catalog of a major exhibition of Sheeler's works, this is a compendium of many reproductions, as well as several essays by and about Sheeler. Extensive bibliographic coverage.

Kramer, Hilton. "Charles Sheeler: American Pastoral...'A Certain Mode of Pastoral Romance.'" ARTFORUM, vol. 7, January 1969, pp. 36-39. Illus.

A tribute to Sheeler as an artist. Kramer characterizes the artist's work as primarily cubist, and at "the farthest possible remove from Dada."

Rourke, Constance. CHARLES SHEELER: ARTIST IN THE AMERICAN TRADITION. New York: Harcourt Brace, 1938. 203 p. Illus. Reprint: New York: Kennedy Galleries, 1969.

An early, thoughtful biography of Sheeler which is still quite readable. The discussions of his work remain valid.

Williams, William Carlos, introduction. CHARLES SHEELER: PAINTINGS, DRAWINGS, PHOTOGRAPHS. New York: Museum of Modern Art, 1939. 53 p. Illus. Bibliography pp. 14-15. Reprint: New York: Arno, 1972?, as part of THREE PAINTERS OF AMERICA: CHARLES DEMUTH, CHARLES SHEELER, EDWARD HOPPER.

This is the catalog of an important early exhibition of Sheeler's handsome, stark works. This combination of his drawings, paintings and photographs reveals how closely related they are. Sheeler had a consistent vision. There is little text but the bibliography is helpful for early sources.

(Also see: HUNTER, p. 467; IND. 20TH C. ARTISTS. Vol. 3: pp. 229-31, no. 11-12, p. 76; A.A.A.)

\* \* \* \* \*

SHINN, EVERETT 1876-1953

(See: HUNTER, p. 468; A.A.A.)

\* \* \* \* \*

SLOAN, JOHN 1871-1951

Brooks, Van Wyck. JOHN SLOAN: A PAINTER'S LIFE. New York: E.P. Dutton, 1955. 246 p. Illus. Index pp. 241-46.

A biography of Sloan by a friend who was a noted essayist. This was written shortly after Sloan's death, and is filled with intimate observations of the artist who was best known earlier in the century as a leader of the "Ash Can Group." Written for the layman in a popular style.

Goodrich, Lloyd. JOHN SLOAN. New York: published for the Whitney Museum of American Art by the Macmillan Co., 1952. 80 p. Illus., a few color plates. Bibliography pp. 78-80. "Research by Rosalind Irvine."

> Monograph written in conjunction with a retrospective exhibition of Sloan's work arranged by the Whitney, which traveled to the Corcoran Gallery and the Toledo Museum. A good survey of Sloan's work, with a brief biographical outline and information about the New York art world of the early twentieth century.

*St. John, Bruce. JOHN SLOAN. New York: Praeger, 1971. 156 p. Illus., some color plates. Bibliography pp. 150-52. Index pp. 153-56.

> An attractive, if brief, survey of Sloan's life and career as an artist. St. John states that the book was "prompted by research and preparation for a fifty-year anniversary celebration of the exhibition of Independent Artists, 1910." Includes reproductions of works done from 1884 (when Sloan would have been only thirteen) to 1951.

*Scott, David and Bullard, E. John. JOHN SLOAN, HIS LIFE AND PAINTINGS BY DAVID W. SCOTT, HIS GRAPHICS BY E. JOHN BULLARD. Boston: Boston Book and Art and Washington, D.C.: National Gallery of Art, 1971. 215 p. Illus., some color plates. Bibliography pp. 211-13. Index of works pp. 214-15.

> A substantial exhibition catalog, issued in a hardbound edition. Heavily illustrated, with reproductions of works from 1890 to 1951 and many photographs of Sloan and his family and associates. Scholarly documentation, brief essays, and comments by Sloan under many of the reproductions.

(Also see: HUNTER, p. 468; IND. 20TH. C. ARTISTS. Vol. 1: pp. 167-74, 29a, 30a, 53a. Vol. 3: no. 11-12, pp. 35-36.)

\* \* \* \* \*

SMIBERT, JOHN 1688-1751

Foote, Henry Wilder. JOHN SMIBERT, PAINTER, WITH A DESCRIPTIVE CATALOGUE OF PORTRAITS AND NOTES ON THE WORK OF NATHANIEL SMIBERT. Cambridge: Harvard University Press, 1950. Reprint: New York: Kennedy Galleries and DaCapo Press, 1969. 292 p. Illus. Bibliography.

> A scholarly biography of John Smibert, an important early portrait painter who immigrated from Scotland. Contains a catalog of extant portraits, and a listing of portraits not located or of questionable attribution. This is the standard work on Smibert; the appendix contains information on his son Nathaniel, also a portrait painter.

SMIBERT, NATHANIEL 1735-1756. See: SMIBERT, JOHN.

SMITH, LEON POLK 1906-

Alloway, Lawrence, introduction. LEON POLK SMITH: AN EXHIBITION OF
THE POSES INSTITUTE OF FINE ARTS. Waltham, Mass.: Brandeis University,
Rose Art Museum; organized by the San Francisco Museum of Art, San Fran-
cisco, California, 1968. 24 p. Illus., cover and 2 plates color silkscreen
prints. References p. 11.

> Slim exhibition catalog with reproductions of Smith's handsome,
> simple, oil abstractions. The reproductions in silkscreen are very
> effective. The text is brief but an adequate introduction to the
> work of this "minimal" painter.

* * * * *

SOYER, MOSES 1899-

Smith, Bernard. MOSES SOYER. New York: A.C.A. Gallery, 1944.
59 p. Illus.

> Twin of Raphael Soyer, Moses' work is largely figurative, includ-
> ing many portraits. This is an early exhibition catalog with a
> good survey of the work done in the 1930's and 1940's. Brief
> but informative text.

Soyer, David. MOSES SOYER. South Brunswick, New Jersey: Barnes, 1970.
47 p., plus 127 plates, some in color.

> An attractive picture book, with reproductions of the artist's works
> from 1922 to 1969. David Soyer is Moses' son; he provides an
> affectionate biography, and describes his father's style as "realism"
> as opposed to "naturalism."

Willard, Charlotte, introduction. MOSES SOYER. Cleveland and New York:
World, 1962? 41 p. plus 134 plates, many in color.

> A good survey of the artist's works, mostly portraits and figure
> paintings. Some of the portraits are of important American artists,
> such as Milton Avery and Joseph Stella. The foreword by Philip
> Evergood describes his friendship and association with Soyer. Wil-
> lard's introduction is biographical.

(Also see: A.A.A.)

* * * * *

SOYER, RAPHAEL 1899-

Foster, Joseph K. RAPHAEL SOYER: DRAWINGS AND WATERCOLORS.
New York: Crown, 1968. 26 p., plus 124 plates, many in color.

> A popularly written introductory monograph on Raphael Soyer's
> work, mostly of reproductions. Raphael and his twin brother Moses
> were born in Russia in 1899 and came to the United States in 1912.
> Both became important in the 1930's and 1940's. This book presents

many intimate and revelatory reproductions, but all are undated.

*Goodrich, Lloyd. RAPHAEL SOYER. New York: Whitney Museum of American Art, distributed by Praeger, 1967. 77 p. Illus., some color plates. Bibliography pp. 72–74. Index p. 77.

Exhibition catalog issued as a monograph by Praeger, this is one of the best-documented and most thorough surveys of the artist's work.

_____. RAPHAEL SOYER. New York: Abrams, 1972. 349 p. Illus., 77 color plates. Bibliography pp. 339–42. Index pp. 342–48.

An oversize, heavily illustrated tribute to Soyer. The text is rather brief, and based heavily on the (above) exhibition catalog. The reproductions are lavish and are the main point of the book. Many photographs of Soyer and his associates are included. The text is printed in extra-large type on a green paper, and is not easy to read.

RAPHAEL SOYER. New York: American Artists Group, 1946. Unpaged. Illus. (Monograph no. 19)

Small monograph with poor reproductions. Soyer has written a brief autobiographical introduction, and there is a "Biographical Note" at the back.

(Also see: HUNTER, p. 468; A.A.A.)

\* \* \* \* \*

SPENCER, LILLY MARTIN 1822–1902 (Lily spelled variously)

Bolton-Smith, Robin and Truettner, William H. LILY MARTIN SPENCER, 1822–1902: THE JOYS OF SENTIMENT. Washington, D.C.: published for the National Collection of Fine Arts, 1973. 253 p. Illus., some color plates. Bibliography pp. 240–46.

Substantial exhibition catalog of an artist whose paintings of children and dogs enjoyed great popularity in the nineteenth century. The homely domestic and genre scenes are perilously close to illustration, and well within the Victorian narrative tradition. Lengthy bibliography included.

\* \* \* \* \*

STAMOS, THEODOROS 1922–

Pomeroy, Ralph. "Stamos' Sun Boxes." ART NEWS, vol. 67, March 1968, p. 30. Illus., color plate.

Article about a major Stamos show at the Emmerich Gallery, New York, which featured his large, colorful abstractions with evocative titles, such as "Aegean Sun Box," etc.

Sawyer, Kenneth B. STAMOS. Paris: G. Fall, 1960. 46 p. Illus., color plates. Bibliography p. 46.

> A small paperback monograph with 12 reproductions of Stamos' handsome abstract paintings. Text is largely biographical, and describes his relation to the New York art scene.

\* \* \* \* \*

STELLA, FRANK 1936-

Baker, Elizabeth C. "Frank Stella: Perspectives." ART NEWS, vol. 69, May 1970, p. 46. Illus. Color plate.

> Review of the major exhibition held at the Museum of Modern Art (catalog, below).

_____. "Frank Stella, Revival and Relief." ART NEWS, vol. 70, November 1971, p. 34. Illus., color plate.

> Review of an exhibition at the Rubin Gallery, New York, of Stella's shaped canvases and bas-relief works.

Cone, Jane Harrison. "Frank Stella's New Paintings." ARTFORUM, December 1967, pp. 34-41. Bibliographic notes. Illus., color plates.

> Lengthy article on Stella's paintings on shaped canvases of stripes in circles and half-circular arrangements.

Finklestein, Louis. "Seeing Stella." ARTFORUM, vol. 11, June 1973, pp. 67-70. Illus.

> Review of Stella's paintings on view at Castelli Gallery, New York, which were extremely complex shaped canvases.

Krauss, Rosalind. "Stella's New Work and the Problem of Series." ARTFORUM, vol. 10, December 1971, pp. 40-44. Illus., color plate. Bibliographic notes.

> Discussion of Stella's work in series and with his complex shaped abstract canvases. Refers to them as "sensuous."

Lebensztejn, Jean-Claude. "57 Steps to Hyena Stomp." ART NEWS, vol. 71, September 1972, p. 60. Illus.

> Tongue-in-cheek analysis of the "hidden system" in an abstract painting by Stella titled "Hyena Stomp."

Leider, Philip. "Literalism and Abstraction." ARTFORUM, vol. 8, April 1970, pp. 44-51. Illus., color plates.

> Leider discusses Stella's development as an artist in the 1960's as evidenced by the major exhibiton at the Museum of Modern Art, New York (catalog, below). Describes the paintings as "fans and rainbows within which an extensive range of color was employed."

McLean, John, introduction. FRANK STELLA: A RETROSPECTIVE EXHIBITION. London: Hayward Gallery, circulated under the auspices of the International Council of the Museum of Modern Art, New York, 1970. Unpaged. Illus., some color plates.

> A brief but attractive exhibition catalog of Stella's bright geometric abstractions. This serves as a good introduction to the work of this young artist.

RECENT PAINTINGS BY FRANK STELLA. Waltham, Massachusetts: Brandeis University, Poses Institute of Fine Arts, Rose Art Museum, 1968. 8 p. Illus. Bibliography.

> Very slight exhibition catalog with minimal text and a few reproductions. Fairly lengthy bibliography by Barbara Gould, however.

*Rosenblum, Robert. FRANK STELLA. Baltimore: Penguin Books, 1971. 62 p. Illus., many color plates. Bibliography pp. 59-60.

> Introductory monograph written for the non-specialist, with many attractive reproductions. The one flaw is the tiny type face, which is a chore to read.

*Rubin, William S. FRANK STELLA. New York: Museum of Modern Art, distributed by the New York Graphic Society, Greenwich, Conn., 1970. 176 p. Illus., some color plates. Bibliography, pp. 161-70, compiled by Carolyn Lanchner. Index to illustrations pp. 71-75.

> The best work to date on Stella. Written to accompany a major exhibition by Rubin, who is a close friend of Stella's. Extensive documentation, although the biographical material is minimal.

(Also see: HUNTER, p. 468.)

<p style="text-align:center">*　*　*　*　*</p>

STELLA, JOSEPH 1877-1946

Baur, John I.H. JOSEPH STELLA. New York: Praeger, 1971. 154 p. Illus., some color plates. Bibliography pp. 145-49. Index pp. 151-54. Research by Irma B. Jaffe.

> Stella, born in Italy as Giuseppe Carlo Stella, is best known for his spare, abstracted view of the Brooklyn Bridge. This monograph was written to accompany a major retrospective at the Whitney Museum. Baur describes well Stella's "peculiarly American hybridization of realism and abstraction." Extensive bibliography.

*Jaffe, Irma B. JOSEPH STELLA. Cambridge: Harvard University Press, 1970, 114 p. Illus., frontispiece in color. Bibliography pp. 231-36. Index pp. 255-62.

> A careful study of Stella's life and work, many details of which are unknown. This includes extensive documentation in the appendixes: "Texts of writings by Stella," "Texts of foreign language

quotations," "Catalogue of works illustrated," "Checklist of works by Stella."

(Also see: HUNTER, p. 469.)

\*   \*   \*   \*   \*

STERNE, MAURICE  1878-1957

Kallen, H.M., introduction.  MAURICE STERNE: RETROSPECTIVE EXHIBITION, 1902-1932; PAINTINGS, SCULPTURE, DRAWING.  New York:  Museum of Modern Art, 1933.  39 p.  Illus.  Bibliography pp. 19-20.

The brief biographical introduction by Kallen is followed by "A Note by the Artist" in this slim exhibition catalog issued by the (then) very young Museum of Modern Art (founded 1929).  The work by Sterne is largely figural, and shows the influence of Cezanne.

Sterne, Maurice.  SHADOW AND LIGHT: THE LIFE, FRIENDS AND OPIN-IONS OF MAURICE STERN.  New York:  Harcourt, Brace and World, 1965. Edited by Charlotte Leon Mayerson, introduction by George Biddle.  266 p. Illus., some color plates.

Sterne was the first American to be given a one-man exhibition by the Museum of Modern Art (catalog, above).  This is an auto-biography, composed largely of his own notes, with narration and editing by Mayerson and the artist's wife, Vera.  An interesting view of the American art world in the early part of the twentieth century.

\*   \*   \*   \*   \*

STETTHEIMER, FLORINE  1871-1944

McBride, Henry.  FLORINE STETTHEIMER.  New York:  Museum of Modern Art, distributed by Simon and Schuster, 1946.  56 p.  Illus., some color plates.  Bibliography pp. 55-56.

Catalog of a rather extensive exhibition of this artist's whimsical, decorative paintings.  McBride comments that "Miss Stettheimer died in May 1944, unrecognized as an artist by the world at large.  There were no obituaries in the newspapers.  Museums as a rule exist upon reputations ready-made, but this time it starts to make one.  The occasion, therefore, is unusual.  In fact, in my experience it is unprecedented."  McBride explains that it was because of her own choosing that Stettheimer remained "unrecog-nized," but the bibliography indicates that she was not so very obscure after all.

Tyler, Parker.  FLORINE STETTHEIMER: A LIFE IN ART.  New York:  Farrar Straus, 1963.  194 p.  Illus., some color plates.  "Prelude" by Carl Van Vechten.

An extensive study of Stettheimer's life and her painting, which was a skillful combination of the "primitive" and the sophisticated.

\* \* \* \* \*

STILL, CLYFFORD 1904-

CLYFFORD STILL. New York: Marlborough-Gerson Gallery, 1969. 89 p. Illus., many color plates.

Catalog issued by Still's dealer, with many handsome color reproductions of his characteristic abstracts, mounted on gray paper. Chronological arrangement of works from 1943 to 1966. No text except for a short "Chronology" of the artist's life and brief documentation of the illustrations.

Hess, Thomas B. "The Outsider." ART NEWS, vol. 68, December 1969, p. 34. Illus., color plates.

Written upon the occasion of a large exhibition at the Marlborough-Gerson Gallery, New York (catalog, above), Hess comments in this article that "Still is usually considered the master of a dark, violent abstract expressionism," yet he is actually "a much more varied artist...."

Kuh, Katherine, foreword. CLYFFORD STILL: THIRTY THREE PAINTINGS IN THE ALBRIGHT-KNOX ART GALLERY. Buffalo, New York: The Buffalo Fine Arts Academy, 1966. 87 p. Illus., 33 color plates. Biographical notes by Ethel Moore, statement by Clyfford Still.

The Albright Art Gallery mounted a major exhibition of Still's work in 1959. In 1964, Still made a gift of 31 paintings to the museum, now called the Albright-Knox Art Gallery. This book is a collection of reproductions of the paintings in that gift, plus the two canvases already owned by the museum. There is little text and minimal documentation, but the reproductions are handsome.

McCaughey, Patrick. "Clyfford Still and the Gothic Imagination." ARTFORUM, vol. 8, April 1970, pp. 56-61. Illus., color plates. Bibliographic notes.

An article on Still's work in which McCaughey likens Still's paintings to "Gothic" art forms, by which he means fantastic and irrational yet very rich and of a whole.

Sharpless, Ti-Grace. CLIFFORD STILL. Philadelphia: University of Pennsylvania, Institute of Contemporary Art, 1963. Unpaged. Illus., some color plates.

The text of this exhibition catalog is a poetic, free-flowing essay of the author's impressions of Still and his work. Mostly reproductions of works from 1937 to 1963, with little documentation.

(Also see: HUNTER, p. 469.)

STUART, GILBERT  1755-1828

Fielding, Mantle.  GILBERT STUART'S PORTRAITS OF GEORGE WASHINGTON. Philadelphia:  printed for the Subscribers, 1923.  264 p.  Illus.  Index pp. 259-64.

> Dated, but a careful compilation of information about 123 portraits by Stuart, along with a rather old-fashioned (in style, at least) biography of Stuart.

Flexner, James Thomas.  GILBERT STUART: A GREAT LIFE IN BRIEF.  New York: Knopf, 1955.  197 p.  Illus.  Bibliography pp. 193-97.

> Expanded version of that in his book, AMERICA'S OLD MASTERS. Anecdotal and written for young adults.

Morgan, John Hill.  GILBERT STUART AND HIS PUPILS: TOGETHER WITH THE COMPLETE NOTES ON PAINTING BY MATTHEW HARRIS JOUETT FROM CONVERSATIONS WITH GILBERT STUART IN 1816.  New York:  New York Historical Society, 1939.  102 p.  Illus.  Index pp. 95-102.  Reprint:  Kennedy Galleries and DaCapo Press, New York, 1969.

> Biographical study of Stuart, with brief information about more than 20 of his students.  The study is quite dated but uses letters and recorded conversations extensively, and is therefore an important source.

*Mount, Charles Merrill.  GILBERT STUART: A BIOGRAPHY.  New York: W.W. Norton, 1964.  384 p.  Illus.  Index pp. 380-84.  Bibliographic references included in notes pp. 333-56.

> The most readable of the existing biographies of Stuart.  This is directed at the educated generalist rather than the art historian. Many reproductions of his portraits are included, although all are in black and white.

_____.  PORTRAITS BY GILBERT STUART, 1755-1828.  Philadelphia:  Pennsylvania Academy of the Fine Arts, 1963.  19 p.  Illus.

> Brief exhibition catalog, with text by Mount, stressing Stuart's involvement with Philadelphia.  The reproductions are black and white and, unfortunately, smaller than postage stamps.

Park, Lawrence.  GILBERT STUART:  AN ILLUSTRATED DESCRIPTIVE LIST OF HIS WORKS; COMPILED BY LAWRENCE PARK, WITH AN ACCOUNT OF HIS LIFE BY JOHN HILL MORGAN AND AN APPRECIATION BY ROYAL CORTISSOZ.  4 vols.  New York: W.E. Rudge, 1926.  Illus.

> A major study of Stuart and his work, including a catalogue raisonne of the artist's portraits and an alphabetically arranged index by surname of the sitters.  This study was completed by William Sawitzky, Mrs. E. Hadley Galbreath, John Hill Morgan, and Theodore Bolton, upon the death of the author.  Volumes 3 and 4 are composed entirely of plates of reproductions.

Whitley, William T. GILBERT STUART. Cambridge: Harvard University Press, 1932. 240 p. Bibliography pp. 227-28. Index pp. 231-40. Illus. Reprint: Kennedy Galleries, DaCapo Press, New York, 1969.

A standard biography of Stuart.

(Also see: N.Y. MET. 19TH C.)

\* \* \* \* \*

## SULLY, THOMAS 1783-1872

Biddle, Edward and Fielding, Mantle. THE LIFE AND WORKS OF THOMAS SULLY, 1783-1872. Philadelphia: M. Fielding, 1921. 411 p. Illus. Reprint: Kennedy Graphics and DaCapo Press, 1970.

Apparently the only substantial monograph on Sully and his work, this was privately printed in a limited edition. The style of writing is quite dated, but the extensive use of letters and documents makes it valuable for study. The list of paintings included is derived from Sully's own handwritten list at the Historical Society of Pennsylvania, and includes the price Sully received for each work.

Sully, Thomas. HINTS TO YOUNG PAINTERS: A HISTORIC TREATISE ON THE COLOR, EXPRESSION AND PAINTING TECHNIQUES OF AMERICAN ARTISTS OF THE COLONIAL AND FEDERAL PERIODS. New York: Reinhold, 1965. 46 p. Illus., facsimiles. Reprint of 1873 edition, with new introduction by Faber Birren.

Probably the earliest American book on painting techniques. Includes formulas, suggestions for arrangement of equipment, and color combinations.

(Also see: N.Y. MET. 19TH C.)

\* \* \* \* \*

## TANNER, HENRY OSSAWA 1859-1937

THE ART OF HENRY OSSAWA TANNER, 1859-1937; FROM THE COLLECTION OF THE MUSEUM OF AFRICAN ART, FREDERICK DOUGLASS INSTITUTE, WASHINGTON, D.C.; EXHIBITION SPONSORED BY THE HYDE COLLECTION, GLENS FALLS, N.Y.; STUDIO MUSEUM IN HARLEM; FREDERICK DOUGLASS INSTITUTE. Glens Falls, N.Y.: Hyde Collection, 1972. 32 p. Illus. Bibliography pp. 30-32.

Illustrated exhibition catalog of the work of this important Black American artist.

"Henry Ossawa Tanner." ART NEWS, vol. 66, December 1967, p. 47. Illus.

Review of an exhibition of Tanner's work held at the Grand Central Gallery, New York. "The first Negro member of the National Academy of Design and the first Negro American painter to gain an international reputation...."

Mathews, Marcia M. HENRY OSSAWA TANNER, AMERICAN ARTIST. Chicago: University of Chicago Press, 1969. 261 p. Illus., some color plates. Bibliographical footnotes.

> The standard biography of Tanner, who studied under Thomas Eakins and traveled extensively. Many letters and writings by contemporaries included.

(Also see: A.A.A.)

\* \* \* \* \*

TAUBES, FREDERIC 1900–

FREDERIC TAUBES. New York: American Artists Group, 1946. Unpaged. Illus. (Monograph no. 20)

> Taubes is better known today as the author of numerous books on art techniques rather than as an artist himself. This little monograph shows his mature painting style, and gives some information about his life and career. The rather poor reproductions are typical of this series.

\* \* \* \* \*

TCHELITCHEW, PAVEL 1898–1957

Soby, James Thrall. TCHELITCHEW: PAINTINGS, DRAWINGS. New York: Museum of Modern Art, 1942. 100 p. Illus., some color plates. Bibliography pp. 98–100.

> Catalog of the most extensive exhibition of Tchelitchew's work ever held. Pages 32–34 are devoted to the best-known of his paintings, "Hide and Seek," which remains one of the most popular paintings at the Museum of Modern Art.

Tyler, Parker. THE DIVINE COMEDY OF PAVEL TCHELITCHEW. New York: Fleet, 1967. 504 p. Illus., frontispiece in color. Bibliography pp. 493–95. Index pp. 497–504.

> The most complete biography of Tchelitchew, a Russian aristocrat who left Russia first for Europe, then later settled in the United States. An extensive bibliography is included.

\* \* \* \* \*

THAYER, ABBOTT HANDERSON 1849–1921

White, Nelson C. ABBOTT H. THAYER. Hartford: Connecticut Printers, 1951. 277 p. Illus., some color plates. Bibliography pp. 265–69. Index pp. 271–77.

> Thayer was a painter of portraits, still lifes, and genre scenes, as well as a color theorist. This substantial monograph about the

man and his work makes use of numerous letters and other contemporary writings about him. The plates included, however, are all undated.

(Also see: A.A.A.)

\* \* \* \* \*

THEUS, JEREMIAH (c. 1719-1774)

Middleton, Margaret. JEREMIAH THEUS, COLONIAL ARTIST OF CHARLES TOWN. Columbia, S.C.: University of South Carolina Press, 1953. 218 p. Illus. Bibliography pp. 187-89. Index pp. 191-218.

The standard work on an early portraitist, with a checklist and many illustrations. Theus was born in Switzerland and immigrated to the United States around 1835. His many portraits have a rather primitive charm, but the reproductions in this book are not particularly good.

\* \* \* \* \*

THIEBAUD, WAYNE 1920-

Coplans, John. WAYNE THIEBAUD. Pasadena, Calif.: Pasadena Art Museum, 1968. 66 p. Illus., some color plates. Bibliography pp. 45-54.

An exhibition catalog of Thiebaud's paintings and etchings, most of which depict food. Thiebaud is best known as a pop artist, whose food portraits are decorative and impersonal. Coplan's text is brief though informative; this is the most extensive collection of reproductions of his work published to date.

\* \* \* \* \*

TOBEY, MARK 1890-

Roberts, Colette. MARK TOBEY. New York: Grove Press, 1959. 63 p. Illus., some color plates. (Published in hard and soft cover.)

In a text translated from the French, Roberts describes Tobey's paintings as "symbolic abstractions." This slim volume was intended as an introductory work for the layman. Includes "Landmarks in Mark Tobey's experience," a chronology (pp. 15-31).

Russell, John. "Tobey at 80." ART NEWS, vol. 69, December 1970, p. 43. Illus., color plates.

An article reviewing several exhibitions held in honor of Tobey's 80th birthday.

Schmied, Wieland. TOBEY. New York: Abrams, 1966. 85 p. Illus., 17 color plates. Bibliography pp. 82-83. List of plates pp. 84-85. Translated from the German by Margaret L. Kaplan.

European appreciation of Tobey's work was stimulated by an important retrospective held at the Louvre's Musee des Arts Decoratifs in 1961, and at the Whitechapel Gallery, London, in 1962. This slim monograph was first published in Stuttgart by Verlag Gerd Hatje, as one of a series on modern artists. The text is adequate, though brief, but the color plates are blurred and the colors poor.

Seitz, William C. MARK TOBEY. New York: Museum of Modern Art, in collaboration with the Cleveland Museum of Art and the Art Institute of Chicago, distributed by Doubleday, 1962. 112 p. Illus., a few color plates. Bibliography pp. 100-6, by Inga Forslund. Index pp. 111-12.

The most scholarly work on Tobey to date, this exhibition catalog accompanied a major traveling show. The bibliography is extensive.

TOBEY. Basel, Switzerland: Galerie Beyeler, 1970. Unpaged. Illus., many color plates.

There were several exhibitions held in 1970 of Tobey's work, the year of his 80th birthday. This handsome catalog, with many excellent color plates, accompanied a large exhibition held in Basel, where Tobey has lived since 1960. A brief introduction (in German) by Marischa Burckhardt and a number of statements by Tobey (in English) comprise the text.

TOBEY'S 80: A RETROSPECTIVE. Seattle: Seattle Art Museum and The University of Washington Press, 1970. Unpaged. Illus., many color plates. Foreword by Richard E. Fuller, introduction by Betty Bowen.

Bowen describes the text of this exhibition catalog as an "unscholarly narrative of the growth of the Seattle Art Museum's Tobey collection..." (acknowledgements). Nevertheless, this attractive exhibition catalog reproduces a substantial number of Tobey's works, dating back to the 1920's. The color plates tend to be a little muddy.

*Tobey, Mark. THE WORLD OF A MARKET. Seattle: University of Washington Press, 1964. 15 p., plus 64 plates, some in color.

"The sketches in this book show my feelings for the Seattle Market ..." (artist's statement). An attractive picture book which had its origin in an exhibition at the Seattle Art Museum entitled "Mark Tobey and the Seattle Public Market." There is little text other than the "Artist's Statement," but the reproductions of drawings and watercolors are quite good.

(Also see: HUNTER, p. 469.)

TOMLIN, BRADLEY WALKER 1899-1953

Baur, John I.H. BRADLEY WALKER TOMLIN. New York: published by Macmillan for the Whitney Museum of American Art, 1957. 62 p. Illus., some color plates. Bibliography pp. 60-61.

Written to accompany a major retrospective held four years after the artist's death, this is the best study of the artist's life and work. Includes notes on the artist by Philip Guston, Robert Motherwell, Duncan Phillips, and Frederick S. Wight.

(Also see: HUNTER, p. 469; A.A.A.)

\* \* \* \* \*

TRUMBULL, JOHN 1756-1843

Sizer, Theodore, ed. THE AUTOBIOGRAPHY OF COLONEL JOHN TRUMBULL. New Haven: Yale University Press, 1953. 404 p. Bibliographic footnotes included. Index pp. 395-404.

First published in 1841, Trumbull's was the first full-length autobiography of an artist published in the United States. Sizer has edited the text and provided extensive footnotes, plus an appendix, to make it more comprehensible to the modern reader.

Sizer, Theodore. THE WORKS OF COLONEL JOHN TRUMBULL: ARTIST OF THE AMERICAN REVOLUTION. New Haven: Yale University Press, 1967. 181 p., plus illustrations. Bibliographic note pp. 9-10.

Revision of a study published in 1950, this is primarily a checklist of Trumbull's works, which are portraits, historical and religious paintings, and landscapes. Appendix includes: "Trumbull's Painting Procedure," "Trumbull's Prices," "Trumbull's Variations of the American Flag," "The John Trumbulls and Madame Vigee Lebrun." In the brief biographical note, Sizer comments that "Trumbull is the earliest American college graduate (Harvard) to become a professional painter" (p.6).

(Also see: N.Y. MET. 19TH C.; A.A.A.)

\* \* \* \* \*

TWACHTMAN, JOHN HENRY 1853-1902

Tucker, Allen. JOHN H. TWACHTMAN. New York: Whitney Museum of American Art, 1931. 57 p. Illus. Bibliography pp. 14-15.

Twachtman is considered by many critics to be one of the authentic "American impressionists." He was also an influential teacher during the early years of the Art Student's League in New York. This is a slim, introductory book, but it provides an adequate description of his life and career. (See also: Hoopes. THE AMERICAN IMPRESSIONISTS.)

(Also see: IND. 20TH C. ARTISTS. Vol. 2: pp. 87-91, 15a. Vol. 3: no. 11-12, p. 51; N.Y. MET. 19TH C.)

TWORKOV, JACK  1900–

*Bryant, Edward.  JACK TWORKOV.  New York:  Praeger for the Whitney Museum of American Art, 1964.  56 p.  Illus., some color plates.  Bibliography pp. 54–56.

> Issued both as an exhibition catalog and a monograph, this is the best publication to date on Tworkov and his work.  The text concentrates on the artist's career from the middle 1940's to the early 1960's, when he was a major force in the abstract expressionist movement.

Tuchman, Phyllis.  "An Interview with Jack Tworkov."  ARTFORUM, vol. 9, January 1971, pp. 62–68.

> Tworkov discusses his painting and the abstract expressionist movement, stating "I begin to see less and less conflict between intuition and reason."

\*    \*    \*    \*    \*

VANDERLYN, JOHN  1775–1852

Lindsay, Kenneth C.  THE WORKS OF JOHN VANDERLYN, FROM TAMMANY TO THE CAPITOL.  Binghamton:  State University of New York at Binghamton, 1970.  150 p.  Illus.  Bibliography p. 155.

> A substantial monograph issued in conjunction with a large exhibition of this lesser-known portraitist, landscape, and historical scene painter.  Black and white plates only.

(Also see:  N.Y. MET. 19TH C.)

\*    \*    \*    \*    \*

VEDDER, ELIHU  1836–1923

CATALOGUE OF AN EXHIBITION OF THE WORKS OF ELIHU VEDDER....
New York:  American Academy of Arts and Letters, 1937.  68 p.  Illus.

> Brief exhibition catalog, with a biographical sketch of Vedder's life by John C. Van Dyke.

Soria, Regina.  ELIHU VEDDER:  AMERICAN VISIONARY ARTIST IN ROME.  Rutherford, N.J.:  Fairleigh Dickinson University Press, 1970.  413 p.  Illus.  Bibliography pp. 389–401.  Index pp. 403–13.

> An exhaustive study of Vedder's life and works, making use of letters and many other primary and secondary documents.  Vedder spent much of his life in Rome; his works consist of depictions of myths, genre, and landscape paintings, portraits, and a number of "ideal heads."  Extensive bibliography included.

Vedder, Elihu.  THE DIGRESSIONS OF V.; WRITTEN FOR HIS OWN FUN;

CONTAINING THE QUAINT LEGENDS OF HIS INFANCY, AN ACCOUNT OF HIS STAY IN FLORENCE, THE GARDEN OF LOST OPPORTUNITIES, RETURN HOME ON THE TRACK OF COLUMBUS, HIS STRUGGLE IN NEW YORK IN WAR-TIME COINCIDING WITH THAT OF THE NATION, HIS PROLONGED STAY IN ROME, AND LIKEWISE HIS PRATTLINGS UPON ART, TAMPERINGS IN LITERATURE, STRUGGLES WITH VERSE, AND MANY OTHER THINGS, BEING A PORTRAIT OF HIMSELF FROM YOUTH TO AGE; WITH MANY ILLUSTRATIONS BY THE AUTHOR. Boston and New York: Houghton Mifflin, 1910. 521 p. Illus., some in color.

A lengthy, digressive autobiography, written in a personal manner and intended for Vedder's friends.

(Also see: N.Y. MET. 19TH C.; A.A.A.)

* * * * *

WARHOL, ANDY 1930-

Coplans, John. ANDY WARHOL. Greenwich, Conn.: New York Graphic Society, 1970. 160 p. Illus., some color plates. Bibliography pp. 157-60. Contributions by Jonas Mekas and Calvin Tomkins.

A popularly written monograph meant to be an introduction to Warhol's paintings and graphics, published in conjunction with a major retrospective exhibition of his work held at the Pasadena Art Museum.

Crone, Rainer. ANDY WARHOL. New York: Praeger, 1970. 332 p. Illus., some in color. Catalogue raisonne pp. 285-312. "Filmography" pp. 313-14. Bibliography pp. 318-31.

The most extensive monograph on Warhol published to date. Crone believes that Warhol is "the most important living artist in North America for the history of the visual arts and film" (p. 9), and he attempts to explain and document this point of view. The text is rather brief, although informative, but most of the book is comprised of reproductions. The majority of reproductions are in black and white, although there are a few in the crudest possible color. Unfortunately, the text and plates are all printed on very poor-quality paper--barely a step above newspaper, which has discolored badly in the few years since it was printed.

Gidal, Peter. ANDY WARHOL: FILMS AND PAINTINGS. London: Studio Vista; New York: Dutton Pictureback, 1971. 160 p. Illus. Index p. 157.

A small paperback meant as an introduction for the layman. In describing Warhol's paintings, Gidal says: "One can speak of Warhol as having been a painter, although strictly speaking, he mostly silkscreened his images and then, sometimes, would 'touch up' the finished pictures by hand" (p. 18).

Perreault, John. "Andy Warhola, This is Your Life." ART NEWS, vol. 69,

May 1970, p. 52. Illus.

Review of a large retrospective of Warhol's work held at the Pasadena Art Museum.

Warhol, Andy et al., eds. ANDY WARHOL. New York: Worldwide Books, 1969, 2nd ed. Unpaged. Illus.

A picture book published on the occasion of a large exhibition held at the Moderna Museet, Stockholm, Sweden. In addition to reproductions of his works, there are a number of photographs of Warhol and his friends. The only text is a collection of Warhol quotations, in English and Swedish. Similar to the Crone book, this is printed on very poor-quality paper, which has now discolored.

(Also see: HUNTER, p. 469.)

\* \* \* \* \*

WATKINS, FRANKLIN 1894-

Ritchie, Andrew C. FRANKLIN C. WATKINS. New York: Museum of Modern Art, 1950. 48 p. Illus., color frontispiece. Bibliography by Anne Bollman pp. 47-48.

A small monograph, made up largely of black and white reproductions of the artist's figure paintings. Brief text stresses his academic roots; his "Advice to students" is included (pp. 43-44).

Wolf, Ben. FRANKLIN C. WATKINS: PORTRAIT OF A PAINTER. Philadelphia: University of Pennsylvania Press, 1966. 103 p. Illus., some in color. Bibliography p. 103.

Biography of Watkins, a New York-born Philadelphia artist who is best known for his mural commissioned by Yale University's Beinecke Library. Wolf's style of writing is informal and personal, and he includes interviews with Watkins.

\* \* \* \* \*

WAUGH, FREDERICK JUDD 1861-1940

Havens, George R. FREDERICK J. WAUGH: AMERICAN MARINE PAINTER. Orono: University of Maine, 1969. 361 p. Illus., 2 color plates. Bibliography pp. 261-81. Index pp. 351-61.

Waugh's seascapes have enjoyed enormous popularity during his lifetime and since, although they are rarely included in histories of American art. His are the prototypical ocean paintings. This is the only monograph to have appeared so far, and it is a rich source of information about Waugh's life, his painting, and the location of works today.

WEBER, MAX   1881-1961

FIFTY YEARS OF PAINTINGS BY MAX WEBER.  New York:  Dannenberg Galleries, 1969.  48 p.  Illus.

> A dealer's catalog reproducing works from a large Weber show, which incoudes paintings spanning the first half of the twentieth century.  The text is an excerpt from Lloyd Goodrich's essay on Weber included in Baur's NEW ART IN AMERICA (New York: Graphic, 1957, above).

Goodrich, Lloyd.  MAX WEBER.  New York:  published for the Whitney Museum of American Art by the Macmillan Co., 1949.  58 p.  Illus., frontispiece in color.  Bibliography pp. 57-58.

> Written to accompany a large Weber exhibition held at the Whitney in 1949, this is an introductory volume meant for the layman, not the art historian.  Goodrich traces Weber's life and painting styles with a sympathetic intimacy.

MAX WEBER.  New York:  American Artists Group, 1945.  Unpaged.  (Monograph no. 4)  Illus., frontispiece in color.

> A small picture book, similar to the others in this series.  Small, rather poor black and white reproductions make up most of the book; the text consists of statements by Weber.

MAX WEBER: RETROSPECTIVE EXHIBITION, 1907-1930.  New York:  Museum of Modern Art, 1930.  22 p.  Illus.

> One of the earliest exhibition catalogs produced by the Museum of Modern Art, this lacks the scholarship and documentation of later publications.  Seventeen paintings are reproduced in black and white; there is a brief unsigned essay on Weber, and no bibliography.

Story, Ala.  FIRST COMPREHENSIVE RETROSPECTIVE EXHIBITION IN THE WEST OF OILS, GOUACHES, PASTELS, DRAWINGS AND GRAPHIC WORKS BY MAX WEBER, 1881-1961":  SELECTED AND COORDINATED BY MRS. ALA STORY.  Santa Barbara:  The Art Galleries, University of California at Santa Barbara, 1968.  86 p.  Illus.  Bibliography pp. 24-27.

> Catalog of a large traveling exhibition of Weber's work which originated in Santa Barbara and was also seen at the California Palace of the Legion of Honor, San Francisco; The Phoenix Museum of Art; and The Fine Arts Gallery of San Diego.  Works from 1907 to 1955 were shown, including Weber's very early abstract paintings.  Weber was a defender of cubism and abstract expressionism.  The plates in this catalog are good, although they are all black and white reproductions.

(Also see:  HUNTER, p. 470; IND. 20TH C. ARTISTS.  Vol. 4:  pp. 349-52; A.A.A.)

WEIR, JULIAN ALDEN  1852-1919

Phillips, Duncan et al.  JULIAN ALDEN WEIR:  AN APPRECIATION OF HIS
LIFE AND WORKS.  New York:  Dutton, 1922.  Illus.

> A collection of brief essays on Weir and a large number of black
> and white reproductions of his works, put together shortly after
> the artist's death.  Includes a catalog of his works prepared by
> Dorothy Weir, the artist's daughter.

Young, Dorothy Weir.  THE LIFE AND LETTERS OF J. ALDEN WEIR.  New
Haven:  Yale University Press, 1960.  277 p.  Illus.  Index pp. 263-77.

> A biography by Weir's daughter.  Weir had correspondences with
> Whistler, Sargent, Ryder, and others important in the art world at
> the turn of the century, and many letters are included.  There are
> only a few of his paintings reproduced at the back of the book,
> but they show his mature style, often described as that of an Amer-
> ican impressionist.

(Also see:  N.Y. MET. 19TH C.)

*  *  *  *  *

WESSELMAN, TOM  1931-

NEW WORK BY WESSELMAN.  New York:  Sidney Janis Gallery, 1970.  Un-
paged.  Illus.

> Catalog issued by Wesselman's dealer, consisting entirely of black
> and white reproductions of paintings by this pop artist.  These
> stylized nudes and abstracted arrangements of female anatomy show
> a closer affinity to surrealist works than pop art, however.

(Also see:  HUNTER, p. 470.)

*  *  *  *  *

WEST, BENJAMIN  1738-1820

Evans, Grose.  BENJAMIN WEST AND THE TASTE OF HIS TIMES.  Carbon-
dale:  Southern Illinois University Press, 1959.  144 p.  Illus., color frontis-
piece.  Bibliography pp. 129-38.

> A monograph which concentrates on West's later works, done when
> he was in England, and his influence in Europe and America.
> Lengthy bibliography.

Galt, John.  THE LIFE AND STUDIES OF BENJAMIN WEST, PRIOR TO HIS
ARRIVAL IN ENGLAND:  COMPILED FROM MATERIALS FURNISHED BY HIM-
SELF.  London:  Cadell, 1817.  160 p.

> A very early narration of the events in West's life in the United
> States (to 1760) and Italy (to 1863).  West was a charter member

of the Royal Academy of Arts, and served as its President during most of the time from 1792 to 1820.

Jackson, Henry Ezekial. BENJAMIN WEST, HIS LIFE AND WORK: A MONO-GRAPH. Philadelphia: Winston, 1900. 115 p. Illus.

A rather dated biography written for the general reader, not the historian. Jackson calls West "the first great American painter" (p. 18).

(Also see: FLEXNER. AMERICA'S OLD MASTERS.)

\* \* \* \* \*

WHISTLER, JAMES ABBOTT MCNEILL 1834-1903

\*Holden, Donald. WHISTLER LANDSCAPES AND SEASCAPES. New York: Watson Guptill in cooperation with the Freer Gallery of Art, Smithsonian Institution, Washington, D.C., 1969. 87 p. Illus., 32 color plates. Bibliographic note p. 10. Index pp. 86-87.

This is a handsome picture book with excellent color reproductions of Whistler's later landscapes and seascapes. Some of these works are quite small, and are reproduced in the actual sizes. Many of these clearly show the seeds of abstract painting. Holden's introduction is a biography, and there is a brief stylistic analysis facing each plate. "With the possible exception of Degas, he was the wittiest man in the recorded history of art" (p. 11).

Kind, Joshua. "The Stinging Butterfly." ART NEWS, vol. 66, February 1968, p. 48. Illus., color plate.

Review of a large exhibition of Whistler's works held at the Chicago Art Institute. "Whistler's art, held in tension between close observation of reality and a radical estheticism...."

Laver, James. PAINTINGS BY JAMES MCNEILL WHISTLER. New York: Studio, 1938? Unpaged. Illus., several color plates.

A large picture book with fairly good reproductions and a readable and authoritative text.

Menpes, Mortimer. WHISTLER AS I KNEW HIM. London: Adam and Charles Black, 1904. 15? p. Illus.

A chatty memoir published shortly after Whistler's death. Menpes attempts to smooth the rough edges of Whistler's reputation. The few reproductions are mostly works which were in the author's collection.

Pennell, Elizabeth Robins and Pennell, Joseph. THE LIFE OF JAMES MCNEILL WHISTLER, 2 vols. Philadelphia: J.B. Lippincott, and London: William Heinemann, 1908. 315 and 328 p. Illus. Index (vol. 2) pp. 315-28.

An important early biography which has been published in several editions. The Pennells managed to remain close friends with the notoriously difficult Whistler, and their book is filled with interesting facts. However, it is much too worshipful to be taken entirely seriously. Joseph Pennell was an important graphic artist in his own right.

_____. THE WHISTLER JOURNAL. Philadelphia: J.P. Lippincott, 1921. 339 p. Index pp. 329-39.

This is not Whistler's journal as one might assume from the title, but one kept by the Pennells. It covers the years 1900 to 1903, the last years of Whistler's life and years during which the Pennells were close to the artist. This is full of important source materials and background for an understanding of Whistler.

*Prideaux, Tom and the editors of Time Magazine. THE WORLD OF WHISTLER: 1834-1903. New York: Time-Life Books, 1970. 192 p. Illus., many color plates. Bibliography p. 187. Index pp. 189-92.

One of the better books for the layman or student for an understanding of Whistler and his paintings. There is an emphasis on the social milieu and the historical context. Excellent reproductions and a readable journalistic text, which has been based on thorough research.

Reff, Theodore. "The Butterfly and the Old Ox." ART NEWS, vol. 70, March 1971, p. 26. Illus., color plates.

Review of paintings by Whistler and his circle on exhibit at Wildenstein Gallery, New York.

*Sutton, Denys. JAMES MCNEILL WHISTLER: PAINTINGS, ETCHINGS, PASTELS AND WATERCOLORS. London: Phaidon Press, 1966. 199 p. Illus., 19 color plates. Bibliographic note p. 199.

A good comprehensive monograph on Whistler. No index, however, and the bibliographic note is inadequate. Mentions a major oeuvre catalog in preparation by Andrew McLaren Young of Glasgow University.

_____. NOCTURNE: THE ART OF JAMES MCNEILL WHISTLER. Philadelphia and New York: Lippincott, 1964. 153 p. Illus., some color plates. Index pp. 143-53.

An examination of Whistler's stylistic development, his relation to his contemporaries and his influences. Includes a good deal of biographical information, but is not strictly a biography.

Sweet, Frederick A. JAMES MCNEILL WHISTLER. Chicago: The Art Institute of Chicago and Utica, N.Y.: The Munson-Williams-Proctor Institute, 1968. 131 p. Illus., some color plates. Bibliography pp. 49-51.

Catalog of an important exhibition, with an excellent introductory

essay by Sweet. Additionally, an essay, "The Societe des Trois" by Carl Paul Barbier, describes the relationship of Whistler with the artists Fantin-LaTour and Legros.

Whistler, James A. McNeill. THE GENTLE ART OF MAKING ENEMIES: AS PLEASINGLY EXEMPLIFIED IN MANY INSTANCES WHEREIN THE SERIOUS ONES OF THIS EARTH CAREFULLY EXASPERATED, HAVE BEEN PRETTILY SPURRED ON TO UNSEEMLYNESS AND INDISCRETION WHILE OVERCOME WITH AN UNDUE SENSE OF RIGHT. New York: Putnam, 1953. 340 p. First published in 1890.

A collection of essays expressing Whistler's outrageous and candid opinions, mostly about art and the art world. Perhaps the best of his writings.

Young, Andrew McLaren. JAMES MCNEILL WHISTLER: AN EXHIBITION OF PAINTINGS AND OTHER WORKS. London: The Arts Council of Great Britain, and New York: Knoedler Galleries, 1960. 127 p. Illus., some color plates. Bibliography pp. 111-25.

Exhibition catalog with detailed information about each work. Young is reputed to be working on an exhaustive catalogue raisonne of Whistler's works. The bibliography included in this catalog is excellent, and it is annotated.

(Also see: N.Y. MET. 19TH C.; IND. 20TH C. ARTISTS. Vol. 1: pp. 129-56, 25a, 26a. Vol. 3: no. 11-12, pp. 29-31; A.A.A.)

\*    \*    \*    \*    \*

WHITTREDGE, THOMAS WORTHINGTON  1820-1910

Baur, John I.H., ed. THE AUTOBIOGRAPHY OF WORTHINGTON WHITTREDGE, 1820-1910. New York: Brooklyn Museum Journal, 1942, pp. 7-68. Illus. Reprint: New York: Arno, 1973?

Autobiography by a leading member of the Hudson River School who became president of the National Academy of Design, 1875 to 1876. This is a fascinating and often amusing chronicle of a long career, although parts have been condensed by Mr. Baur.

(Also see: N.Y. MET. 19TH C.; A.A.A.)

\*    \*    \*    \*    \*

WOOD, GRANT  1891-1942

Brown, Hazel E. GRANT WOOD AND MARVIN CONE: ARTISTS OF AN ERA. Ames: The Iowa State University Press, 1972. 150 p. Illus., some in color.

Biographies of two artists who were life-long friends. A warm and familiar memoir by Cone, who knew both artists well. Both artists painted in a homely realistic manner which was admired more in

previous decades.

Garwood, Darrell. ARTIST IN IOWA: A LIFE OF GRANT WOOD. New York: Norton, 1944. Reprint: New York: Greenwood, 1971. 259 p. Illus. Index pp. 255-59.

An admiring and anecdotal biography of an artist who is considered prototypically American. His "American Gothic" painting (1930) remains a classic.

(Also see: HUNTER, p. 470; IND. 20TH C. ARTISTS. Vol. 2: pp. 111-12, 20a. Vol. 3: no. 11-12, p. 58; A.A.A.)

\*     \*     \*     \*     \*

WYANT, ALEXANDER HELWIG  1836-1872

Clark, Eliot. ALEXANDER WYANT. New York: privately printed, 1920. 145 p. Illus., color frontispiece.

Biography of a nineteenth-century landscape painter of the Hudson River school. The reproductions are handsome photo-engravings, and while the title, size and collection are given, they are undated. He is compared to the French artists of the Barbizon school, but the text is more descriptive of his paintings than truly informative about his life and career.

(Also see:  N.Y. MET. 19TH C.)

\*     \*     \*     \*     \*

WYETH, ANDREW 1917-

*McCord, David, introduction. ANDREW WYETH. Boston: Museum of Fine Arts, distributed by New York Graphic Society, 1970. 224 p. Illus., 24 color plates. Index of titles p. 224.

An attractive picture book of the work of one of America's most popular artists. This was issued in conjunction with a large exhibition of Wyeth's work held during the Museum of Fine Arts' centennial celebration. McCord's brief essay is a charming personal memoir, but the main point of the book is the reproductions.

Meryman, Richard. ANDREW WYETH. Boston: Houghton Mifflin, 1968. 174 p. Illus., many color plates. Index of paintings and drawings pp. 169-74.

An oversized volume of the highest quality. There is very little text, but the reproductions are exceptional. A beautifully designed book, first-rate for experiencing Wyeth's work. Although this book would be an excellent addition to any library collection, its original high price and the fact that it is no longer on the market makes it an unlikely choice for a small unspecialized collection.

*Mongan, Agnes, introduction. ANDREW WYETH, DRY BRUSH AND PENCIL DRAWINGS. Cambridge: Harvard University, Fogg Art Museum, distributed by the New York Graphic Society, 1963. 73 p. Illus., some color plates.

> A handsome exhibition catalog which was also issued as a hard-bound book by New York Graphic. Again, this is mainly a book of reproductions. There are, however, only a few of Wyeth's finished works included, for most of the reproductions are of sketches and unfinished works. The result is a sense of intimacy rare in art books.

Richardson, Edgar P. ANDREW WYETH: TEMPERAS, WATERCOLORS, DRY BRUSH DRAWINGS; 1938 INTO 1966. Philadelphia: Pennsylvania Academy of the Fine Arts, 1966. 111 p. Illus., some color plates.

> Catalog of a large traveling exhibition. Richardson's text is more informative than most of the essays on Wyeth in other published monographs. The reproductions are quite good, and include a broad survey of his works.

(Also see: HUNTER, p. 470.)

<center>* * * * *</center>

WYETH, NEWELL CONVERS 1882-1945

Allen, Douglas and Allen, Douglas, Jr. N.C. WYETH: THE COLLECTED PAINTINGS, ILLUSTRATIONS AND MURALS. New York: Crown, 1972. 335 p. Illus., many color plates. Foreword by Paul Hogan, introduction by Richard Layton. "A bibliography of the published work of N.C. Wyeth" pp. 193-286. Bibliographic index pp. 319-28.

> A comprehensive survey of N.C. Wyeth's life and work. N.C. Wyeth was the father of Andrew Wyeth, and is better known for his book illustrations than for his paintings and murals. The reproductions are only fair in this book, presumably because many are taken from published reproductions rather than the originals.

Wyeth, Betsy James, ed. THE WYETHS: THE LETTERS OF N.C. WYETH, 1901-1945. Boston: Gambit, 1971. 858 p. Illus., some color plates. Index pp. 849-58.

> A rich source book for background information about the Wyeth family, and the artists in the family circle. Because it is composed largely of letters, this is a warm and intimate portrait of N.C. Wyeth and family. A strong optimism and faith is revealed.

WYETH FAMILY. See (above): ANDREW WYETH AND N.C. WYETH.

(Also see: Pitz. THE BRANDYWINE TRADITION.)

<center>* * * * *</center>

YUNKERS, ADJA 1900-

Sawyer, Kenneth. ADJA YUNKERS: RECENT PAINTINGS. Baltimore: Baltimore Museum of Art, 1960. 23 p. Illus., one color plate. Bibliography pp. 18-19.

> Brief exhibition catalog of the work of this abstract artist of the New York school. Statement by the artist and an extensive bibliography included.

(Also see: A.A.A.)

\* \* \* \* \*

ZORACH, WILLIAM 1887-1966

Hoopes, Donelson F. WILLIAM ZORACH: PAINTINGS, WATERCOLORS AND DRAWINGS, 1911-1922. New York: The Brooklyn Museum, 1968. 71 p. Illus., some color plates.

> Zorach is known today primarily for his sculpture, but he began his career as a painter. This catalog documents the early work and reveals his sophistication and awareness of European movements. After 1922 he gave up painting altogether and turned entirely to sculpture.

(Also see: HUNTER, p. 470; A.A.A.)

Chapter 7

# SOURCES: EARLY WRITINGS ON AMERICAN ART

# Chapter 7

# SOURCES: EARLY WRITINGS ON AMERICAN ART

Below are listed works which may be considered important source books, and must be read with an understanding of the period in which they were written. Often modern scholarship has rendered them obsolete. Early books on individual artists have, in many cases, been included in the previous section of this guide.

Benjamin, Samuel G.W. OUR AMERICAN ARTISTS. Boston: Lothrop, 1879. 62 p. Illus.

> Sentimental, anecdotal essays on artists, presumably for children or young adults, illustrated by wood engravings. Contents: W.H. Beard, A.F. Bellows, R.S. Gifford, W.M. Chase, S.R. Gifford, W. Shirlaw, J.J. Enneking, T.W. Wood, S. Colman, W. Thompson, G.L. Brown, D. Neal. The reputations of most of these artists have fallen into obscurity today.

Caffin, Charles Henry. AMERICAN MASTERS OF PAINTING: BEING BRIEF APPRECIATIONS OF SOME AMERICAN MASTERS. New York: Doubleday Page, 1906. 195 p. Illus.

> Rather hopelessly outdated essays on: George Inness, John La Farge, J.A. McNeill Whistler, John Singer Sargent, Winslow Homer, Edwin A. Abbey, George Fuller, Homer D. Martin, George de Forest Brush, Alexander H. Wyant, Dwight W. Tryon, Horatio Walker, and Gilbert Stuart.

_____. THE STORY OF AMERICAN PAINTING. New York: Stokes, 1907. 396 p. Illus. Index pp. 387-96.

> One of the earliest histories of American art, with strong emphasis upon the European influences.

Cummings, Thomas S. HISTORIC ANNALS OF THE NATIONAL ACADEMY OF DESIGN, NEW YORK DRAWING ASSOCIATION, ETC., WITH THE OCCASIONAL DOTTINGS BY THE WAY-SIDE FROM 1825 TO THE PRESENT TIME. Philadelphia: G.W. Childs, 1865. 364 p.

An important early history of the National Academy of Design, which exerted a great deal more influence in the nineteenth century than in the twentieth century. This includes letters, reports, addresses, documents, and lists of officers, and is a useful volume for research.

Dunlap, William. A HISTORY OF THE RISE AND PROGRESS OF THE ARTS OF DESIGN IN THE UNITED STATES, 3 vols. Boston: Goodspeed, 1918 (rev. ed.). Reprint of 1834 edition: Peter Smith, n.d.

First published in 1834, this was one of the first histories of the arts in America. The emphasis is upon the European tradition in the United States, and there is extensive biographical information about many early artists, including Benjamin West, John Smibert, John Trumbull, Washington Allston. Also included is information about academies, art patronage, and discourse between the United States and Europe. The 1918 edition has an extensive bibliography by Frank H. Chase at the end of Volume 3, which is an exhaustive list of early sources.

French, H.W. ART AND ARTISTS IN CONNECTICUT. Boston: Lee and Shepherd, New York: C.T. Dillingham, 1879. 176 p. Illus. Reprint: New York: Kennedy Graphics, 1970.

Histories of early art schools in Connecticut and biographies of nearly 200 artists, mostly nineteenth century painters. "Female artists" listed separately. The original edition has an exceptionally handsome Victorian cover with an elaborate stamped design.

Hartman, Sadakichi. A HISTORY OF AMERICAN ART, 2 vols. Boston: L.C. Page, 1902. Illus. Index pp. 357-63. Rev. ed.: New York: Tudor, 1934.

An anecdotal early history written for the layman. Very outdated now, some of the opinions expressed are surprising to today's reader (e.g., "John Singleton Copley was the only American artist of this period who did meritorious work before he came under foreign influences" p. 18).

Isham, Samuel. THE HISTORY OF AMERICAN PAINTING. New York: Macmillan, 1927. 608 p. Illus. Bibliography pp. 593-600. A reprint of the 1905 edition, with additions by Royal Cortissoz.

This was first published in 1905 as volume 3 of THE HISTORY OF AMERICAN ART, edited by J.C. Van Dyck. It is generally considered to be the first history of American painting to have applied professional standards of criticism, as well as logical history. Biographical rather than stylistic information is stressed, and it is overly chatty.

Jarves, James Jackson. THE ART IDEA. New York: Hurd and Houghton, 1864. Reprint: Cambridge: Harvard University Press, 1960. 313 p. Index pp. 307-13. Reprint edited and with an introduction by Benjamin Rowland.

Jarves is better known for his important art collection which is

now at Yale University. His writings about art are those of a
nineteenth-century American intellectual. This book was first pub-
lished as Part 2 of WHY AND WHAT AM I? in 1864 and 1865,
and in it Jarves expresses hearty disapproval of foreign and Roman
Catholic influences on art. He deplores the influence of the Church
to be seen in the history of European painting, and he predicts
that Protestantism and the spirit of democracy in America will fos-
ter a new and brilliant art.

Sheldon, George W. AMERICAN PAINTERS: WITH ONE HUNDRED AND
FOUR EXAMPLES OF THEIR WORK ENGRAVED ON WOOD. New York: Ap-
pleton, 1879. Reprint of 1881 edition: New York: Benjamin Blom, 1972.
288 p. Illus.

Essays on eighteenth and nineteenth century artists, many of whom
have now become obscure. Among the better-known: F.E. Church,
Winslow Homer, George Inness, Thomas Hicks, William Morris
Hunt, William Chase and Eastman Johnson. The original edition
has an exceptionally handsome gold-stamped Victorian binding.

_____. HOURS WITH ART AND ARTISTS. New York: Appleton, 1882.
182 p. Illus.

A collection of anecdotes and conversations with French, English
and American artists. Wood and steel engravings reproduce paint-
ings and the interiors of many artists' studios.

_____. RECENT IDEALS OF AMERICAN ART: 175 OIL PAINTINGS AND
WATERCOLORS IN THE GALLERIES OF PRIVATE COLLECTORS; REPRODUCED
IN PARIS ON COPPER PLATES BY THE GOUPIL PHOTOGRAVURE AND TYPO-
GRAVURE PROCESSES. New York: Appleton, 1890. 150 p. Illus.

The "taste of the time." The equivalent of today's coffee-table
book: a large, lavishly illustrated volume of the art considered
by Sheldon to be most important among his contemporaries. Sen-
timental genre and literary works predominate, and most of the
artists included have been forgotten today. However, scattered
among the salon-type paintings are works by Winslow Homer, East-
man Johnson, and Frederick Church. The reproductions are ex-
ceptionally fine.

Tuckerman, Henry. ARTIST-LIFE: OR SKETCHES OF AMERICAN PAINTERS.
New York: Appleton, 1847. 237 p.

Brief biographical essays on early American artists, including West,
Copley, Stuart, Trumbull, Allston, and others. The artists' first
names are usually not given, and dates are ignored, so that while
this is an important and very early source, it must be used with
caution.

_____. BOOK OF THE ARTISTS: AMERICAN ARTIST LIFE COMPRISING
BIOGRAPHICAL AND CRITICAL SKETCHES OF AMERICAN ARTISTS: PRE-
CEDED BY AN HISTORICAL ACCOUNT OF THE RISE AND PROGRESS OF

ART IN AMERICA. New York: G.P. Putnam's Sons, 1867. Reprint: New York: James F. Carr, 1966. 639 p. Index pp. 635-39.

Tuckerman includes the biographies of over 200 American artists in this major early work. The chronicles are inclined to be chatty, even gossipy, but this book is a spirited defense of American art. An appendix lists "American pictures in public and private collections."

# Chapter 8

# PERIODICALS

## Chapter 8

## PERIODICALS

AMERICAN ART JOURNAL (biennial, 1969-   ).   DaCapo Press/Kennedy Galleries, 20 East 56th Street, New York, New York  10022.  Indexed in:  ART INDEX.

AMERICAN ARTIST (monthly, September–July, 1937-   ).  1 Astor Plaza, New York, New York  10036.  Indexed in: ART INDEX, READERS' GUIDE, P.A.I.S.

AMERICAN HERITAGE:  MAGAZINE OF HISTORY (bimonthly, 1954-   ). American Heritage Publishing Co., 1221 Avenue of the Americas, New York, New York  10020.  Indexed in:  READERS' GUIDE.

AMERICAN MAGAZINE OF ART:  See:  MAGAZINE OF ART.

ANTIQUES (monthly, 1922-   ).  Straight Enterprises, 551 Fifth Avenue, New York, New York  10017.  Indexed in:  READERS' GUIDE.

ART AND ARTISTS (monthly, 1959-   ).  Hansom Books, Artillery Mansions, 75 Victoria Street, London, S.W.1, England.  Indexed in:  ART INDEX.

ART BULLETIN (quarterly, 1917-   ).  College Art Association, 16 East 52nd Street, New York, New York  10022.  Indexed in:  ART INDEX.

ART EDUCATION (nine times a year, 1948-   ).  National Art Education Association, 1201 16th Street, Washington, D.C.  20036.  Indexed in:  EDUCATION INDEX.

ART GALLERY (monthly, 1957-   ).  Hollycraft Press, Ivoryton, Connecticut 06442.

ART IN AMERICA (bimonthly, 1913-   ).  Whitney Communications Corp., Art in America, Corp., 150 East 58th Street, New York, New York  10022. Indexed in:  ART INDEX, READERS' GUIDE.

ART INTERNATIONAL (ten times a year, 1956-   ).  Via Maraini 17-A, 6900 Lugano, Switzerland.  Indexed in:  ART INDEX.

ART JOURNAL (formerly, COLLEGE ART JOURNAL, 1941-1960; quarterly, 1941-    ). College Art Association, 16 East 52nd Street, New York, New York 10022. Indexed in: ART INDEX.

ART NEWS (monthly, September-May; plus summer issue, 1902-    ). 750 Third Avenue, New York, New York 10017. Indexed in: ART INDEX, READERS' GUIDE.

ART TEACHER (three times a year, 1971-    ). National Education Association, 1201 16th Street, N.W., Washington, D.C. 20036. Indexed in: ART INDEX.

ART QUARTERLY (quarterly, 1938-    ). Detroit Institute of Arts, 5200 Woodward Avenue, Detroit, Michigan 48202. Indexed in: ART INDEX.

ARTFORUM (ten times a year, 1962-    ). 667 Madison Avenue, New York, New York 10021. Indexed in: ART INDEX.

Subscriptions: 155 Allen Boulevard, Farmingdale, New York 11735.

ARTS IN SOCIETY (three times a year, 1958-    ). University of Wisconsin, Extension, 610 Langdon Street, Madison, Wisconsin 53706. Indexed in: CURRENT INDEX TO JOURNALS IN EDUCATION.

ARTSCANADA (formerly, CANADIAN ART, 1943-1967; bimonthly, 1943-    ). 129 Adelaide W., Suite 4000, Toronto, M5H, Ontario, Canada. Indexed in: ART INDEX.

ART WEEK; WEST COAST ART NEWS (weekly, September-May; biweekly, June-August, 1970-    ). C. McCann, Box 2444, Castro Valley, California 94546.

ARTS AND ACTIVIITIES: THE TEACHERS ARTS AND CRAFTS GUIDE (monthly, September-June, 1937-    ). 8150 North Central Park Avenue, Skokie, Illinois 60076. Indexed in: EDUCATION INDEX.

ARTS MAGAZINE (bimonthly, 1926-    ). Art Digest, Inc., 23 East 26th Street, New York, New York 10010. Indexed in: ART INDEX.

ATELIER: See: STUDIO

AVALANCHE (quarterly, 1970-    ). 93 Grand Street, New York, New York 10003.

BULLETIN OF THE DETROIT INSTITUTE OF ARTS, (quarterly, 1919-    ). Founders Society, Detroit Institute of Arts, 5200 Woodward Avenue, Detroit, Michigan 48202. Indexed in: ART INDEX.

CREATIVE ART: A MAGAZINE OF FINE AND APPLIED ART 1927-33 New York: Boni. Merged into AMERICAN MAGAZINE OF ART.

FLASH ART (monthly, 1967-    ). Viale Piave 6, 20129 Milano, Italy.

THE JOURNAL OF AESTHETIC EDUCATION (quarterly, 1966-    ). University of Illinois Press, Urbana, Illinois 61801. Indexed in: EDUCATION INDEX,

PHILOSOPHICAL INDEX, SOCIAL SCIENCE & HUMANITIES INDEX.

THE INTERNATIONAL STUDIO, 1897-1931 London: Studio. Merged with CONNOISSEUR. Vol. 1-73, 1897-1921, American edition published.

JOURNAL OF AESTHETICS AND ART CRITICISM (quarterly, 1941-    ). American Society for Aesthetics, Cleveland Museum of Art, Cleveland, Ohio 44106. Indexed in: ART INDEX, PSYCHOLOGICAL ABSTRACTS, MUSIC INDEX.

LEONARDO (quarterly, 1968-    ). Pergamon Press, Oxford OX3 OBW, England. United States: Maxwell House, Fairview Park, Elmsford, New York 10523.

LITURGICAL ARTS (quarterly, 1931-    ). Liturgical Arts Society, 10 Ferry Street, Concord, New Hampshire 03301. Indexed in: ART INDEX, CATHOLIC INDEX.

MAGAZINE OF ART 1909-1953 Washington, D.C.: American Federation of Arts. Prior to 1936 titled: AMERICAN MAGAZINE OF ART. (There is a British MAGAZINE OF ART, published 1878-1904, also.) Indexed in: ART INDEX.

METROPOLITAN MUSEUM OF ART BULLETIN (quarterly, 1942-    ). (new series) Metropolitan Museum of Art, Fifth Avenue and 82nd Street, New York, New York 10028. Indexed in: ART INDEX.

MUSEUM OF MODERN ART, BULLETIN OF THE (1933-1961). New York: Museum of Modern Art. Indexed in: ART INDEX.

PICTURES ON EXHIBIT (monthly, October-May, 1937-    ). 30 East 60th Street, New York, New York 10022.

SCHOOL ARTS (ten times a year, 1901-    ). Davis Publications, 50 Portland Street, Worcester, Massachusetts 01608.

STUDIO INTERNATIONAL (formerly, THE STUDIO: AN ILLUSTRATED MAGAZINE OF FINE AND APPLIED ARTS, 1897-1926; CREATIVE ART, 1927-33: ATELIER, 1931-32; THE LONDON STUDIO, 1932-39; THE STUDIO, 1939-65; eleven times a year, 1893-    ). Studio International Publications Ltd., 14 West Central Street, London WC1A 1JH, England. Indexed: ART INDEX.

VVV (1942-44). New York: VVV. 4 volumes published. A surrealist magazine.

WASHINGTON INTERNATIONAL ARTS LETTER (ten times a year, 1962-    ). 1321 4th Street, Washington, D.C. 20024

*For brief descriptions of many older periodicals which are no longer published, see: HUNTER, p. 441.

Chapter 9

# MAJOR PUBLISHERS OF BOOKS
# ON AMERICAN PAINTING

Chapter 9

# MAJOR PUBLISHERS OF BOOKS ON AMERICAN PAINTING

Names and addresses of publishers may be found listed in BOOKS IN PRINT (New York: R.R. Bowker, annual) and also in LITERARY MARKET PLACE (New York: R.R. Bowker, annual). However, some of the most important ones are listed below.

Abrams, Harry N., Inc., 110 East 59th Street, New York, New York 10022.

Arno Press, A New York Times Co., 330 Madison Avenue, New York, New York 10017.

Boston Museum of Fine Arts, Boston, Massachusetts 02115.

> Books published by the Boston Museum of Fine Arts are often distributed by the New York Graphic Society.

Braziller, George, Inc., 1 Park Avenue, New York, New York 10016.

> Braziller distributes books published by the Smithsonian Institution Press.

University of California Press, 2223 Fulton Street, Berkeley, California 94720.

The University of Chicago Press, 11030 South Langley Avenue, Chicago, Illinois 60628.

DaCapo Press, 227 West 17th Street, New York, New York 10011.

> DaCapo is reprinting many classic works, in collaboration with Kennedy Galleries.

Dover Publications, Inc., 180 Varick Street, New York, New York 10014.

> Dover specializes in excellent and inexpensive reprints.

Gale Research Co., 700 Book Tower, Detroit, Michigan 48226.

Harvard University Press, Kittredge Hall, 79 Garden Street, Cambridge, Massachusetts 02138.

McGraw-Hill Book Co., 1221 Avenue of the Americas, New York, New York 10020.

The M.I.T. Press, Massachusetts Institute of Technology, Cambridge, Massachusetts 02142.

New York Graphic Society, Greenwich, Connecticut 06830.

New York Graphic Society distributes many of the publications of: New York Metropolitan Museum of Art; Boston Museum of Fine Arts; Asia House Gallery of the Asia Society; New York Museum of Modern Art; Baltimore Museum of Art; and the Brandywine River Museum.

Penguin Books, Inc., 7110 Ambassador Road, Baltimore, Maryland 21207.

Praeger Publishers, 111 Fourth Avenue, New York, New York 10003.

Praeger distributes Phaidon Press publications.

Princeton University Press, Princeton, New Jersey 08540.

St. Martin's Press, 175 Fifth Avenue, New York, New York 10010.

Tudor Publishing Co., 572 Fifth Avenue, New York, New York 10036.

Van Nostrand Reinhold Co., 450 West 33rd Street, New York, New York 10001.

Watson Guptill Publications, 165 West 46th Street, New York, New York 10036.

Yale University Press, 92A Yale Station, New Haven, Connecticut 06520.

## DISTRIBUTORS OF EXHIBITION CATALOGS

Wittenborn and Co., 1018 Madison Avenue, New York, New York 10021.

Worldwide Books, Inc., 1075 Commonwealth Avenue, Boston, Massachusetts 02117

Chapter 10

# SOME IMPORTANT LIBRARY RESEARCH COLLECTIONS FOR THE STUDY OF AMERICAN PAINTING

Chapter 10

# SOME IMPORTANT LIBRARY RESEARCH
# COLLECTIONS FOR THE STUDY OF AMERICAN PAINTING

Because of increasing demands by users, the escalating costs of materials, shrinking budgets, and the rarity of so many items, most of these libraries restrict access to their collections. You may be confident of free use only of the public libraries, and many of these do not circulate fine arts materials. If you wish to visit or use one of these collections, and are not certain of your access, please inquire in writing or by telephone first. It is usually advisable to make an appointment.

## CALIFORNIA

### Berkeley

University of California Library, Berkeley, California  94720.

### Los Angeles

Los Angeles County Museum of Art Library, 5905 Wilshire Boulevard, Los Angeles, California.

Los Angeles Public Library, Art and Music Department, 630 West 5th Street, Los Angeles, California  90017.

University of Southern California, Architecture and Fine Arts Library, 824 West 37th Street, Los Angeles, California  90007.

### Oakland

Oakland Public Library, Department of Fine Arts, 125 14th Street, Oakland, California  94612.

### San Diego

San Diego Public Library, Art and Music Section, 820 East Street, San Diego, California  92101.

### San Francisco

San Francisco Public Library, Art and Music Department, Civic Center, San Francisco, California  94102.

## CONNECTICUT

New Haven

Yale University Art Library, Art and Architecture Building, 1111 Chapel Street, New Haven, Connecticut 06510.

## DELAWARE

Winterthur

H.F. DuPont Winterthur Museum, Waldron Phoenix Belknap Library of American Painting, Winterthur, Delaware 19735.

## DISTRICT OF COLUMBIA

Washington

The Library of Congress, First Street, Washington, D.C. 20540.

Public Library of the District of Columbia, Art Division, Eighth and K Streets N.W., Washington, D.C. 20001.

Smithsonian Institution, National Collection of Fine Arts, National Portrait Gallery Branch Library, Eighth Street N.W., Washington, D.C. 20001.

## ILLINOIS

Chicago

Art Institute of Chicago, Ryerson Library, Chicago, Illinois 60603.

The Chicago Public Library, Art Department, 78 East Washington Street, Chicago, Illinois 60602.

## MARYLAND

Baltimore

Enoch Pratt Free Library, Fine Arts Department, 400 Cathedral Street, Baltimore, Maryland 21201.

Walters Art Gallery, Library, 600 North Charles Street, Baltimore, Maryland 21201.

## MASSACHUSETTS

Boston

Boston Public Library, Fine Arts Department, Copley Square, Boston, Massachusetts 02117.

Museum of Fine Arts, Library, 465 Huntington Avenue, Boston, Massachusetts 02115.

## Cambridge

Harvard University, Fine Arts Library, Fogg Museum, Quincy Street, Cambridge, Massachusetts 02117.

## Northampton

Smith College Library, Elm Street, Northampton, Massachusetts 01060.

## Wellesley

Wellesley College, Art Library, Jewett Art Center, Wellesley, Massachusetts 02181.

## MICHIGAN

## Ann Arbor

University of Michigan, Fine Arts Library, Ann Arbor, Michigan 48104.

## Detroit

Detroit Institute of Arts, Research Library, Detroit, Michigan 48202.

Detroit Public Library, Fine Arts Department, 5201 Woodward Avenue, Detroit, Michigan 48202.

## MISSOURI

## St. Louis

City Art Museum of St. Louis, Richardson Memorial Library, Forest Park, St. Louis, Missouri 63101.

St. Louis Public Library, 1301 Olive Street, St. Louis, Missouri 63103.

Washington University, Art and Architecture Library, St. Louis, Missouri 63105.

## NEW HAMPSHIRE

## Hanover

Dartmouth College, Art Library, Hanover, New Hampshire 03755.

## NEW JERSEY

## Newark

The Newark Museum, Library, 43-49 Washington Street, Newark, New Jersey 07101.

Newark Public Library, Art and Music Department, 5 Washington Street, Newark, New Jersey 07102.

## Princeton

Princeton University, Marquand Library, Department of Art and Archaeology, Princeton, New Jersey 08540.

## NEW YORK

### Hyde Park

Franklin D. Roosevelt Library, Hyde Park, New York 12538.

> A rich source for documentation of the Federal Art Projects.

### New York

American Academy of Arts and Letters Library, 633 West 155th Street, New York, New York 10032.

Brooklyn Museum Library, Eastern Parkway, Brooklyn, New York 11238.

Brooklyn Public Library, Art and Music Department, Grand Army Plaza, Brooklyn, New York 11238.

Columbia University, Fine Arts Library, Schermerhorn Hall, New York, New York 10027.

Columbia University, Oral History Collection, New York, New York 10027.

> Includes many interviews with artists and material on Federal Art Projects.

Frick Art Reference Library, 10 East 71st Street, New York, New York 10021.

> Includes the most extensive collection of photographs of American paintings.

The Metropolitan Museum of Art, Photograph & Slide Library, Thomas J. Watson Library, Fifth Avenue at 82nd Street, New York, New York 10028.

Museum of Modern Art Library, 21 West 53rd Street, New York, New York 10019.

New York Historical Society Library, 170 Central Park West, New York, New York 10024.

New York Public Library, Art and Architecture Division, Fifth Avenue and 42nd Street, New York, New York 10018.

New York University, Institute of Fine Arts, 1 East 78th Street, New York, New York 10021.

Pierpont Morgan Library, 29 East 36th Street, New York, New York 10016.

Queens Borough Public Library, Art and Music Division, 89-11 Merrick Boulevard, Jamaica, New York 11432.

Pratt Institute Library, Art and Architecture Department, Brooklyn, New York 11205.

Whitney Museum of American Art Library, Madison Avenue at 75th Street, New York, New York 10021.

## OHIO

### Athens

Ohio University, Fine Arts Library, Athens, Ohio 45701.

### Cincinnati

Public Library of Cincinnati and Hamilton, Art and Music Department, Eighth and Vine Streets, Cincinnati, Ohio 45202.

### Cleveland

Cleveland Museum of Art Library, 11150 East Boulevard, Cleveland, Ohio 44106

Cleveland Public Library, Fine Arts Department, 325 Superior Avenue, Cleveland, Ohio 44114.

### Columbus

Ohio State University, Fine Arts Library, 1858 Neil Avenue, Columbus, Ohio 43210.

### Oberlin

Oberlin College, Art Library, Allen Memorial Art Museum, Oberlin, Ohio 44074.

## PENNSYLVANIA

### Philadelphia

Free Library of Philadelphia, Art Department, Logan Square, Philadelphia, Pennsylvania 19103.

Moore College of Art Library, 20th and Race Streets, Philadelphia, Pennsylvania 19103.

Philadelphia College of Art Library, Broad and Pine Sts., Philadelphia, Pennsylvania 19101.

Philadelphia Museum of Art Library, Parkway at 26th Street, Philadelphia, Pennsylvania 19102.

### Pittsburgh

Carnegie Library of Pittsburgh, Art Division, Pittsburgh, Pennsylvania 15213.

University of Pittsburgh, Henry Clay Frick Arts Library, Pittsburgh, Pennsylvania 15213.

## RHODE ISLAND

### Providence

Rhode Island School of Design Library, 2 College Street, Providence, Rhode Island 02903.

## TEXAS

### Fort Worth

Amon Carter Museum of Western Art Library, Camp Bowie Boulevard, Fort Worth, Texas 76101.

## GENERAL REFERENCES FOR LIBRARY COLLECTIONS

AMERICAN ART DIRECTORY. New York: R.R. Bowker. Triennial.

> Many art libraries and their collections are described in the sec-
> tion "Museums and Art Organizations."

Ash, Lee and Lorenz, Denis. SUBJECT COLLECTIONS: A GUIDE TO SPECIAL
BOOK COLLECTIONS AND SUBJECT EMPHASIS AS REPORTED BY UNIVERSITY,
COLLEGE, PUBLIC AND SPECIAL LIBRARIES. New York: Bowker, 3rd ed.
1967.

> There are listings under the subject headings "Art," "Art, Ameri-
> can," "Design," etc. The lack of evaluation of the collections
> and the lack of an index to the book make this a less-than-perfect
> reference source.

Chamberlin, Mary. GUIDE TO ART REFERENCE BOOKS. (See listing in:
"BIBLIOGRAPHIES.")

> The section "Special collections and resources" (pp.345–60) lists
> many important art libraries all over the world. A few U.S. col-
> lections are described.

INTERNATIONAL DIRECTORY OF ARTS. (See: "Indexes and directories,"
listed under Rauschenbusch.)

> Addresses for many art libraries in most countries may be found in
> this excellent source.

Kruzas, Anthony T., ed. DIRECTORY OF SPECIAL LIBRARIES AND INFOR-
MATION CENTERS. 3 vols. Detroit: Gale Research, 2nd ed., 1968.

> This is particularly good for the smaller and private art libraries
> and private art libraries. Volume 1 is the directory itself, volume
> 2 is a geographic and personnel index, and volume 3 is a loose-
> leaf binder holding "New special libraries, a semiannual supple-
> ment."

SPECIAL LIBRARIES DIRECTORY OF GREATER NEW YORK. New York: Spe-
cial Libraries Association, 12th ed., 1972. (See the subject area: "Art,
Architecture and Archaeology.")

> Information about more than 1,000 special collections of all kinds
> in the New York area.

Steiner-Prag, Eleanor F. and MacKeigan, Helaine. AMERICAN LIBRARY DI-
RECTORY. New York: R.R. Bowker. Biennial.

> The basic directory to most U.S. libraries.

Chapter 11

# NATIONAL ART ORGANIZATIONS
# RELATING TO THE FIELD OF AMERICAN PAINTING

Chapter 11

# NATIONAL ART ORGANIZATIONS
# RELATING TO THE FIELD OF AMERICAN PAINTING

For a complete listing of U.S. art organizations, see the AMERICAN ART DI-
RECTORY (New York: Bowker, triennial).

American Association of Museums, 2333 Wisconsin Avenue, Washington, D.C.
20007.

American Federation of Arts, 41 East 65th Street, New York, New York 10021.

American Society for Aesthetics, c/o Virgil Aldrich, Department of Philosophy,
University of North Carolina, Chapel Hill, North Carolina 27515.

American Society of Contemporary Artists, c/o Nancy Ranson, 1299 Ocean
Avenue, New York, New York 11230.

American Watercolor Society, 1083 Fifth Avenue, New York, New York 10028.

Archives of American Art, Center: Eighth and G Street, N.W., Washington, D.C.

Regional Offices:

41 East 65th Street, New York, New York 10021.
5200 Woodward Avenue, Detroit, Michigan 48202.
87 Mount Vernon Street, Boston, Massachusetts 02108.
545 Canyon Road, Santa Fe, New Mexico.

*McCoy, Garnett. ARCHIVES OF AMERICAN ART: A DIRECTO-
RY OF RESOURCES. New York: R.R. Bowker, 1972. 163 p.
Index pp. 149-63.

This lists materials in the collection of the Archives. Personal
papers of painters, sculptors, art dealers, critics, curators and
institutions are collected for use by scholars. In the "Individ-
ual Artists" section of this information guide, I have indicated

*appropriate for a small library, which does not necessarily specialize in art books

by the designation A.A.A. when materials on the artist are in the Archives of American Art.

Art Dealers Association of America, Inc., 575 Madison Avenue, New York, New York 10021.

Artists Equity Association, 229 Broadway East, Seattle, Washington 98102.

Associated Councils of the Arts, 1564 Broadway, New York, New York 10036.

College Art Association, 432 Park Avenue, South, New York, New York 10016.

Inter-Society Color Council, c/o Fred W. Billmeyer, Jr., Department of Chemistry, Rensselaer Polytechnic Institute, Troy, New York 12181.

National Academy of Design, 1083 Fifth Avenue, New York, New York 10028.

Cummings, Thomas S. HISTORIC ANNALS OF THE NATIONAL ACADEMY OF DESIGN, NEW YORK DRAWING ASSOCIATION, ETC.; WITH OCCASIONAL DOTTINGS BY THE WAY-SIDE FROM 1825 TO THE PRESENT TIME. Philadelphia: Childs, 1865. Reprint: New York: Kennedy Galleries, 1971.

An early history of this art organization which exerted far more influence in the nineteenth century than in the twentieth. Includes many letters and various documents.

NATIONAL ACADEMY OF DESIGN EXHIBITION RECORD: 1826-1860, 2 vols. New York: New York Historical Society, 1943. 200 and 365 p.

Compilation of the annual exhibition records of this important institution. Artists arranged alphabetically and titles of paintings exhibited listed chronologically by date of exhibition. This is a major reference source for records of early to mid-nineteenth century American paintings and sculpture.

See also: Clark. HISTORY OF THE NATIONAL ACADEMY OF DESIGN.

Chapter 12

# MUSEUMS WITH IMPORTANT
# COLLECTIONS OF AMERICAN PAINTINGS

## Chapter 12

# MUSEUMS WITH IMPORTANT
# COLLECTIONS OF AMERICAN PAINTINGS

## ARIZONA

Tempe

Arizona State University, Collection of American Art, Tempe, Arizona 85281.

## CALIFORNIA

Los Angeles

Los Angeles County Museum of Art, 5905 Wilshire Boulevard, Los Angeles, California 90036.

San Francisco

M.H. De Young Memorial Museum, Golden Gate Park, San Francisco, California 94118.

> ILLUSTRATIONS OF SELECTED WORKS. San Francisco: M.H. De Young Memorial Museum, 1950. 155 p. Illus.
>
>> Reproductions of works from the collection, a few American works included. Little text.

## COLORADO

Colorado Springs

Colorado Springs Fine Arts Center, 30 West Dale Street, Colorado Springs, Colorado 80903.

## CONNECTICUT

Hartford

Wadsworth Atheneum, 25 Atheneum Square, N., Hartford, Connecticut 06103.

New Haven

Yale University Art Gallery, 1111 Chapel Street, New Haven, Connecticut 06510.

DELAWARE

Winterthur

The Henry Francis DuPont Winterthur Museum, Winterthur, Delaware  19735.

DISTRICT OF COLUMBIA

Washington

The Corcoran Gallery of Art, New York Avenue and 17th Street, Washington, D.C.  20006.

\* \* \* \* \*

The Phillips Collection, 1600 21st Street, N.W., Washington, D.C.  20009.

\* \* \* \* \*

Smithsonian Institution, National Collection of Fine Arts, Eighth and G Streets, Washington, D.C.  20565.

\* \* \* \* \*

Smithsonian Institution, National Gallery of Art, Sixth Street and Constitution Avenue, Washington, D.C.  20565.

> NATIONAL GALLERY, WASHINGTON.  New York:  Newsweek, 1968.  172 p.  Illus.

> > Heavily illustrated guide to the collection for the layman.  Introduction by John Walker.  Bibliography p. 168.

> Walker, John.  NATIONAL GALLERY OF ART:  WASHINGTON, D.C.  New York:  Abrams, 1963.  347 p.  Illus.

> > History of, and guide to, the collection.

\* \* \* \* \*

Smithsonian Institution, National Portrait Gallery, Eighth and F Streets, Washington, D.C.  20560.

\* \* \* \* \*

U.S. Capitol Building, Washington, D.C.  20540.

> COMPILATION OF WORKS OF ART AND OTHER OBJECTS IN THE UNITED STATES CAPITOL.  Washington, D.C.:  United States Government Printing Office, 1965.  427 p.  Illus.  Index pp. 404-26.

> > Catalog of the extensive collection housed in the Capitol Building.  "Prepared by the Architect of the Capitol under

the direction of the Joint Committee on the Library."

## ILLINOIS

### Chicago

The Art Institute of Chicago, Michigan Avenue at Adams Street, Chicago, Illinois 60603.

> Maxon, John. THE ART INSTITUTE OF CHICAGO. New York: Abrams, 1970. 288 p. Illus.

## KANSAS

### Wichita

Wichita Art Museum, 619 Stackman Drive, Wichita, Kansas 67203.

## MAINE

### Brunswick

Bowdoin College Museum of Art, Walker Art Building, Brunswick, Maine 04011.

### Waterville

Colby College Art Museum, Waterville, Maine 04901.

## MARYLAND

### Baltimore

Maryland Historical Society, 201 West Monument Street, Baltimore, Maryland 21201.

*    *    *    *    *

The Peale Museum, 225 North Holliday Street, Baltimore, Maryland 21202.

*    *    *    *    *

Walters Art Gallery, 600 North Charles Street, Baltimore, Maryland 21201.

## MASSACHUSETTS

### Amherst

Amherst College, Mead Art Building, Amherst, Massachusetts 01002.

### Andover

Addison Gallery of American Art, Phillips Academy, Andover, Massachusetts 01810.

## Boston

Massachusetts Historical Society, 1157 Boylston Street, Boston, Massachusetts 02215.

\*   \*   \*   \*   \*

Museum of Fine Arts, 469 Huntington Avenue, Boston, Massachusetts 02115.

ART NEWS, vol. 68, September 1969. Special issue: "Boston and the Boston Museum." Illus.

Articles included: "Boston is Here, Now" by John Koethe, and "The Boston Museum of Fine Arts, 1870-1970."

Cavallo, Adolph S. MUSEUM OF FINE ARTS, BOSTON: WEST-ERN ART. Greenwich, Conn.: distributed by New York Graphic Society, 1971. 211 p. Illus., many color plates.

Lavishly illustrated volume of reproductions of important works in the museum's collection. The emphasis is on European works, however, and only three American paintings are included. Very little text.

ILLUSTRATED HANDBOOK: MUSEUM OF FINE ARTS. Boston: Museum of Fine Arts, 1964. 389 p. Illus.

Guide to the entire collection; very few American paintings described.

Whitehill, Walter Muir. MUSEUM OF FINE ARTS: A CENTEN-NIAL HISTORY, 2 vols. Cambridge: Belknap Press of Harvard University, 1970. Illus. Includes notes and references.

A detailed and scholarly history of this excellent museum by a fine scholar. This stops short of the scandal of the Raphael painting and the retirement of Perry Rathbone.

(Also see: Boston. Museum of Fine Arts, M. AND M. KAROLIK collections; Hipkiss, Edwin J. EIGHTEENTH CENTURY....)

## Cambridge

Harvard University, William Hayes Fogg Art Museum, Quincy Street, Cambridge, Massachusetts 02138.

## Gloucester

Cape Ann Scientific, Literary and Historical Association, 27 Pleasant Street, Gloucester, Massachusetts 01930.

## Springfield

Museum of Fine Arts, 49 Chestnut Street, Springfield, Massachusetts 01103.

## Waltham

Brandeis University, Rose Art Museum, Waltham, Massachusetts 02154.

EXCHANGE EXHIBITION: EXHIBITION EXCHANGE. Waltham: Brandeis University, Poses Art Institute, and Providence: Rhode Island School of Design, 1967. Unpaged.

Catalog of an exchange exhibit of these two excellent museum collections. The Brandeis collection is one of the younger ones in the country, founded in 1951; R.I.S.D. is one of the older collections, founded in 1878. Brief histories of the collections are included.

## Wellesley

Wellesley College Art Museum, Jewett Art Center, Wellesley, Massachusetts 02181.

## Williamstown

Sterling and Francine Clark Art Institute, South Street, Williamstown, Massachusetts 01267.

## Worcester

Worcester Art Museum, 55 Salisbury Street, Worcester, Massachusetts 01608.

### MICHIGAN

## Ann Arbor

University of Michigan Museum of Art, Ann Arbor, Michigan 48104.

## Detroit

Detroit Institute of Arts, 5200 Woodward Avenue, Detroit, Michigan 48202.

### MINNESOTA

## Minneapolis

The Minneapolis Institute of Arts, 201 East 24th Street, Minneapolis, Minnesota 55404.

*     *     *     *     *

Walker Art Center, 1710 Lyndale Avenue South, Minneapolis, Minnesota 55403.

## MISSOURI

### Kansas City

William Rockhill Nelson Gallery of Art and Mary Atkins Museum of Fine Arts, 4525 Oak Street, Kansas City, Missouri 64111.

### St. Louis

City Art Museum of St. Louis, Forest Park, St. Louis, Missouri 63110.

## NEBRASKA

### Lincoln

University of Nebraska Art Galleries, Lincoln, Nebraska 68508.

## NEW JERSEY

### Newark

Newark Museum, 43-49 Washington Street, Newark, New Jersey 07101.

### Princeton

Princeton University, The Art Museum, Princeton, New Jersey 08540.

## NEW YORK

Faison, S. Lane, Jr. ART TOURS AND DETOURS IN NEW YORK STATE. New York: Random House, 1964. 303 p. Illus.

> Describes the collections of more than 75 museums and landmarks outside New York City. Useful mostly for the tourist and for brief information about collections, historic houses, etc.

Scott, Thomas J. GREATER NEW YORK ART DIRECTORY. New York: Center for Urban Education, 1968. 314 p.

> This lists information about art organizations in the New York area, including parts of Connecticut, New Jersey, Long Island, and Westchester County. Museums, art schools, associations, and brief biographical entries for many local artists. Already significantly out of date, however.

### Albany

Albany Institute of History and Art, 125 Washington Avenue, Albany, New York 12210.

### Buffalo

Albright-Knox Art Gallery, Buffalo Fine Arts Academy, 1285 Elmwood Avenue, Buffalo, New York 14222.

CONTEMPORARY ART; 1942-1972: ALBRIGHT-KNOX ART GAL-
LERY. New York: Praeger, 1972. 479 p. Many color plates.
Bibliographic footnotes.

> The Albright-Knox Art Gallery has one of the best col-
> lections of contemporary art, particularly contemporary
> American art, and this handsome catalog shows it off
> to advantage. Arranged by artists, with many biograph-
> ical entries and essays: "Abstract Expressionism" by Irv-
> ing Sandler, "Assemblage, Pop and Nouveau Realism,
> 1956-67" by Jan van der Marck, and "American Paint-
> ing since 1960" by Henry Geldzahler.

Ritchie, Andrew C. CATALOGUE OF CONTEMPORARY PAINT-
INGS AND SCULPTURE. Buffalo: The Fine Arts Academy, Al-
bright Art Gallery, 1949. 212 p. Illus.

> "A companion volume records the Galleries extensive
> collection mainly produced before 1900." Catalog of
> selected twentieth-century works, many of which are
> American.

PAINTINGS FROM THE ALBRIGHT-KNOX ART GALLERY (Buffalo,
New York). Washington, D.C.: National Gallery of Art, 1968.
96 p. Illus., some color plates.

> Catalog of an exhibition of paintings selected from this
> fine collection.

Townsend, J. Benjamin. 100, THE BUFFALO FINE ARTS ACADE-
MY, 1862-1962. Buffalo: Albright-Knox Art Gallery, 1962.
144 p. Illus., some color plates.

> A heavily illustrated history of one of the oldest museums in
> the U.S. The Buffalo Fine Arts Academy was organized in
> 1862, renamed the Albright Art Gallery in 1905, and finally,
> the Albright-Knox Art Gallery in 1962. An interesting fea-
> ture of this book is the "Outline History of Events in the World
> of Art," which chronicles events in the arts from 1500 to 1966,
> including the opening of major museums and influential exhibi-
> tions throughout the world.

## Canajoharie

Canajoharie Library and Art Gallery, 97 Church Street, Canajoharie, New
York 13317.

## Cooperstown

New York Historical Association, Fenimore House, Cooperstown, New York
13326.

## New York Museums - General Works

*Ashton, Dore. NEW YORK. New York: Holt, Rinehart and Winston, 1972.

(World Cultural Guide Series.) 288 p. Illus., several color plates. Bibliography p. 249. Index.

> A handsome and quite good guidebook to New York, describing museums, galleries, buildings, monuments and other cultural features of the city. Aimed at the tourist but useful to the librarian.

New York. Art Commission. CATALOGUE OF THE WORKS OF ART BELONGING TO THE CITY OF NEW YORK. New York: The Art Commission. Vol. 1, 1909; vol. 2, 1920. 241 and 113 p. Illus.

> Long out of date and out of print, these two volumes are compendia of information about paintings, statues, fountains, etc., owned by the city at the time of publication. Many of the works remain as described.

Osman, Randolph E. ART CENTERS OF THE WORLD: NEW YORK. Cleveland: World, 1968. 192 p. Illus., a few color plates.

> Another guidebook intended for the tourist, this describes several museum collections at length, as well as giving descriptive information about galleries, monuments, and other cultural information about the city.

## New York - Individual Museums

The Brooklyn Museum, Eastern Parkway and Washington Avenue, Brooklyn, New York 11238.

THE BROOKLYN MUSEUM HANDBOOK. New York: Brooklyn Museum, 1967. 551 p. Illus., a few color plates.

> Describes and pictures objects from the entire collection. American paintings to be found pp. 464-507.

Marlor, Clark S. A HISTORY OF THE BROOKLYN ART ASSOCIATION, WITH AN INDEX OF EXHIBITIONS. New York: James F. Carr, 1970. 421 p. Index p. 415-20. (Offset of typescript.)

> From 1859 to the 1880's, the Brooklyn Art Association was an important institution. But by the 1890's it barely functioned and was absorbed by the Brooklyn Institute of Arts and Sciences (the Brooklyn Museum). This is a detailed, scholarly history of nineteenth-century art activities in Brooklyn, then an important city in its own right.

\*　\*　\*　\*　\*

Frick Collection, 10 East 70th Street, New York, New York 10021.

THE FRICK COLLECTIONS: AN ILLUSTRATED CATALOGUE (to be nine volumes). New York: The Frick Collection, distributed by Princeton University, 1968-    .

> The Frick Collection is primarily of European works of art. The few American paintings--"George Washington"

by Gilbert Stuart (1795-96), and four by Whistler--are
in the first volume of this excellent multi-volume cata-
log of the museum's collection.

\* \* \* \* \*

The Metropolitan Museum of Art, Fifth Avenue at 82nd Street, New York,
New York 10028. The Metropolitan has one of the world's finest collections,
and the American paintings are outstanding. The museum is planning to open
"The American Bicentennial Wing" in 1976.

Clark, Kenneth. MATERPIECES OF FIFTY CENTURIES. New
York: Dutton, in association with the Metropolitan Museum of
Art, 1970. 336 p. Illus., some color plates. Bibliography
pp. 333-36.

Catalog of a large exhibition of works from the museum's
vast collections. Good documentation about major works
in the collection, although few American works were
included. On p. 331 is a listing of publications on the
American art works in the Metropolitan.

Gardner, Albert Ten Eyck and Feld, Stuart P. AMERICAN PAINT-
INGS: A CATALOGUE OF THE COLLECTION OF THE METRO-
POLITAN MUSEUM OF ART. New York: Metropolitan Museum
of Art, distributed by New York Graphic Society, Greenwich,
Conn., 1965- . Illus.

Projected as a multi-volume set, only vol. 1, "Painters
Born by 1815," has been published so far. These are
mostly portraits, and detailed information is given about
the painters, the sitters, the provenances of the paint-
ings. The reproductions are all in black and white,
and quite small.

*GUIDE TO THE METROPOLITAN MUSEUM OF ART. New York:
Metropolitan Museum of Art, 1972. 320 p. Illus. Index pp.
316-20. Paperback.

A handy survey of major objects in the museum's col-
lections. "American paintings and sculpture" is the
first chapter. The illustrations are all in black and
white. This is intended for the visitor, not the scholar.

Lerman, Leo. THE MUSEUM: ONE HUNDRED YEARS AND THE
METROPOLITAN MUSEUM OF ART. New York: Studio/Viking,
1969. 400 p. illus., some color plates. Index pp. 397-400.

A history of the museum and its collections, written for
the 1970 centennial celebration.

Virch, Claus, introduction. MASTERPIECES OF PAINTING IN
THE METROPOLITAN MUSEUM OF ART. Comments on the paint-
ings by Edith A. Standen and Thomas A. Folds. New York: Met-
ropolitan Museum of Art, distributed by the New York Graphic
Society, Greenwich, Conn., 1971? 120 p. Illus., many color
plates.

A handsome selection of some of the important paint-
ings with brief commentary. "American School" pp. 101-
18.

Also see:  N.Y. MET. 19TH C.

\* \* \* \* \*

The Museum of Modern Art, 11 West 53rd Street, New York, New York 10019.

Barr, Alfred H.  MASTERS OF MODERN ART.  New York:  Muse-
um of Modern Art, distributed by Simon and Schuster, New York,
1954.  239 p.  Illus., some color plates.  Bibliography and index
pp. 237-39.

> Extensive selections from the collection of the Museum
> of Modern Art illustrate this volume written for the lay-
> man as a general introduction to modern art.  In paint-
> ing, the emphasis is upon the evolution of abstract styles.

Lynes, Russell.  THE GOOD OLD MODERN.  New York: Athe-
neum, 1973.  490 p.  Illus.  Index pp. 471-90.

> A history of the events and the collection of this major
> modern art museum established in 1929.  Written as a
> popular rather than scholarly book, Lynes tends to ignore
> the negative and controversial issues.

\* \* \* \* \*

Museum of the City of New York, Fifth Avenue at 103rd Street, New York,
New York  10029.

\* \* \* \* \*

National Academy of Design, 1083 Fifth Avenue, New York, New York  10028.

\* \* \* \* \*

New York Historical Society, 170 Central Park West, New York, New York 10024.

CATALOGUE OF AMERICAN PORTRAITS IN THE NEW YORK
HISTORICAL SOCIETY.  New York:  New York Historical Society,
1941.  374 p.  Illus.

\* \* \* \* \*

Solomon R. Guggenheim Museum, 1071 Fifth Avenue, New York, New York
10028.

SELECTIONS FROM THE GUGGENHEIM MUSEUM COLLECTION;
1900-1970.  New York:  Solomon R. Guggenheim Foundation,
1970.  437 p.  Illus., some in color.

> Extensive collections of modern European and American
> artists.

Whitney Museum of American Art, Madison Avenue and 75th Street, New York, New York 10021. The Whitney is one of the giants in the field of American painting. The annual and biennial shows have been landmarks. (See: New York Whitney Museum of American Art. BIENNIAL EXHIBITIONS.)

Alloway, Lawrence. "Institution: Whitney Annual." ARTFORUM, vol. 11, March 1973, pp. 32-35.

A brief history of the annuals (biennials) from 1932 to the present, and rather critical appraisal.

Golub, Leon. "16 Whitney Museum Annuals of American Painting: Percentages, 1950-72." ARTFORUM, vol. 11, March 1973, pp. 36-39.

Analysis of artists included in the annuals, and some criticism of the exhibitions. Accompanied by charts.

Goodrich, Lloyd and Baur, John I.H. AMERICAN ART OF OUR CENTURY. New York: published for the Whitney Museum of American Art by Praeger, 1961. 309 p. Illus., many color plates. Index pp. 298-300. "Books published by the Whitney" p. 306.

A history of the collection to 1960 (prior to the move into the Marcel Breuer building in 1966); at this time the collection was housed on 54th Street.

## Ogdensburg

Remington Art Memorial, 303 Washington Street, Ogdensburg, New York 13669.

A large collection of paintings and bronzes by Frederic Remington.

## Syracuse

Everson Museum of Art, 401 Harrison Street, Syracuse, New York 13202.

Joe and Emily Lowe Art Center of Syracuse University, 309 University Place, Syracuse, New York 13210.

## Utica

Munson-Williams-Proctor Institute, 310 Genesee Street, Utica, New York 13502.

## Yonkers

The Hudson River Museum, 511 Warburton Avenue, Trevor Park-on-Hudson, Yonkers, New York 10701.

### NORTH CAROLINA

## Raleigh

The North Carolina Museum of Art, 107 East Morgan Street, Raleigh, North

Carolina 27611.

## OHIO

### Cincinnati

Cincinnati Art Museum, Eden Park, Cincinnati, Ohio 45202.

### Cleveland

The Cleveland Museum of Art, 11150 East Boulevard, Cleveland, Ohio 44106.

> SELECTED WORKS, THE CLEVELAND MUSEUM OF ART. Cleveland: Museum of Art, 1966? 240 p. Illus., many color plates.

>> Mostly reproductions, little text. European works predominate, few American paintings are included.

### Columbus

Columbus Gallery of Fine Arts, 480 East Broad Street, Columbus, Ohio 43215.

> Tucker, Marcia. AMERICAN PAINTINGS IN THE FERDINAND HOWALD COLLECTION. Columbus: Columbus Gallery of Fine Arts, 1969. 119 p. Illus., some color plates. Bibliography p. 116. Index pp. 117-18. Introduction by E.P. Richardson.

>> Catalog of an important collection of early twentieth-century paintings, donated to the Columbus Gallery in the 1920's.

### Toledo

The Toledo Museum of Art, Monroe Street and Scottwood Avenue, Toledo, Ohio 45967.

### Youngstown

Butler Institute of American Art, 524 Wick Avenue, Youngstown, Ohio 44502.

## OKLAHOMA

### Tulsa

Thomas Gilcrease Institute of American History and Art, 2500 W. Newton Street, Tulsa, Oklahoma 74127.

## PENNSYLVANIA

### Greensburg

Westmoreland County Museum of Art, 221 North Main Street, Greensburg, Pennsylvania 15601.

## Philadelphia

Historical Society of Pennsylvania, 1300 Locust Street, Philadelphia, Pennsylvania 19107.

\*   \*   \*   \*   \*

The Pennsylvania Academy of the Fine Arts, Broad and Cherry Streets, Philadelphia, Pennsylvania 19102.

\*   \*   \*   \*   \*

Philadelphia Museum of Art, Benjamin Franklin Parkway at 26th Street, Philadelphia, Pennsylvania 19101.

## Pittsburgh

Carnegie Institute Museum of Art, 4400 Forbes Avenue, Pittsburgh, Pennsylvania 15213.

## Reading

Reading Public Museum and Art Gallery, 500 Museum Road, Reading, Pennsylvania 19602.

### RHODE ISLAND

## Providence

Rhode Island School of Design, Museum of Art, 224 Benefit Street, Providence, Rhode Island 02903.

> THE ALBERT PILAVIN COLLECTION: TWENTIETH CENTURY AMERICAN ART. Providence: Rhode Island School of Design Museum of Art, 1969. 58 p. Illus., some color.
>
> Nineteen works purchased by R.I.S.D.
>
> Also see: MASSACHUSETTS. Waltham. Brandeis University.

### TEXAS

## Fort Worth

Amon Carter Museum of Western Art, 3501 Camp Bowie Boulevard, Fort Worth, Texas 76101.

\*   \*   \*   \*   \*

Fort Worth Art Center Museum, 1309 Montgomery Street, Fort Worth, Texas 76107.

## VIRGINIA

Richmond

Virginia Museum of Fine Arts, Boulevard and Grove Avenue, Richmond, Virginia 23221.

Williamsburg

Abby Aldrich Rockefeller, Folk Art Collection, South England Street, Williamsburg, Virginia 23105.

> Little, Nina Fletcher. THE ABBY ALDRICH ROCKEFELLER FOLK ART COLLECTION: A DESCRIPTIVE CATALOGUE. Williamsburg, Va.: Colonial Williamsburg, 1957 (distributed by Little Brown, Boston). 402 p. Illus., color.
>
> > Catalog of an important collection of American folk art, including paintings. There is little text; all the reproductions are in color, but all appear muddy. "Paintings on Glass" (p. 259) is brief, but helpful for this elusive subject.

## WASHINGTON

Seattle

Seattle Art Museum, Volunteer Park, Seattle, Washington 98102.

### GENERAL REFERENCES FOR MUSEUMS

Christensen, Erwin O. *A GUIDE TO ART MUSEUMS IN THE UNITED STATES. New York: Dodd Mead, 1968. 303 p. Illus. Index pp. 295-302.

> Written for the tourist, this has brief descriptions of the collections of 88 U.S. museums. Small, postage-stamp size illustrations are for identification purposes only.

Constable, W.G. ART COLLECTION IN THE UNITED STATES OF AMERICA: AN OUTLINE OF A HISTORY. London: Thomas Nelson and Sons, 1964. 210 p. Index pp. 197-210. Illus.

> A brief history of private and public collections of art. "The Return of the Native" (pp. 141-54) describes collections of American art.

Davenport, William et al. ART TREASURES IN THE WEST. Menlo Park, California: Lane Magazine and Book Co., 1966. 320 p. Illus., many in color.

> U.S. art resources are heavily concentrated in the eastern half of the country, and so is the literary coverage. This is written for the tourist and gives a brief survey of collections in museums in California, Hawaii, Arizona, Utah, Idaho, Oregon, Washington, and western Canada. Not limited to American art, nor to paintings.

*THE OFFICIAL MUSEUM DIRECTORY, 1973. Washington, D.C.: The American Association of Museums and National Register Publishing Co., Skokie, Illinois, 1973. 1173 p.

> The basic directory of museums, historic houses, and other related institutions in the United States and Canada. Not limited to art museums. There are subject, alphabetical and personnel indexes, and the basic arrangement is geographical.

O'Doherty, Brian, ed. MUSEUMS IN CRISIS. New York: Braziller, 1972. Illus. Includes bibliographical notes.

> A collection of essays which were first published in the Special Museum Issue of ART IN AMERICA (July-August, 1971). The current problems of museums, particularly American museums, are intelligently discussed in this topical book.

(Also see: AMERICAN ART DIRECTORY and INTERNATIONAL DIRECTORY OF THE ARTS. H. Rauschenbush, ed.)

# INDEX

# INDEX

When there are several pages listed after an entry, and one is more important, it has been underlined.

## A

A.A.A.: See Archives of American Art

Abbey, Edwin A.   <u>61</u>, 189

Abels, Alexander   41

Abrams, Harry   201

Abstract expressionism   41, 48, 50, 55, 56, 223

Abstract painting   39-40, 42, 44, 46, 47, 54

Adams, Adeline   101

Adams, Philip   118

Adams, Ramon F.   155

Addison Gallery of American Art   219

Afro-American art: See Black American artists

Agee, William C.   39, 126

Albany Institute of History and Art   222

Albers, Josef   40, 49, <u>61-62</u>

Albright, Ivan   49, 51, <u>62</u>

Albright - Knox Art Gallery   222-23

Alexander, John White   62

Allen, Douglas   150, 184

Allentuck, M.E.   98

Alloway, Lawrence   40, 50, 93, 94, 122, 124, 129, 135, 153, 163, 227

Allston, Washington   63, 190, 191

Amaya, Mario   39, 40

American Abstract Artists   39-40, 44

American Academy of Arts and Letters   208

AMERICAN ART ANNUAL   5

AMERICAN ART DIRECTORY   5, 6, 210

AMERICAN ART JOURNAL   195

AMERICAN ARTIST   195

American Association of Museums   213

American Federation of Arts   213